VAN GOGH AND THE COLORS OF THE NIGHT

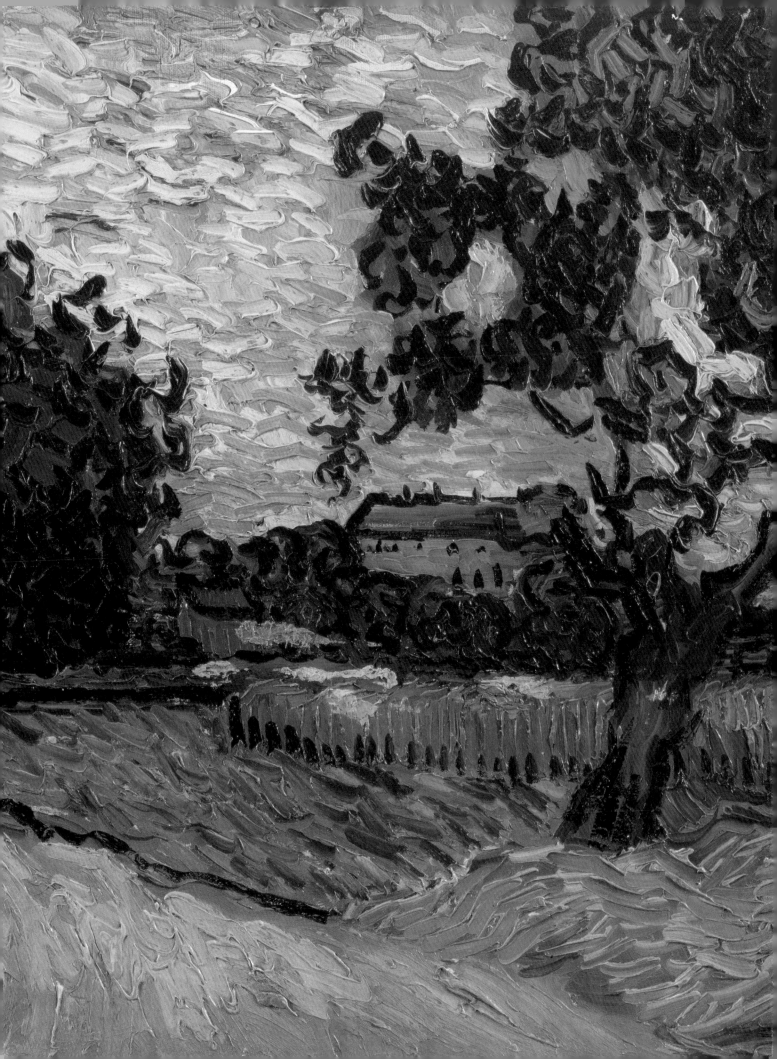

VAN GOGH AND THE COLORS OF THE NIGHT

Sjraar van Heugten, Joachim Pissarro, and Chris Stolwijk

with contributions by
Geeta Bruin, Maite van Dijk, and Jennifer Field

THE MUSEUM OF MODERN ART | VAN GOGH MUSEUM

Published in conjunction with the exhibition *Van Gogh and the Colors of the Night*, organized by Joachim Pissarro at The Museum of Modern Art, New York, September 21, 2008–January 5, 2009, and Sjraar van Heugten and Chris Stolwijk at the Van Gogh Museum, Amsterdam, February 13–June 7, 2009.

The exhibition is made possible in part by the Eugene V. and Clare E. Thaw Charitable Trust.
Major support is provided by an indemnity from the Federal Council on the Arts and the Humanities.
Additional funding is provided by The Consulate General of the Netherlands in New York.

Produced by the Department of Publications, Van Gogh Museum, Amsterdam, and the Department of Publications, The Museum of Modern Art, New York, in collaboration with Mercatorfonds, Brussels.

Project Management by Suzanne Bogman, Van Gogh Museum
Editorial assistance by Geri Klazema, Van Gogh Museum
Edited by Aggie Langedijk and Kate Norment
Designed by Caroline Van Poucke
Production by Tijdsbeeld & Pièce Montée, Ghent, under the direction of Ronny Gobyn
Color scanning by Die Keure, Bruges

Texts by Sjraar van Heugten, Chris Stolwijk, Geeta Bruin, and Maite van Dijk have been translated into English by Lynne Richards.

Printed and bound by Die Keure, Bruges
Typeset in Joanna and Grotesque
Printed on Satimat 170g (Arjo-Wiggins)

English edition published by The Museum of Modern Art
11 West 53 Street
New York, New York 10019
www.moma.org

Library of Congress Control Number: 2008925989 (hardcover)
Library of Congress Control Number: 2008926745 (paperback)
ISBN: 978-0-87070-736-0 (hardcover)
ISBN: 978-0-87070-737-7 (paperback)

Distributed in the United States and Canada by D.A.P. / Distributed Art Publishers, Inc., New York

Distributed outside the United States, Canada, Belgium, The Netherlands and Luxembourg by Thames & Hudson, Ltd, London

Distributed exclusively in Belgium, The Netherlands and Luxembourg by Mercatorfonds, Brussels

Printed in Belgium

Page 2: Detail of ill. 66. Vincent van Gogh. *Landscape at Twilight*. 1890. Oil on canvas, 19 ¹¹⁄₁₆ x 39 ¾" (50 x 101 cm). Van Gogh Museum, Amsterdam. F770 / JH2040

FOREWORD

The night and twilight hours occupied Van Gogh's thoughts and imagination and served as the inspiration for many of his masterworks, from early paintings such as *The Potato Eaters*, to his later, expressionistic painting *The Starry Night*. Recent research conducted in conjunction with this exhibition brought to light the fact that Van Gogh was deeply fascinated by the nocturnal world long before he thought of becoming an artist. He viewed the dark hours as a period of contemplation and creativity, a moment when he could reflect on the happenings of the day and express his inner thoughts on the beauty of the nocturnal landscape in letters to close friends and family. When Van Gogh decided, in 1880, to become an artist, his sentiments about the night informed his visual representations of it. He infused his depictions of the evening and nighttime environment with his ideas about the symbolic properties of these hours, especially in connection to the cycles of life, the effects of modernity, and a romantic view of nature.

The works in this exhibition offer a cogent testimony to Van Gogh's abiding interest in the artistic problem of representing nighttime. To the extent that there is any truth in the idea that the Impressionists set out to represent light through color, we could also say that one of Van Gogh's major accomplishments was to pursue the complementary goal of capturing the mood and light effects of night through color. The night presented Van Gogh with a means of articulating the various facets of his complex psyche, as well as the artistic challenges he took on during his short career as a painter. This is revealed in the hundreds of letters he wrote to his brother Theo, and to friends such as the artists Emile Bernard and Paul Gauguin. A careful selection of these intimate texts is presented in this exhibition, alongside many of the paintings Van Gogh discussed and illustrated within them.

The Museum of Modern Art and the Van Gogh Museum are delighted to present, for the first time, this exhibition and catalogue on Van Gogh's nocturnal compositions, a theme that binds together all periods of the artist's career in a way that has seldom been done before. This project was guided from its inception by the insight and expertise of its organizers, Joachim Pissarro, Adjunct Curator in the Department of Painting and Sculpture, The Museum of Modern Art, and Sjraar van Heugten, Head of Collections, Van Gogh Museum. Their essays in this catalogue, along with that of Chris Stolwijk, Head of Research, Van Gogh Museum, and the texts by Geeta Bruin, Maite van Dijk, and Jennifer Field, provide enlightening analyses of the profound role that twilight and night themes played throughout Van Gogh's oeuvre.

This exhibition and the accompanying publication could not have been realized without the generosity of sponsors to whom we are most grateful. The exhibition is made possible in part by the Eugene V. and Clare E. Thaw Charitable Trust. Major support is provided by an indemnity from the Federal Council on the Arts and the Humanities. Additional funding is provided by The Consulate General of the Netherlands in New York.

Glenn D. Lowry
Director
The Museum of Modern Art

Axel Rüger
Director
Van Gogh Museum

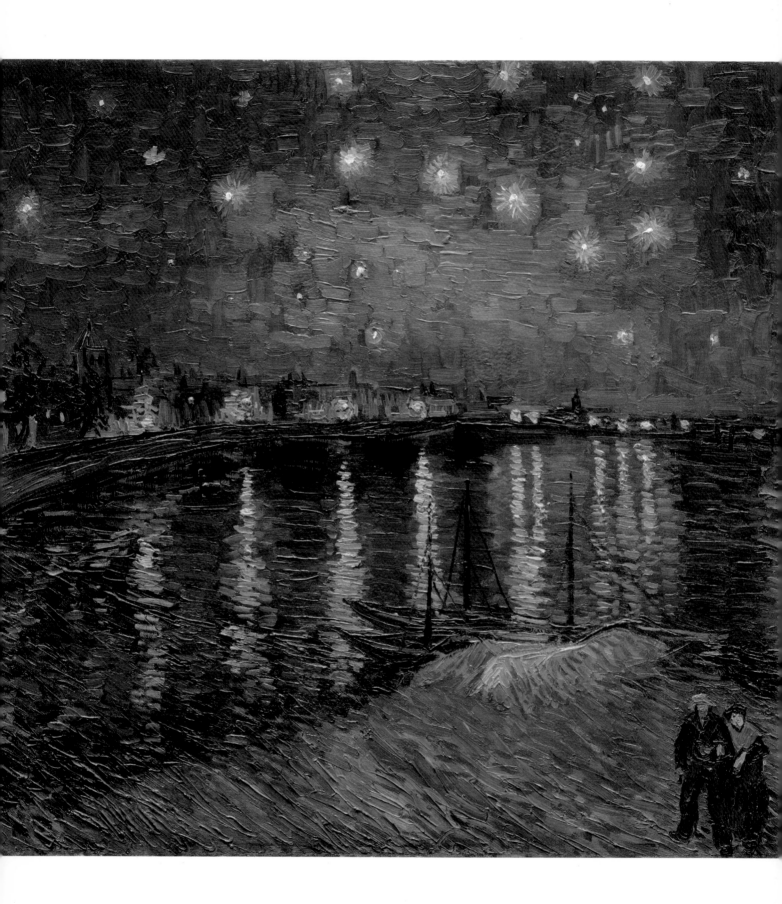

INTRODUCTION

Joachim Pissarro and Sjraar van Heugten

"It often seems to me that the night is much more alive and richly colored than the day."
Vincent van Gogh[1]

Well before he became an artist, Vincent van Gogh was fascinated by the cycles of nature and human life and the times of day. In a letter from 1873 to his friends Willem and Caroline van Stockum-Hanebeek he enclosed a handwritten copy of one of his favorite poems, "Avondstond (The Evening Hour)," by the Flemish poet Jan van Beers. In it, the day is at end, peasants and a cowherd are returning home, and nature is at its most glorious—and the scene is keenly observed by a painter.[2]

When Van Gogh started his artistic career, he gave the different times of day, the seasons of the year, and the activities associated with them a solid place in his oeuvre. Scenes set at dusk, evening, or night form a recurring motif in his work. The weight that those dark hours had for Van Gogh becomes clear when one considers the number of masterpieces in this crepuscular and nocturnal genre, including major works from his Dutch years, *The Potato Eaters* (1885, ill. 69) and *The Cottage* (1885, ill. 73); a series of sowers from Arles, in which he consciously tried to make an ambitious contribution to the modern art of his time; *Terrace of a Café at Night (Place du Forum)* (1888, ill. 39) and *The Night Café* (1888, ill. 27); *The Starry Night over the Rhône* (1888, ill. 1), which he painted in Arles, and the famous version of *The Starry Night* (1889, ill. 54) from Saint-Rémy; *Country Road in Provence by*

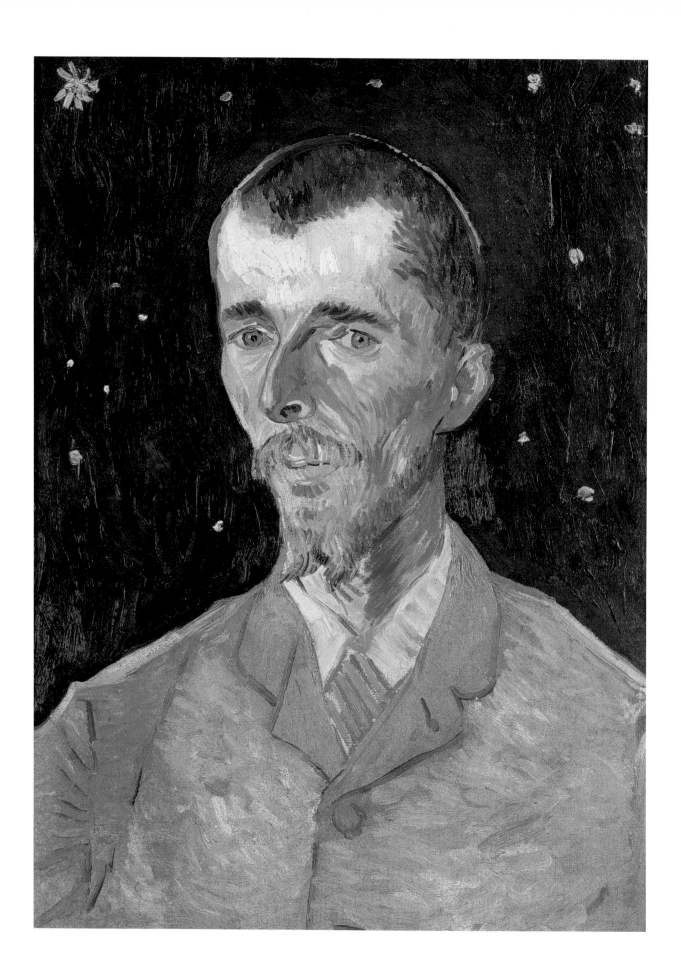

Night (1890, ill. 104), from that same period; and *Landscape at Twilight* (1890, ill. 66), from Auvers-sur-Oise. All of these works are highlights of his career, some of them having achieved nothing less than iconic status.

Over the years much attention has been devoted to these works, individually and in diverse contexts. Never before, however, have they been studied as a group, let alone brought together in an exhibition and accompanying catalogue, as we have done here.

Van Gogh's night scenes offer rich layers of content. They are the result of tradition on one hand and modernity on the other (ill. 4). Some show the strong relationship that Van Gogh and his contemporaries perceived between the cycles of nature and those of rural labor. Others evoke a poetic association of the evening with either modern times or nature. Van Gogh's works and letters not only carried on the art historical tradition of twilight and night scenes but also reflected how his thoughts were influenced by literary sources. The stylistic and technical methods that Van Gogh applied to capture the effects of dark and light proved to be a rewarding field of investigation. The essays in this catalogue address these and other subjects.

Every curatorial choice in grouping works of art can be disputed, but a certain logic surfaced during the making of this exhibition that led to the organization of works into four major sections. The first section, "Landscapes at Twilight," focuses on Van Gogh's earliest landscapes at dusk, painted in 1883–84. With these works the artist aligned himself with the centuries-old tradition of evening and night scenes, of which Van Gogh was well aware. Nocturnal landscapes were particularly numerous in the work of Barbizon painters like Charles Daubigny and Jules Dupré, whom Van Gogh greatly admired. At first merely a follower of their well-established genre of *effets de soir*, Van Gogh soon took up the challenge to make his own variations. As with so many other themes in his oeuvre, he remained loyal to the subject, but transformed it in his later work.

The second section of the exhibition, "Peasant Life: 'Les Paysans chez eux'," refers to Van Gogh's study of peasants in Nuenen in the southern Dutch province of Brabant. There he would create his first masterpiece, *The Potato Eaters* (ill. 69), a painting that makes a clear reference to night scenes by Rembrandt, giving us a clue to the meaning of this work. Closely connected is the theme of cottages— picturesque buildings that Van Gogh fondly labeled "human nests"—as a safe haven for their humble occupants. It is a recurrent motif in his work, and shortly after finishing his second version of *The Potato Eaters* Van Gogh painted a cottage similar to the one in which the interior scene was set (ill. 73). It captures the early evening hour, and a tiny flame seen through the window points toward the hut's inhabitants.

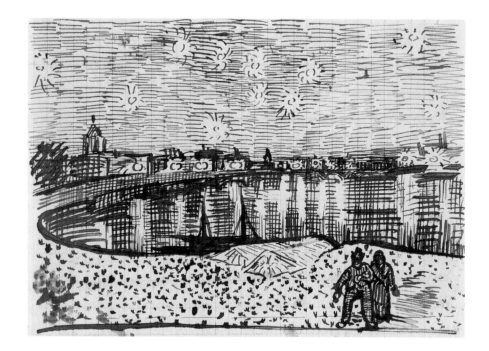

3

Vincent van Gogh

Sketch of *The Starry Night over the Rhône* enclosed with a letter to Eugène Boch.

October 2, 1888

Van Gogh Museum, Amsterdam

The life and work of peasants and their close association with the cycles of nature were a matter of prime artistic importance to Van Gogh. In the rural areas where he lived throughout his career he was captivated by the sowing of wheat, by the harvest, and by sheaves of wheat in the fields. These elements form the basis for many of his works, major sunset and evening scenes among them. In Arles, he emulated Millet's *Sower* (ill. 16), but painted it in strong, bold colors in an attempt to make it truly modern. Two works in this series—the first, from July 1888 (ill. 50), which he deemed unsuccessful; and the last, painted in November of that year (ill. 51)—are set at dusk; here the beginning of life (sowing) takes place at the end of the day, a subtle play on the never-ending cycles of life. These works, together with paintings of wheat fields under either a setting sun or a rising moon, form the third section, "The Voice of the Wheat: A Nocturne" (a title taken from a Jules Breton poem quoted by Van Gogh).

Van Gogh's poetic associations with evening and night are fundamental to the works in his oeuvre that depict these evocative hours. They are the topic of the last section, "Poetry of the Night." Nowhere is Van Gogh's lyrical view of night more evident than in his portrait of Eugène Boch (1888, ill. 2), in which he portrayed his artist friend against the background of a starry sky, thus presenting him as a poet. However, the dark hours had more than one aspect. Under the open skies, Van Gogh perceived the formidable forces of nature that give humanity a sense of eternity and provide consolation in this hard world; these feelings led to his two versions of *The Starry Night* (ills. 1 and 54). On the other hand, as *The Night Café* (ill. 27) illustrates, evening in the modern world might be a harsher time, when people get lost or led astray in their lives.

This book cannot begin to do complete justice to the complex, multifaceted, and thought-provoking aspects of its subject. Studying the work of Van Gogh is in many senses a humbling experience, and one is often left with a profound feeling of having merely scratched the surface. By doing so, however, we and our coauthors—Chris Stolwijk, Geeta Bruin, Maite van Dijk, and Jennifer Field—hope to give access to, and perhaps shed some new light on, a remarkable group of works in Van Gogh's oeuvre.

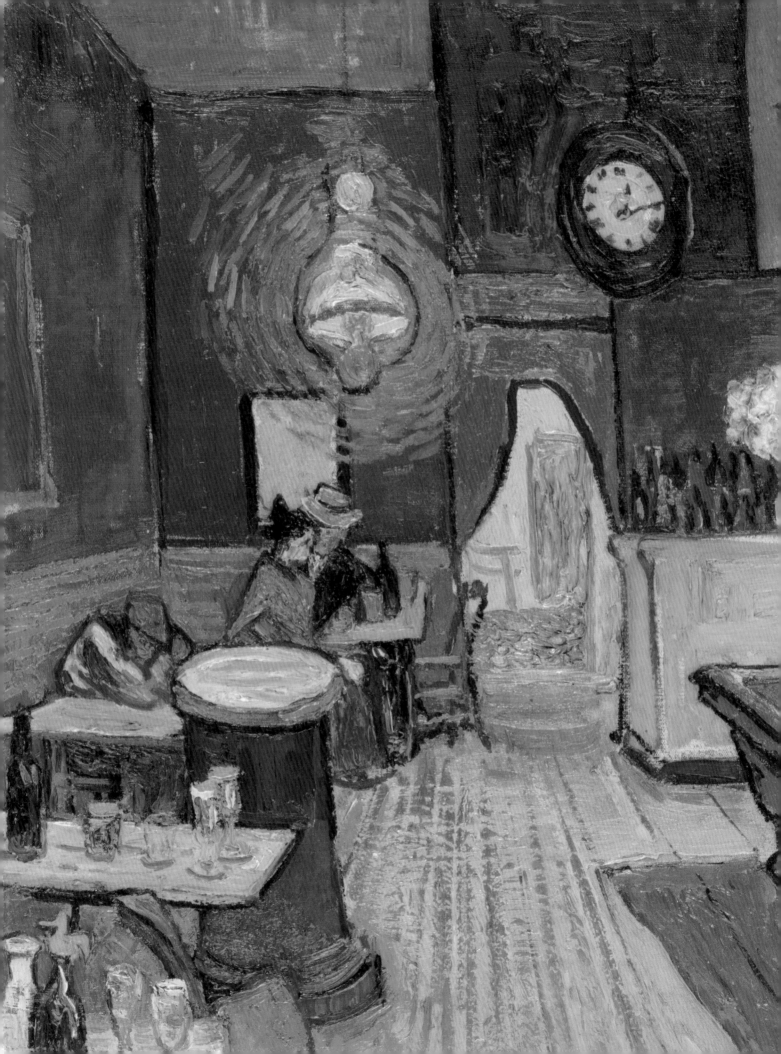

VAN GOGH AND THE PICTORIAL GENRE

OF EVENING AND NIGHT SCENES

Chris Stolwijk

"Anyway, I tried with contrasts of delicate pink and blood-red and wine-red. Soft Louis XV and Veronese green contrasting with yellow greens and hard blue greens. All of that in an ambience of a hellish furnace, in pale sulphur. To express something of the power of the dark corners of a grog-shop."
Vincent van Gogh[1]

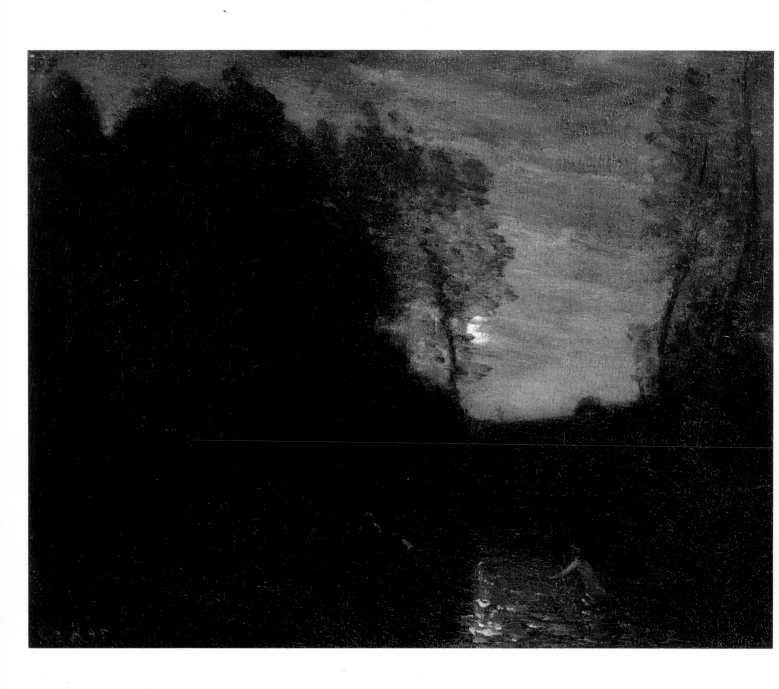

5
Camille Corot
Moonlight. c. 1855
Museum Mesdag, The Hague

Vincent van Gogh, inspired painter of intense light and bright colors, was fascinated by somber twilights and atmospheric nights. There are countless paintings and drawings of these subjects in his oeuvre and some of them are now considered to be among his most important works.

Van Gogh's deep feeling for and portrayal of the still, dark hours after sunset are part of a long and honorable tradition. Since time immemorial, composers, writers, and painters have tried to capture the hours of darkness and their unique poetry in their art. In the early modern age the night had become a culture in its own right, with its own customs and rituals that were very different from daytime reality. In stark contrast to the daylight hours, the night provided unfettered license to good and evil forces alike.[2] During the nineteenth century technological innovations like gaslight and street lamps pushed the darkness back, revealing some of its secrets but at the same time magnifying the attractions of the once-so-black night. Composers like John Field and Frédéric Chopin wrote nocturnes celebrating night's lyrical moods, and nineteenth-century literature offered a wealth of writings describing and extolling the dark. Van Gogh, who was widely read, frequently quoted from books like these in his letters. He cited works by authors like Victor Hugo, a writer par excellence about darkness and night, and Walt Whitman, whose poetry, he said, evoked "a world of health, of generous, frank carnal love—of friendship—of work, with the great starry firmament, something, in short, that one could only call God and eternity, put back in place above this world."[3]

Since painting from life at night is extremely tricky, an artist who wants to paint darkness—in the dark—has to summon his powers of imagination.[4] The special quality of light between dusk and dawn presents an additional challenge to a painter. There were numerous examples in the history of Western European art that Van Gogh could consult in his endeavor to capture darkness in a successful composition.[5] His assimilation of this tradition in his own work is discussed at length in other contributions to this book; the present essay focuses on Van Gogh's predilection for the pictorial genre of evening and night scenes and his admiration for his predecessors.

Van Gogh succeeded in modernizing the encyclopedic and traditional iconography of the dark in a radical way. In his work we find none of the fashionable cityscapes with lamp-lit boulevards so popular at the time, and the hidden nightlife in cafés, theaters, and brothels has similarly left little trace. In choosing his subjects Van Gogh sought to connect with a tradition of *somber* scenes of the landscape in the evening and at night. He preferred to depict the harsh reality of rural life by portraying peasants at work or resting within the confines of the family in the evening. He was also fascinated by the eternal poetry of the night, appealing to such comforting sentiments as belief in the unending regeneration of nature and

the possibility of compassion. Even his *Night Café*, in which he wanted to express "the terrible human passions," conveys a sense of hope for better times (see ill. 27).[6]

Van Gogh's efforts to depict the dark were firmly rooted in reality. Here he parted company with Symbolist contemporaries like Odilon Redon who turned their gaze inward and focused on expressing the more destructive, inner forces that can beset one at night. These artists were indebted to predecessors like William Blake and Henry Fuseli.

ETERNAL POETRY AND EXPRESSION

Prints had a fundamental impact on Van Gogh's development as an artist.[7] New reproduction techniques had brought graphic art within the reach of the general public, and the instant Van Gogh started work in the art trade in 1869 he became a passionate collector of reproductions of prints. His letters are full of enthusiastic descriptions of the prints he had managed to get from illustrated magazines like *The Graphic, The Illustrated London News,* and *L'Illustration.* He filled albums with his acquisitions and hung them on the walls of his rooms.

Van Gogh valued these prints for their aesthetic qualities—the techniques used, the convincing composition, the expression being sought—and for the message they conveyed and the mood they evoked. When it came to evening and night scenes Van Gogh was particularly interested in the portrayal of "that eternal poetry of Christmas night with the baby in the manger . . . that light in the darkness—a brightness in the midst of a dark night," as is evident from his collection of nativity scenes by artists like Edwin Abbey, Alexandre Jazet, and Nicolaes Maes.[8] Christmas night made Van Gogh, son of a Protestant minister, long for his family, whose members were accustomed to celebrating the holiday at home together. And so in 1883 he described the mood that the English engraver Myles Birket Foster had captured in his *Christmas Eve* as "very convivial" (ill. 6).[9] But the eternal poetry spoke to him most poignantly in Rembrandt's *The Holy Family at Night* (see ill. 31).

Van Gogh's collection also contained numerous works exposing the hard lives of the laboring classes and the fringes of society. He particularly admired *A Midsummer Night's Dream: A Sketch in a London Park* (ill. 7) by Harry Furniss, which shows a number of people spending the night on a park bench, rendered with the social realism of Daumier's prints.[10]

6
Myles Birket Foster
Christmas Eve—The Cottager's Return from Market. In *The Illustrated London News* 27 (December 22, 1855), p. 720

7
J. Swain after Harry Furniss
A Midsummer Night's Dream: A Sketch in a London Park. In *The Illustrated London News* 81 (July 8, 1882), p. 37

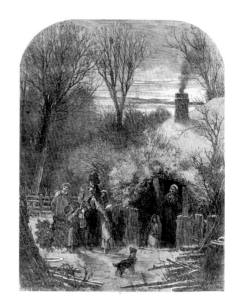

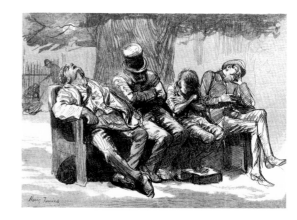

8
Utagawa Hiroshige II
The Shōhei Bridge. 1862
Van Gogh Museum,
Amsterdam

As far as technique was concerned, he was fascinated by the evocative qualities of strong chiaroscuro effects and by the means of achieving them,[11] and he had immense respect for artists who were able to engrave a scene expressively. In 1883 he praised the etchings of James Abbott McNeill Whistler, a painter who was universally recognized for his night scenes, for their well-wrought detailing rather than for the compositions as such.[12]

From 1886 onwards the majority of the works Van Gogh added to his print collection were Japanese woodcuts. In his view these works united daring compositions, remarkable cropping, bright contrasting colors and areas of color, crisp outlines, and a highly individual use of line. He was most interested in scenes of nightlife—brothels, theaters, and the like—and the Japanese landscape, and concentrated on acquiring evening and night scenes like *Night View of Saruwakacho Theater Street* (1856) from Hiroshige's renowned *One Hundred Famous Views of Edo*, and *The Shōhei Bridge* (1862) by Hiroshige II (ill. 8).[13] One evening in Arles, as he watched a barge being unloaded, the effect reminded him of the work of Hokusai: ". . . the water was a white yellow and dark pearl-gray, the sky lilac and an orange strip in the west, the town violet. On the boat, little workmen, blue and dirty white, were coming and going, carrying the cargo ashore. It was pure Hokusai."[14]

SEVENTEENTH-CENTURY PREDECESSORS

Van Gogh's perception of and regard for evening and night scenes, particularly landscapes, were closely bound up with his experience of life. He was a true nature-lover. As an avid walker from his childhood on, he had spent a great deal of time outdoors, and landscapes could conjure up all sorts of associations and memories for him. In May 1876 he wrote:

> I also saw the sea last Sunday night, everything was dark gray, but day was beginning to break on the horizon. . . . That same night I looked out of the window of my room onto the roofs of the houses one sees from there and the tops of the elms, dark against the night sky. Above those roofs, one single star, but a nice, big friendly one. And I thought of us all, and I thought of the years of my life that had already passed, and of our home.[15]

During his bout of mental illness in 1888–90 Van Gogh was more than usually receptive to the specific mood of evening and night, and above all to the solace that a night landscape could bring him.[16]

Van Gogh made a close study of nature and, as an artist, recorded it in a personal and penetrating manner.[17] The shifting effects of light and shade that occur with the changes of the seasons, the weather, and the time of day are a prominent feature of his work. He much admired the night pieces by seventeenth-century Dutch masters.

By the sixteenth and seventeenth centuries, the depiction of darkness, which had its origins in the fifteenth century, had developed into a full-fledged subgenre of landscape and figure painting in the southern and northern Netherlands.[18] Such pictures were described as "a moonlight," "a night landscape," "a night-piece," or "a fire-piece."[19] The night landscapes were based on biblical and sometimes mythological themes. A subject like the flight into Egypt was still popular in the early decades of the seventeenth century, but was gradually overshadowed by the "secular" landscape. Van Gogh's religious background notwithstanding, he seldom if ever referred to history pieces of this kind, unless it was in the period before he turned seriously to art, when he spent considerable time in intense study of the Bible. He wrote then that his father—"who oft-times travels at night, carrying a lantern, to a sick or dying person, for example, to speak to him about Him whose word is also a light in the night of suffering and mortal fear"—would probably be able to appreciate Rembrandt's etchings like *The Flight into Egypt* (ill. 9) for their true worth. In the same letter he referred approvingly to *The House at Bethany* (*Christ Conversing with Martha and Mary*), in which twilight prevails and "the figure of the Lord" stands "noble and impressive."[20]

In 1888, after years of dwindling faith, Van Gogh frankly admitted that he saw little point in depicting biblical figures and events. He now believed that Rembrandt

9
Rembrandt van Rijn
The Flight into Egypt. 1651
Rijksprentenkabinet,
Rijksmuseum, Amsterdam

10
Camille Corot
*Christ in the Garden of
Gethsemane.* 1849
Musée d'Art et d'Histoire,
Langres

and Delacroix had done this so admirably that there was nothing he could add. Instead he looked for subjects from daily life that offered the viewer the possibility of a more philosophical interpretation. One of the few contemporary nocturnes with a religious theme that he did approve of was Corot's *Christ in the Garden of Gethsemane* of 1849, which he saw at an exhibition in the École Nationale des Beaux-Arts in Paris in May 1875 and was still describing as a sublime work in 1889 (ill. 10).[21]

Oddly enough, Van Gogh nowhere mentions the work of Aert van der Neer, one of the leading seventeenth-century exponents of the secular night landscape, even though it is more than likely that he saw nocturnes by the artist during visits to the Mauritshuis and the Rijksmuseum. When it came to Rembrandt, who also produced numerous evening landscapes, Van Gogh chiefly admired chiaroscuro figure pieces, and he praised Jacob van Ruisdael for his mysterious lighting effects in the morning and evening, without mentioning any specific paintings. He was greatly impressed by Aelbert Cuyp's handling of evening light, more specifically his "strong golden glow," which Van Gogh experienced in person during a walk at

sunset in and around Dordrecht in January 1877: "This evening when the sun went down and was reflected in the water and the windows, throwing a strong golden glow on everything, it was just like a painting by Cuyp."[22] It is not clear whether Van Gogh was familiar with Cuyp's masterly *Dordrecht from the North* (ill. 11), with its spectacular golden tone; he did, though, study an eighteenth-century copy—of the left-hand side only—in the Rijksmuseum in 1885.[23]

11

Aelbert Cuyp

Dordrecht from the North.

c. 1650

Anthony de Rothschild

Collection (The National Trust),

Ascott

THE BARBIZON SCHOOL

Perhaps greater even than Van Gogh's admiration for seventeenth-century examples was his love of landscapes by the painters of the Barbizon School, who had successfully carried on the Dutch tradition. Van Gogh appreciated their honest, personal representation of nature, and he was not alone in his views. Their reputation was widespread, particularly in the last quarter of the nineteenth century and among the artists of the Hague School, who harked back directly to the Barbizon example in their own work.

Van Gogh thought that painters like Camille Corot, Charles-François Daubigny, Jules Dupré, Georges Michel, Théodore Rousseau, and Constant Troyon were responsible for "the beginning of the great revolution in art."[24] Their landscapes were not harmonious versions of an idealized countryside; they were individually experienced and faithful versions of a piece of nature they had selected themselves—"a corner of nature seen through a temperament" and "man added to nature," as, quoting Emile Zola, he described their efforts. The result was "more than nature, more like a revelation."[25]

To Van Gogh, who in his youth had conceived of nature as a revelation of God, it remained inspired, animated, possessed of a soul. He saw in it a "mysterious endeavor" expressed in a particular mood that could be felt and portrayed by a painter.[26] The Barbizon artists, said Van Gogh, were true masters of this.[27] Personally, he preferred the picturesque and melancholy fall scenes and sunsets. An evening or night scene was imbued with a "dramatic quality . . . a *je ne sais quoi* . . . it expresses that moment and that place in nature where one can go alone, without company."[28]

Van Gogh was a great admirer of Corot's work. A print after *Evening* hung in his room in 1875, and later on Van Gogh would make his own studies after Corot. Van Gogh talked about a "Corot mood," informed by "a silence, a mystery, a peace"; Corot captured just this mood in his *Moonlight* of 1855 (ill. 5).[29] In 1888 Van Gogh recounted in a letter that the artist supposedly spoke on his deathbed of seeing pink skies in a dream.[30] Van Gogh believed that Corot's atmospheric landscape art (and that of Daubigny, Dupré, and Rousseau) was enduring and that Impressionists like Monet, Pissarro, and Renoir, who also painted "completely pink skies," had continued that tradition.[31]

In Daubigny's nocturnes and landscapes set in the hours "long before sunrise," Van Gogh found the "greatest peace and majesty" and poignant emotion. Daubigny had drawn his inspiration from the landscape and achieved "inexpressible effects of nature" in his work.[32] Van Gogh was particularly moved by his *Effet de lune* (Salon 1865), which he probably knew only from an engraving. Van Gogh liked the way Michel rendered twilight, and he regarded Rousseau's *The Edge of the Forest at Fontainebleau, Setting Sun* as one of his best works (ill. 12). His admiration for Jules Dupré was virtually boundless. In 1883 in Drenthe he drew inspiration from Dupré's *Evening*, in which "the mossy roofs stand out surprisingly deep in tone against a hazy, dusty evening sky" (ill. 13).[33] Dupré's landscapes and his sunsets "in black, in violet, in flame red" projected a whole range of moods that the painter had succeeded in expressing in "symphonies of color." Van Gogh recognized him as a colorist and even rated him on a par with Delacroix, his mentor and guide in the use of color.[34]

In the Netherlands, the painters of the Hague School emulated the landscape art of the Barbizon School. Van Gogh knew their work well— as he did the work of the Barbizon artists—through his employment in the art trade.[35] Nevertheless he drew only occasionally on the work of his Dutch contemporaries for inspiration for night and evening landscapes.

12

Théodore Rousseau

The Edge of the Forest at Fontainebleau, Setting Sun.

c. 1849

Musée du Louvre, Paris

13
Jules Dupré
Evening. c. 1875–80
Museum Mesdag, The Hague

THE SIMPLICITY OF PEASANT LIFE

Starting around 1840, the "peasant genre" developed into one of the best-loved and most widely practiced genres in both art and literature.[36] While life in towns and cities became ever more crowded and hectic, painters turned to the countryside, where time appeared to have stood still and ancient traditions and customs were still honored. In their works Jean-François Millet, Jules Breton, Léon Lhermitte, Jozef Israëls, and Charles de Groux sustained this nostalgic view of largely unspoiled rural life and presented the simplicity of the peasants' existence, their harmonious unity with the land and the eternal cycle of nature, and their deep-rooted faith in an almighty God. Van Gogh, who felt a strong affinity to traditional rural life, decided to emulate these artists and become a peasant painter. He wanted to paint peasants "in their setting," and in 1885 he described the peasant genre as the most essential contribution to modern art.[37] Van Gogh believed that Breton and Millet were able to convey a religious feeling in their work, a feeling he described as "something on high." He called them the "voice of the wheat," acknowledging them as the supreme exponents of the genre.[38]

Van Gogh got to know Breton's monumental canvases of peasant life in the early 1870s, and it was from this time, too, that his interest in Breton's bucolic poetry

14
Jules Breton
The Feast of St. John. 1875
Private collection

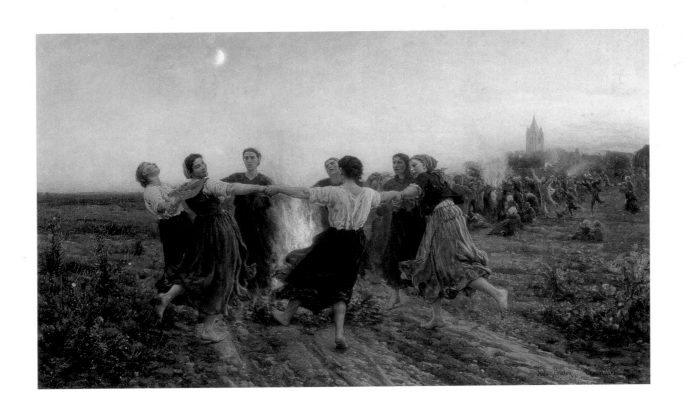

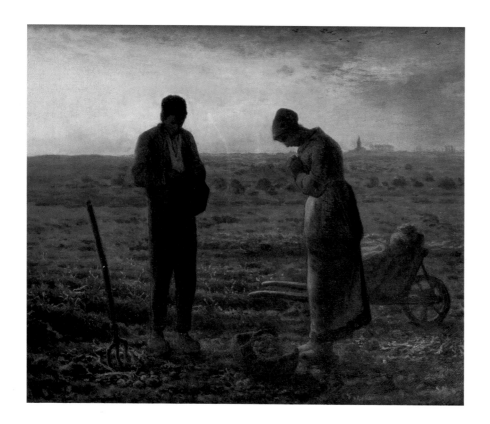

of life in the French countryside dated. Van Gogh considered the poet and painter from Courrières one of the greatest talents of his age: Breton's work, like Millet's, would endure.[39] In May 1875 Van Gogh saw Breton's imposing *The Feast of St. John* (ill. 14) at the Paris Salon: "peasant girls dancing on a summer evening round the St. John's bonfire, in the background the village with its church and the moon above it."[40] Among his favorites in the Musée du Luxembourg were *Calling in the Gleaners* of 1859 and *Evening*, which he thought were sublime. Some years later he was deeply impressed by *The Weeders* (ill. 77), with peasants working in the field against a red sunset. In his view Breton was able to express the human soul in an almost biblical tone that he shared with painters like Rembrandt and Millet.

Even more than to Breton, Van Gogh was indebted to "Father Millet," his master in the peasant genre, who was a "counselor and guide in *everything*" for young artists.[41] For a long while Millet's celebrated *The Angelus*, in which a peasant man and woman stand by a basket of potatoes in a field and pray, was the painting of paintings for Van Gogh (ill. 15); he said it was imbued with "infinite emotion." Just a few months before his death Van Gogh wrote that Millet had painted "humanity and the 'something on high,' familiar and yet solemn."[42] Reading Sensier's biography *La vie et l'oeuvre de J.-F. Millet* (1881) in 1882 strengthened Van Gogh's resolve to prove himself as a peasant painter, and its highly romanticized image of the artist became Van Gogh's model for his own life and work. Following the example of the deeply religious French painter, he wanted to go and live as a

15
Jean-François Millet
The Angelus. 1857–59
Musée d'Orsay, Paris

16
Jean-François Millet
The Sower. 1850
Museum of Fine Arts, Boston

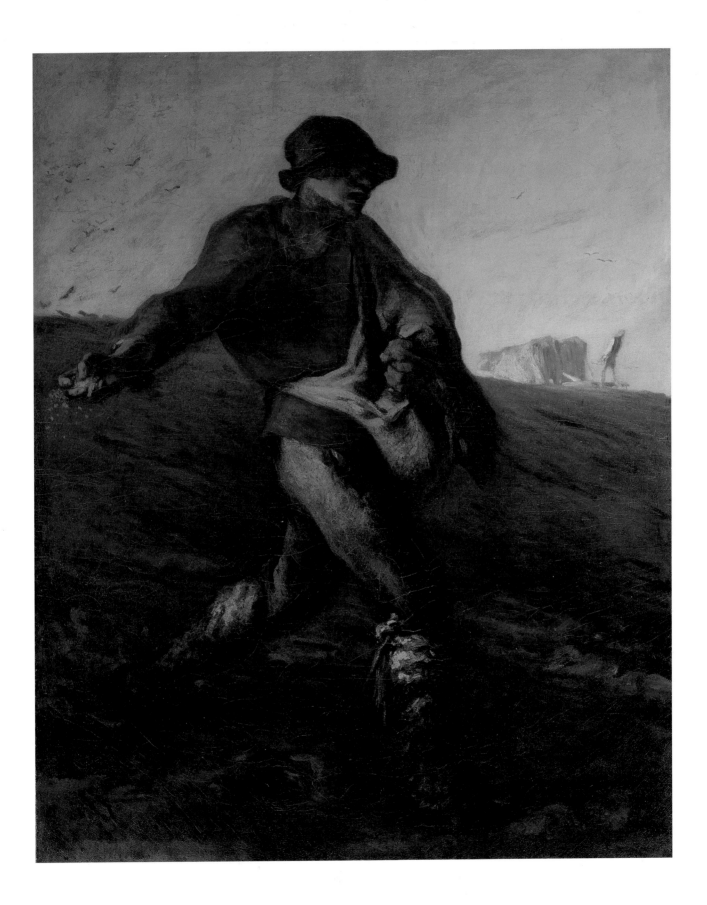

peasant among peasants so that he would be able to draw an honest, personal picture of the simple rural life.

Van Gogh was particularly struck by the portrayal of seasonal agricultural labor on a monumental scale in the work of Breton and Millet. He saw plowing, sowing, and harvesting as symbols of the cycle of overwhelming nature herself; the sower and the wheat sheaf stood for eternity, and the reaper and his scythe for irrevocable death.[43] He considered Millet's *Sower* of 1850 the very highest in art because it elevated everyday life (ill. 16); here art had conquered nature and achieved immortality. He believed that the work was fundamentally good, and as such it could bring solace.[44] Van Gogh recognized this higher art in Millet's portrayal of the daily cycle, *The Four Hours of the Day*, engravings that he translated into color in 1889–90.[45]

For a long time Van Gogh regarded Jozef Israëls, one of the leading lights of the Hague School, as the equal of Breton and Millet in depicting the human soul. Like his French counterparts, Israëls, who was famed for his romantic scenes of fishermen and peasants, was able to portray them as noble and with an almost "evangelical tone."[46] Van Gogh discerned a similar tone in *Old Friends* (ill. 17), which he described at length, dwelling on the twilight and its echo in the profound loneliness of the old man sitting silently with his dog in a humble room.[47] Van Gogh saw the piece as a companion to Millet's *Death and the Woodcutter*, where death waits to take the old man.

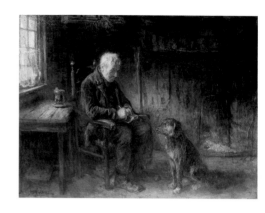

17
Jozef Israëls
Old Friends. 1882
Philadelphia Museum of Art

REMBRANDT: LIGHT IN THE DARKNESS

While Millet showed Van Gogh the way in his desire to become a peasant painter, it was Rembrandt who gave him guidance in painting light in the darkness. The Dutch master's unrivaled powers of imagination enabled him to evoke the specific feeling of evening and night—particularly in figure paintings.[48] And when Van Gogh walked through Amsterdam at dusk in 1877, "the ground dark, the sky still lit by the glow of the sun, already gone down, the row of houses and towers standing out above, the lights in the windows everywhere, everything reflected in the water," it was as if Rembrandt walked beside him.[49]

In his art, asserted Van Gogh, Rembrandt succeeded in expressing that "for which there are no words in any language."[50] He saw him as a realistic artist who, even if he used biblical iconography, always worked from his observation of nature. He imbued nature with a profound significance, so that even for contemporary viewers his work was a revelation of the highest order rather than

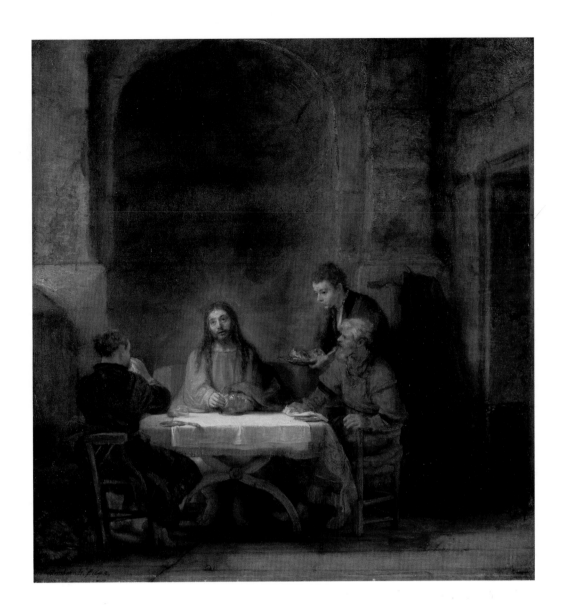

18

Rembrandt van Rijn

The Supper at Emmaus. 1648

Musée du Louvre, Paris

a reflection of the everyday. Rembrandt could also capture the essence of a subject or the character of a figure with an astonishing, seemingly careless technique in which details were subordinated to the overarching effect he wanted to achieve. In 1889 Van Gogh said that Rembrandt touched him so deeply because of "that heartbroken tenderness, that glimpse of a superhuman infinite which appears so natural."[51]

He was fascinated by Rembrandt's chiaroscuro, the inimitable way he could capture effects of light and darkness by illuminating specific areas of a composition; Rembrandt, to his mind, did not start from color or tone, but rather played with the changing values of the light (ill. 18). Rembrandt's greatest qualities, said Van Gogh, came together in *The Holy Family at Night*, which has since been attributed to Rembrandt's studio: "those two women beside the cradle, one reading from the Bible by the light of a candle, while the great cast shadows put the whole room in deep chiaroscuro" (see ill. 31).[52]

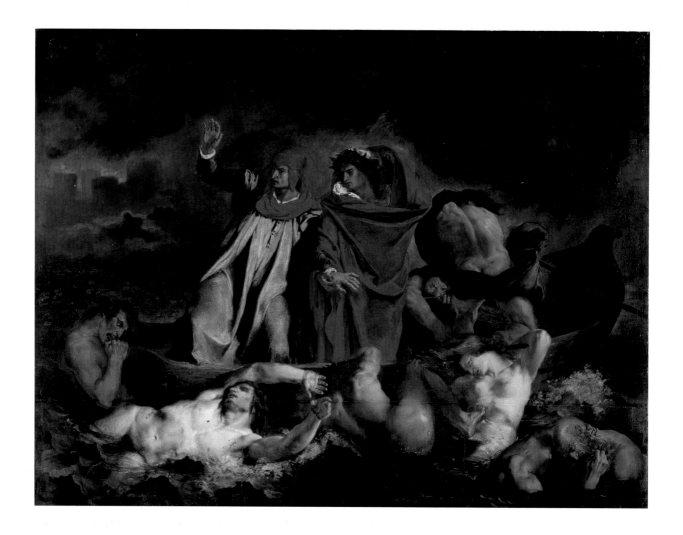

FROM DARKNESS TO COLOR

In April 1885 Van Gogh wrote that his *Potato Eaters* (see ill. 69) could not be conceived of as a traditional "lamplight" work like those of his predecessors, the seventeenth-century "fine" painter Gerrit Dou or the nineteenth-century painter of nocturnes Petrus van Schendel.[53] He wanted to paint "DARKNESS that is still COLOR," and to this end turned to Delacroix's color theories, which he studied in books by Charles Blanc and Théophile Silvestre.[54] Van Gogh was impressed by the way the artist used bright colors and color contrasts that may not have accorded with reality to make a convincing painting. He really admired Delacroix for his boldness in calling on "the greatest powers of blue- or violet-blacks" for the shadows in *The Barque of Dante (Dante and Virgil in Hell)*, in direct opposition to the academic tradition (ill. 19).

Between 1886 and 1888, while he was in Paris, Van Gogh was able to study the artist's work, and from then on Delacroix became, even more than before, his guide and counsel in questions of color. He admiringly described Delacroix's *Christ Asleep during the Tempest* as a "brilliant sketch": "He—with his pale lemon halo—sleeping,

19
Eugène Delacroix
*The Barque of Dante
(Dante and Virgil in Hell)*. 1822
Musée du Louvre, Paris

luminous—within the dramatic violet, dark blue, blood-red patch of the group of stunned disciples. On the terrifying emerald sea, rising, rising all the way up to the top of the frame."[55] Whereas Rembrandt had infused reality with a deeper, timeless significance through the power of his imagination, Delacroix did the same in his religious and history paintings chiefly through his use of color.

Toward the end of his life, Van Gogh regarded color as the measure for the modernity of a work of art, and he harked back to Delacroix's example—and that of his follower Adolphe Monticelli with his "orchestration of colors"—for his conception of color as an autonomous, symbolically charged means of expression.[56] Van Gogh also recognized Monticelli's use of intense colors and impasto handling in his evening scenes (ill. 20).

THE MODERN LANDSCAPE

During his period in Paris Van Gogh also encountered the Impressionist paintings of Edgar Degas, Claude Monet, and Camille Pissarro. A year before he went there he had not even known "what the Impressionists were, now I have seen them and though not being one of the club yet I have much admired certain impressionist pictures—*Degas*, nude figure—Claude Monet, landscape."[57]

Van Gogh had immense admiration for the Impressionists' modern landscapes, recorded with a swift, spontaneous touch that, he believed, reflected an individually "felt" idea of nature. He was particularly taken with Monet's depiction of changing weather conditions and lighting, including the evening light, and he talked of a

21

Claude Monet

Under the Pine Trees at the End of the Day. 1888

Philadelphia Museum of Art

"Monet effect." "It's funny that one evening recently at Montmajour I saw a red sunset that sent its rays into the trunks & foliage of pines growing in a mass of rocks, coloring the trunks and foliage with orange fire while other pines in the further distance stood out in Prussian blue against a soft blue-green sky—cerulean. So it's the effect of that Claude Monet. It was superb."[58] It is not clear which of the artist's landscapes he was reminded of, but he could have seen various of them at the branch of Boussod, Valadon & Cie on Boulevard Montmartre, where his brother Theo was the manager, which started dealing in the Impressionists' work in the mid-1880s. Among the works Theo showed was Monet's *Under the Pine Trees at the End of the Day,* one of the countless works the artist painted to capture the changing moods of light (ill. 21).[59]

Van Gogh agreed with Pissarro that "the effects colors produce through their harmonies or discords" had to be exaggerated, and that attempting to reproduce precise colors would simply result in "the reflection of reality in the mirror," not art.[60] For the most part Pissarro found these colors in sun-drenched scenes of rural life. In that sense, Van Gogh may have seen him as Millet and Breton's contemporary counterpart: while they preferred to paint life on the land in the evening, Pissarro portrayed the French countryside in the full glare of the midday sun.[61]

Van Gogh tried out Impressionist color effects for some time while he was in Paris, but gradually came to realize that in essence these painters were simply looking for visual effects. With his friends Louis Anquetin, Emile Bernard, Paul Gauguin, Georges Seurat, and Henri de Toulouse-Lautrec he began to search for new

22

Georges Seurat

Evening, Honfleur

(Honfleur, un soir, embouchure

de la Seine). 1886

The Museum of Modern Art,

New York

ways of modernizing the style and content of contemporary art. Their admiration for Japanese prints, with their powerful, contrasting areas of color, directed their thinking. In Van Gogh's case, these influences eventually resulted in a bright, colorful palette that he continued to develop when he moved to the South of France.

At the Independents' Salon of 1887 Van Gogh saw several evening scenes by Seurat, among them *Evening, Honfleur* (*Honfleur, un soir, embouchure de la Seine*) (ill. 22).[62] In view of his interest in the specific mood of the evening landscape, Van Gogh must have been struck by this nocturne of the coast of the famous Normandy resort, executed in Seurat's characteristic technique of varied dabs of paint and flat colors. This pointillist technique, based on the laws of optics, came as a revelation to Van Gogh. He described Seurat's work as personal and original, and regarded him as the leader of the painters of the Petit Boulevard.

23
Louis Anquetin
Avenue de Clichy. 1887
Wadsworth Atheneum
Museum of Art, Hartford

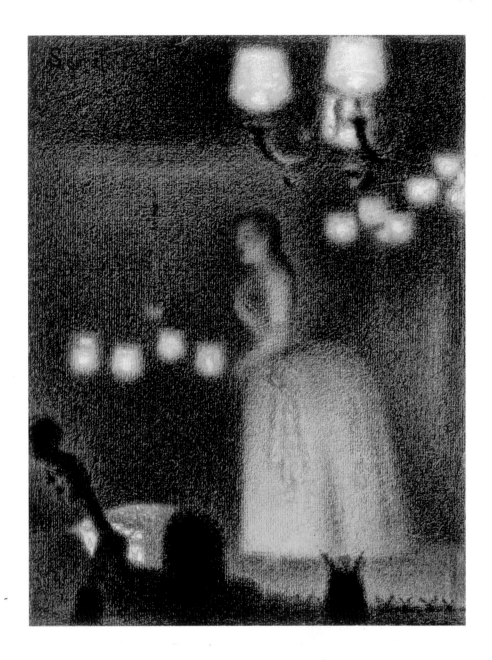

24
Georges Seurat
Woman Singing in a Café Chantant. 1887
Van Gogh Museum,
Amsterdam

BIG CITY NIGHT-LIFE

The bustling nightlife of Paris, with its countless café-concerts, cabarets, and theaters, was a major source of inspiration for many of Van Gogh's colleagues.[63] Anquetin, with whom Van Gogh exhibited in Paris, captured it most convincingly in his famous *Avenue de Clichy* (ill. 23). Seurat was widely praised for his modern nocturne *Circus Parade* (1887–88), which Van Gogh may have seen in the artist's studio shortly before he went to Arles.[64] In *Woman Singing in a Café Chantant* (ill. 24), which Theo bought in the spring of 1888, Van Gogh rediscovered his old love of the expressive and evocative power of working with the simple contrast of black and

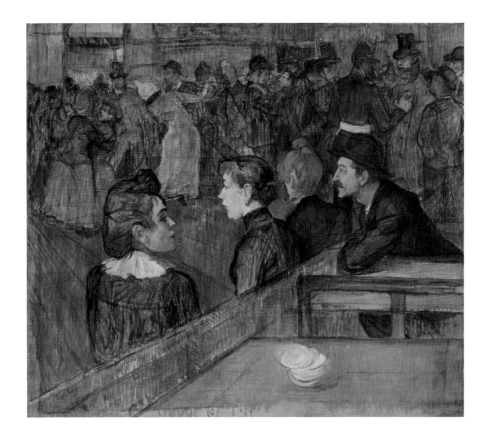

25
Henri de Toulouse-Lautrec
Dance Hall at the Moulin de la Galette. 1889
The Art Institute of Chicago

white. In this drawing Seurat captures the intimate atmosphere of a performance by a singer in a Paris café-concert by gaslight.[65]

Toulouse-Lautrec and Bernard also relished the subject of big city nightlife.[66] In 1886–87 and in the early 1890s, Toulouse-Lautrec produced several different large figure works. Van Gogh was very familiar with the work of his former fellow student at Fernand Cormon's studio, and experimented with his painting "à l'essence." Coincidentally, in September 1889 Van Gogh's *The Starry Night* (see ill. 54) and Lautrec's *Dance Hall at the Moulin de la Galette* (ill. 25) graced the walls of the Independents' exhibition.[67] Van Gogh undoubtedly knew Bernard's series of drawings *The Hour of the Flesh* (*L'heure de la viande*), which centers on the forbidden nighttime world of prostitution (ill. 26). In any event in 1888 Van Gogh received from his younger colleague, with whom he had worked closely in the fall of 1887, a collection of colored sketches titled *At the Brothel* that he found very "interesting."[68] He wrote Bernard that he and Gauguin had had a couple of "excursions to the brothels" and that he was planning to look for subjects there. These twilight hours full of illicit pleasures were recorded in *The Night Café* (ill. 27) and *The Brothel* (ill. 28).

Gauguin, who shared the Yellow House in Arles with Van Gogh in the last nine weeks of 1888, painted the same night café, "but with figures seen in the brothels" (ill. 29).[69] Van Gogh thought it was a very successful work; Gauguin was much less happy with it because he felt the "coarse local color" did not suit him.[70] Van

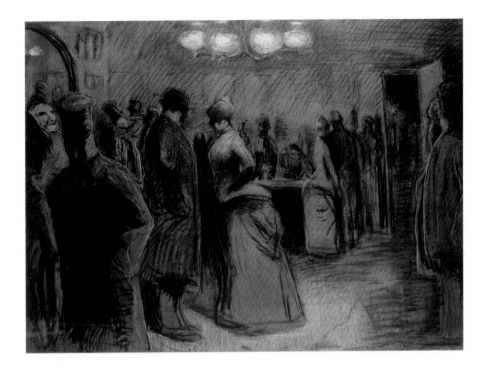

26
Emile Bernard
The Hour of the Flesh
(L'heure de la viande). 1885–86
Private collection

Gogh's collaboration with Gauguin, whom he idolized, was very intense but short-lived. They experimented with each other's styles and use of color, and tested their views on art in heated discussions. Gauguin stressed the importance of suggestion: a painter should not unthinkingly copy reality, but should use his imagination and, with the aid of colors and shapes, provoke an emotional response in the viewer. Gauguin took this approach in his *Human Miseries* (*Grape Harvest in Arles*), the inspiration for which came to him during an evening walk to the vineyards of Montmajour with Van Gogh (ill. 30). Gauguin painted it "entirely from memory," as Van Gogh wrote, "but if he doesn't spoil it or leave it there unfinished it will be very fine and very strange."[71]

For some time Van Gogh was deeply impressed by the work of "young Bernard" and Gauguin, and wanted, like them, to prepare the way for a more comforting art. Bernard had, he believed, produced some astounding works, "in which there's a gentleness and something essentially French and candid, of rare quality."[72] But whereas his colleagues were inspired by biblical motifs, Van Gogh sought simple subjects that he explored in a robust pictorial language and in expressive, often contrasting colors. His debt was always to Delacroix and Monticelli.[73] In February 1890 he described his goal in these words: "But the truth is so dear to me, *trying to create something true* also, anyway I think, I think I still prefer to be a shoemaker than to be a musician, with colors."[74]

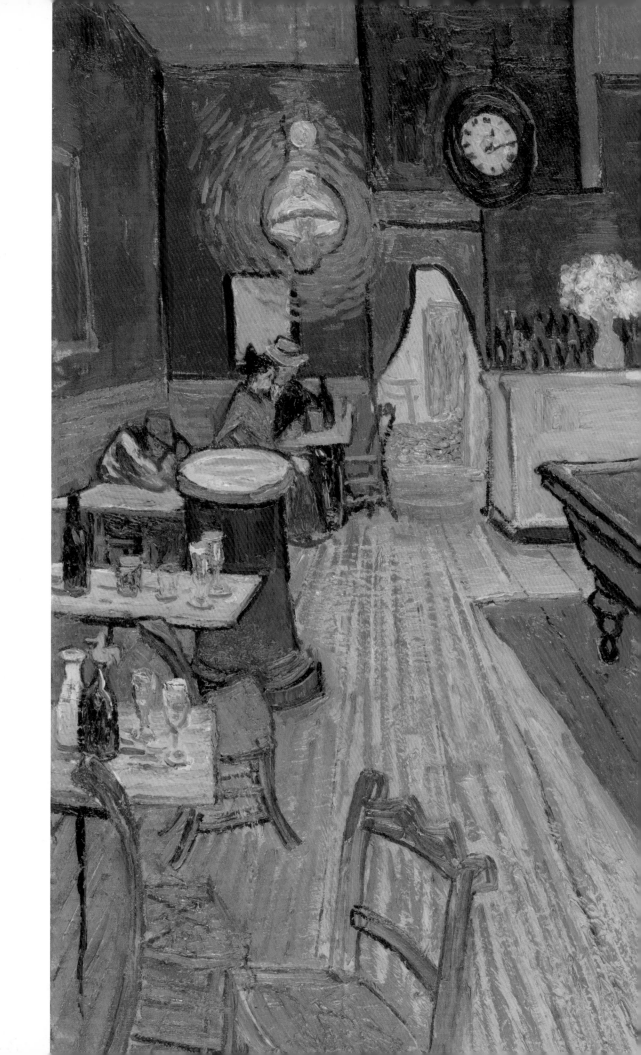

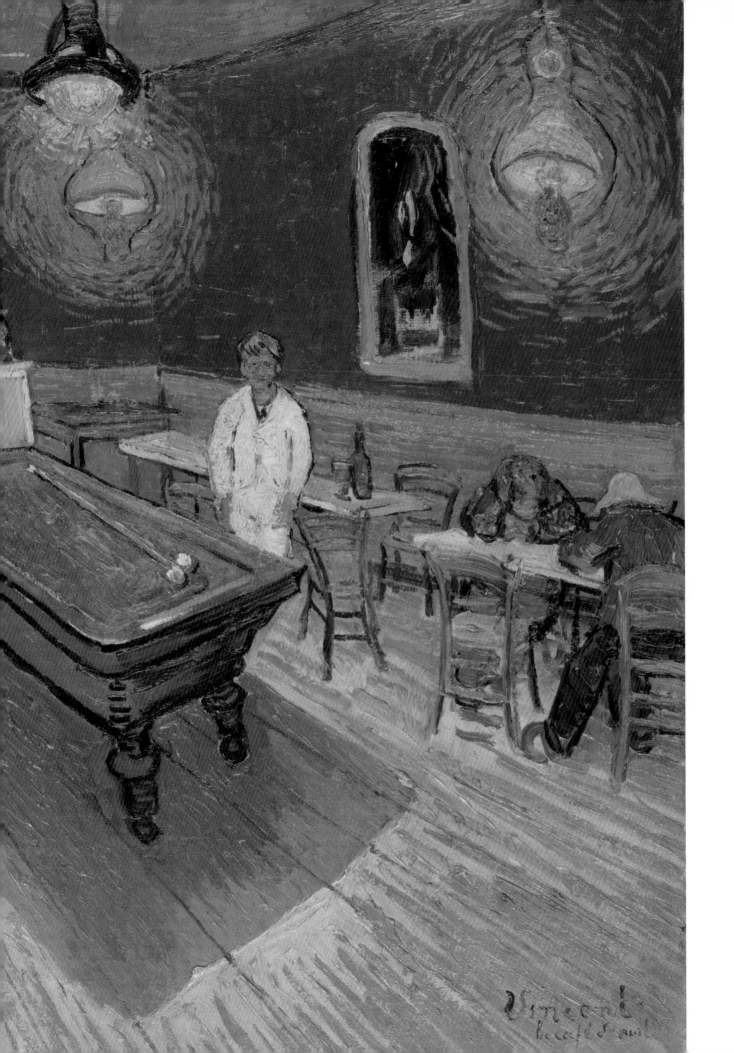

(pages 38–39)

27
Vincent van Gogh
The Night Café. 1888
Yale University Art Gallery,
New Haven

28
Vincent van Gogh
The Brothel. 1888
The Barnes Foundation,
Merion, Pennsylvania

29
Paul Gauguin
Night Café. 1888
The Pushkin State Museum of
Fine Arts, Moscow

30
Paul Gauguin
Human Miseries (Grape Harvest in Arles). 1888
Ordrupgaard, Copenhagen

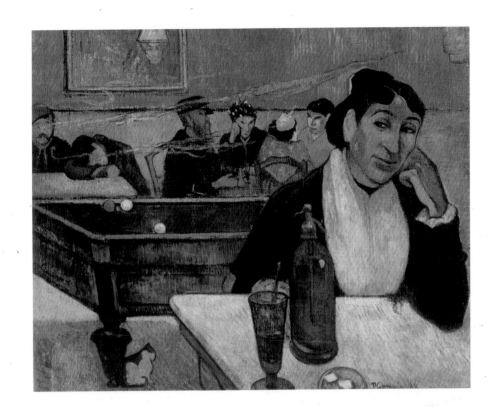

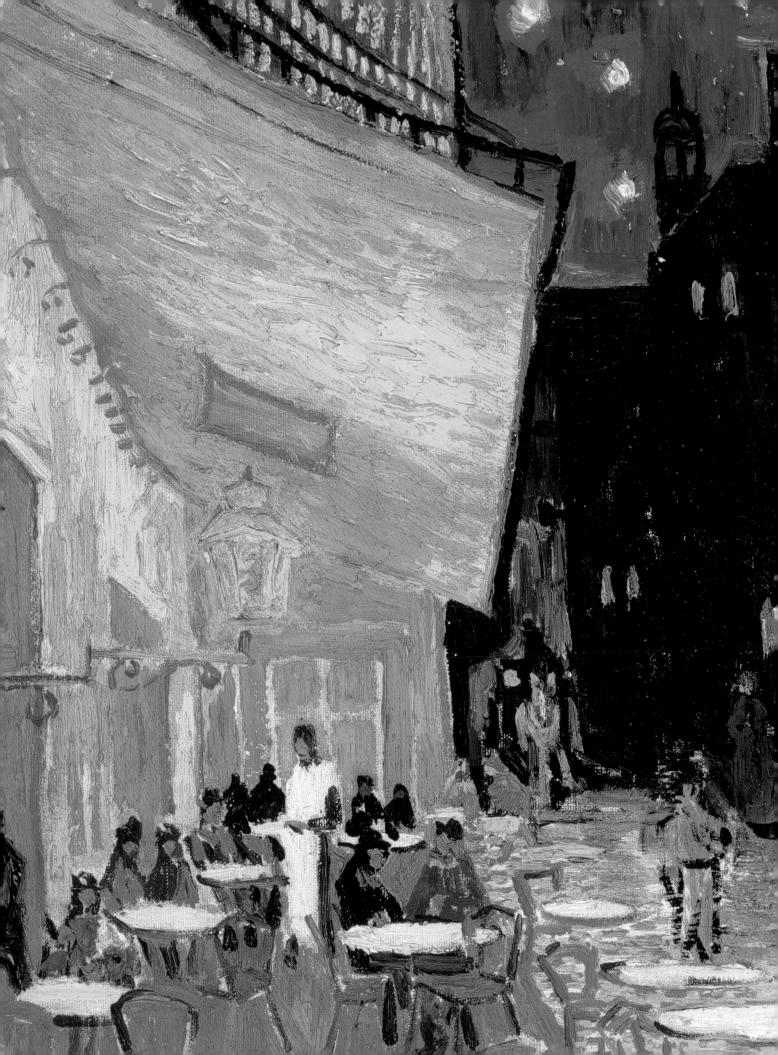

THE FORMATION OF CREPUSCULAR AND NOCTURNAL THEMES IN VAN GOGH'S EARLY WRITINGS[1]

Joachim Pissarro

"On the terrace, there are little figures of people drinking. A huge yellow lantern lights the terrace, the facade, the pavement, and even projects light over the cobblestones of the street, which takes on a violet-pink tinge. The gables of the houses on a street that leads away under the blue sky studded with stars are dark blue or violet, with a green tree. Now there's a painting of night without black. With nothing but beautiful blue, violet, and green, and in these surroundings the lighted square is colored pale sulphur, lemon green."

Vincent van Gogh[2]

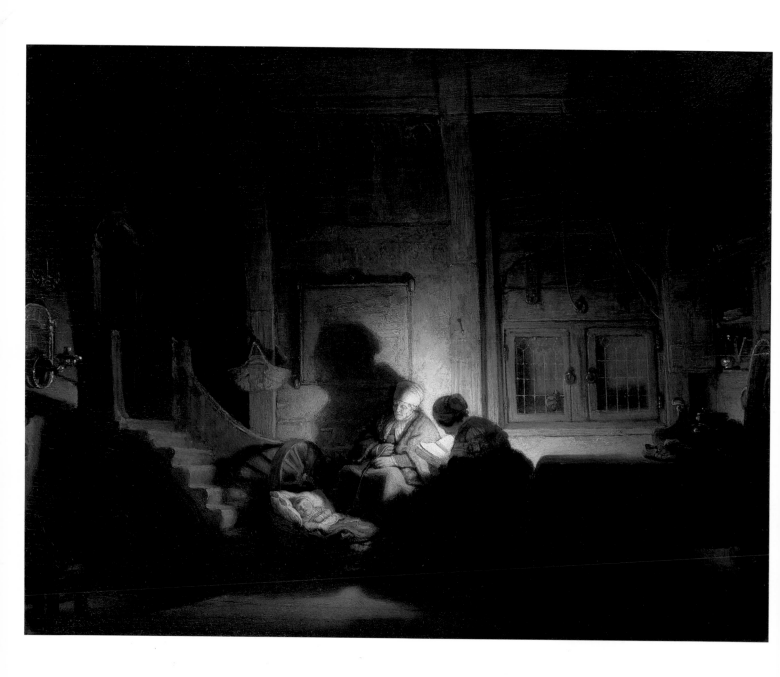

31
Studio of Rembrandt van Rijn
The Holy Family at Night.
1638–40
Rijksmuseum, Amsterdam

"Whenever he saw a beautiful evening sky, he became ecstatic, so to say. Once when we were coming from Nuenen to E[indhoven] toward evening, he suddenly stood still before a splendid sunset, and using his two hands to frame it somehow, and with his eyes half closed, he cried out: 'My God, how does such a fellow—whether God, or whatever you want to call him—how does he do that? We must be able to do that, too! God, God, how beautiful that is; what a pity that we haven't a palette already set up, because it will surely be gone soon.'"
Anton Kerssemakers[3]

"We walked along Buitenkant and there by the sand works at the Oosterspoor, I can't tell you how beautiful it was there in the twilight . . . like one sometimes sees in a Rembrandt. And it put us in such a mood that we began talking about all sorts of things. Sat up late last night writing, and early this morning it was such gorgeous weather. In the evening there's also a beautiful view of the yard, where everything is deathly still and the street-lamps are burning and the sky above full of stars. When all sounds cease—God's voice is heard—Under the stars."
Vincent van Gogh[4]

Much of Van Gogh's oeuvre was dedicated to the representation, in painting or drawing, of crepuscular and nocturnal reality. As far back as 1878, the date of his earliest sketch of a night café, Van Gogh was fascinated by this dual and paradoxical moment: the fading of daylight, culminating in an intense though short-lived sunset, followed by the fall of darkness and then by the emergence of focal points of artificial light and the scintillation of stars and moon against the night sky.

The history of night scenes in Western painting is long, rich, and much commented upon. Van Gogh was well aware of this history, both as a frequent museum visitor and, in his early life, as an art dealer working with prints reflecting such themes.[5] We know that Van Gogh saw and studied a number of Rembrandt's prints and paintings of interiors illuminated by candlelight,[6] and was familiar with one particular painting now attributed to Rembrandt's studio (ill. 31).[7] We also know of Van Gogh's abiding admiration for Jean-François Millet, especially his twilight and night scenes (ill. 32). Nonetheless, Van Gogh's prodigious and long-sustained creative interest in nocturnal phenomena is remarkable, both in its intensity and in the number of works it inspired

The artist's letters are a repository of the night-related themes in his artistic psyche. As with most things pertaining to Van Gogh's imaginative and poetic forces, his ideas about twilight and night, as articulated in his own words, are rich, paradoxical, sometimes contradictory, often moving in their simplicity and directness,

and occasionally startling in their anticipatory premonition. But they all resonate with one dominant concept: that the dark hours are a time conducive to germination and regeneration—a theme epitomized, of course, by Van Gogh's sowing scenes and wheat fields at sunset.[8]

The artist's thoughts about the night take several forms in his correspondence. Some of his letters refer to the spiritual, or even openly religious, dimension of the night: it is a time for meditation and self-reflection, a moment of repose that is fertile with metaphysical and introspective questions. But night is also a time when Van Gogh experienced bursts of energy, as if he were tapping into renewed sources of imagination and creativity; he clearly enjoyed working at night, as he wrote in a letter from 1888 describing *The Starry Night over the Rhône* (ill. 1).[9] Finally, night offered him moments of physical rejuvenation, stimulated by ample drinking and smoking within the low-life contexts of brothels, night cafés, and entertainment venues such as dance halls (ill. 33) and cabarets.

Scores of depictions of night cafés and night entertainments were produced by close contemporaries of Van Gogh—those of Manet, Degas, and Toulouse-Lautrec come immediately to mind (ill. 34).[10] In fact, Van Gogh's treatment of such themes is less present in his work than in the oeuvre of Degas or Toulouse-Lautrec. Van Gogh's originality lies not in his interest in exploring nocturnal themes but in his ability to articulate, in an organic way, all the diverse experiences nurtured and stimulated by the night: spiritual contemplation, boundless creativity, and the convivial enjoyment of life. For him, there is no inherent conflict between such nighttime activities as writing a sermon and drinking with friends, or reading a verse of the Bible and going to the brothel. In fact, in Van Gogh's mind (or psyche), moments of metaphysical questioning, intense creativity, and orgiastic ecstasy seem to be intimately connected. Unlike Degas or Toulouse-Lautrec on the one hand, or Millet on the other hand, Van Gogh grappled with the nocturnal world as a totality, weaving all of its multifaceted aspects into a cohesive whole.

THE POINT OF DEPARTURE: VAN GOGH'S FIRST NIGHT SCENE AND HIS SERMON ON THE BARREN FIG TREE

Given the richness and density of twilight and night references in Van Gogh's writings and the narrow constraints of this essay, we can select and highlight only a few of the most telling passages from his letters. Especially rich and informative are his earliest letters. One beautiful letter Van Gogh wrote to his brother Theo in November 1878 offers a poignant and powerful example of his literature of the night.[11] This important letter not only describes his fascination with the night but

also includes his first visual treatment of a night motif. Together, the letter and the drawing contain the central aspects of Van Gogh's visual and spiritual interest in nocturnal themes.

The sketch depicts an establishment in Laken (Brussels) called a *charbonnage* (ill. 35)—a working-class shop and café where one could buy coal, have a few drinks, and meet up with friends—on a moonlit night. It is significant that the artist chose this particular moment to begin a practice that would become integral to his work: the habit of including sketches with his letters, depicting visually what he is describing in words.

The caption he provides for what he calls his "scratch" reveals clearly that his thoughts about the night are already in place as he begins to explore nocturnal themes visually.[12]

> I hereby enclose that scratch, "The Au Charbonnage café." I should really rather like to start making rough sketches of some of the many things one meets along the way, but considering I wouldn't actually do it very well and it would most likely keep me from my real work, it's better I don't begin. As soon as I got home I began working on a sermon on "the barren fig tree," Luke XIII: 6-9.[13]

Although Van Gogh's "real work" at the time was preaching, there is a palpable connection between his spiritual and creative endeavors, which meet in this representation of a night café. He creates his drawing and then, in the text of the accompanying letter, writes of his desire to make sketches as well as his involvement in

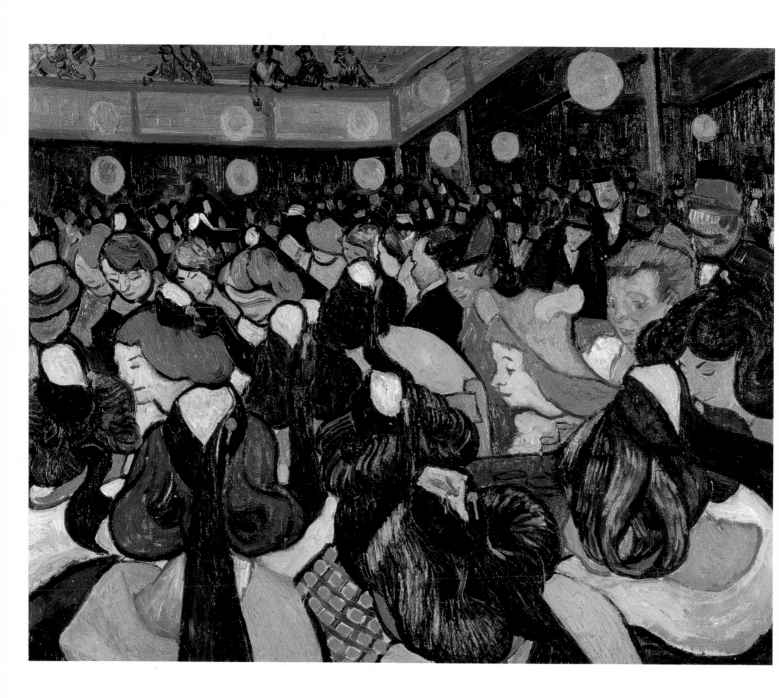

33

Vincent van Gogh

The Dance Hall in Arles. 1888

Musée d'Orsay, Paris

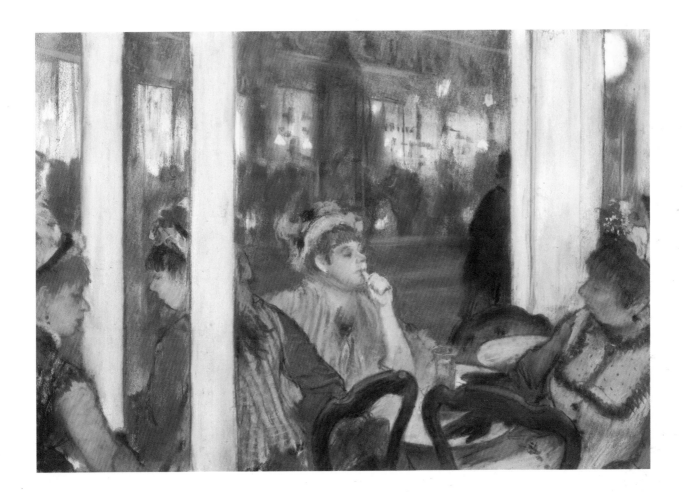

34

Edgar Degas

Women on a Café Terrace,

Evening. 1877

Musée d'Orsay, Paris

writing a sermon—another form of work or creative act that Van Gogh performed in the evening hours. The two activities are linked: they are equivalent and analogous in Van Gogh's mind, originating from the same creative impulses but finding fruition in different media.

The sermon he was working on that evening[14] involved the biblical parable of the barren fig tree, a text that would have been familiar to both Vincent and Theo, who were sons of a pastor.

> *A man had a fig tree planted in his vineyard; and he came looking for fruit on it and found none. So he said to the gardener, "See here! For three years I have come looking for fruit on this fig tree, and still I find none. Cut it down! Why should it be wasting the soil?" He replied, "Sir, let it alone for one more year, until I dig around it and put some manure on it. If it bears fruit next year, well and good; but if not, you can cut it down."*[15]

It is unfortunate that the sermon based on this parable no longer exists,[16] as it would be fascinating to read what Van Gogh produced on the same night that he was working on his very first nocturnal sketch and writing a long, emotional letter to his brother. Reading the biblical passage, one can only surmise that the notion of delayed fruition would have had special meaning for him: what at first sight appears sterile may, if one is patient and has faith, produce unexpected late fruit. He was

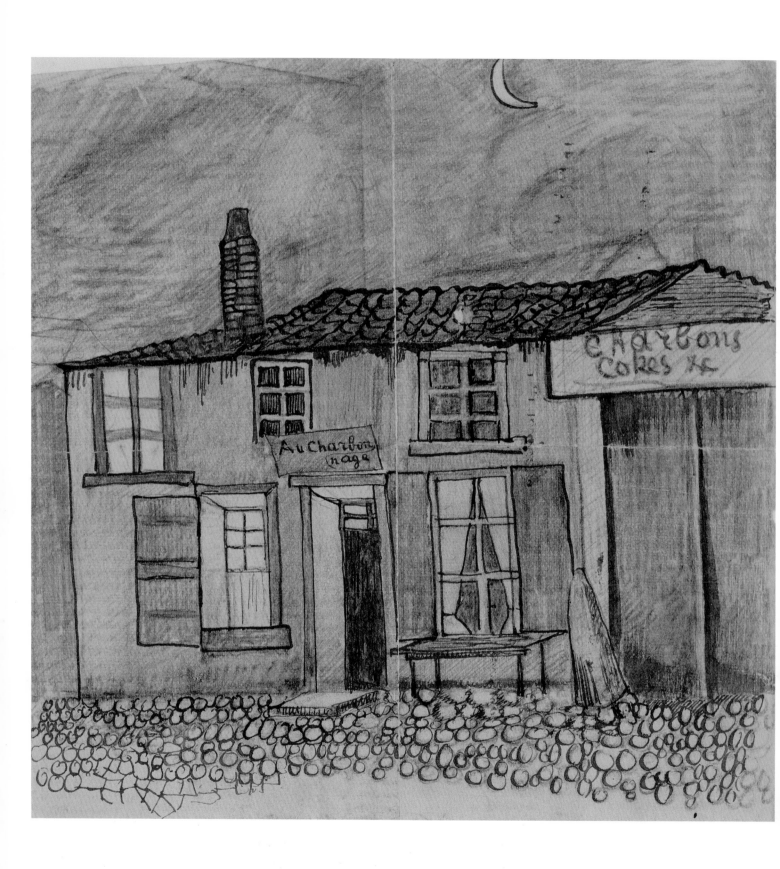

probably interested, too, by the idea that out of manure ("mest" is the Dutch translation, but the Greek word was much coarser)[17] comes fertilizing matter. What we do know from Van Gogh's letter to Theo is that, even though it would have been "better" for him not to interrupt his "real work" by toying with drawing, he did what he was not supposed to do. Instead of focusing early in the evening on his sermon, he went first to the café, probably had a few drinks, and then—giving in to the most dangerous temptation of all—made a sketch.

In the same way that Van Gogh comments on the parable of the fig tree, he goes on to describe his drawing, thus initiating a long stream of fascinating commentary by the artist on his own visual work. One layer of his work thus feeds (or fertilizes) another layer of production. Van Gogh may not have been able to carve out a living from writing sermons, but he was very good with words when it came to describing his own work.

> That little drawing, "The Au Charbonnage café" is really nothing special, but the reason I couldn't help making it is because one sees so many coalmen, and they really are a remarkable people. This little house is not far from Trekweg, it's actually a simple inn right next to the big workplace where the workers come in their free time to eat their bread and drink a glass of beer.

Van Gogh then describes, in a few lines, what inspired him to make this unpretentious drawing ("nothing special," as the artist characteristically puts it), which is, in effect, his very first night café. The descriptive terms he chose, as well as the themes he highlighted, anticipate some of the poetic and imaginary concerns of his later work. Looking at his oeuvre as a whole, a unified and consistent interest in nocturnal themes resonates throughout.

> After we'd taken leave of each other I walked back, not the shortest way but along Trekweg. There are workshops of all kinds there that look pleasant, especially lit up in the evening, which also speak in their own way to us who are, after all, laborers and workers, each in the sphere and in the work whereunto we have been called, if only we care to listen. For they say, work while it is day, before the night cometh, when no man can work, and they remind us that the Father worketh hitherto, and that we too must work.

Here Van Gogh expresses his undeniable excitement at the view of buildings "lit up in the evening," not only because they provide a pleasant sight, but also because they testify to the fact that all of us, laborers in our own way, are meant to rest at night. The notion of productivity and creation is, here again, paramount in his thinking, and it offers the missing link between the "work" of drawing and his other work, the sermon on the fig tree—a tree that might produce fruit, if one has faith. It is interesting to note that Van Gogh's reference to work, central as it is to his entire system, is phrased in somewhat contradictory terms. On the one hand, he exhorts us to work during the day and to cease our labors when night falls. On

the other hand, we know that eventually Van Gogh would work almost ceaselessly, and that the night was a particularly fruitful time for him to focus on his work—or to write his brother about it, and thus critically evaluate the harvest of the day. In another letter to Theo, quoted in the epigraph to this essay, Van Gogh refers to a beautiful twilight that put him and his companion "in such a mood" that they talked into the night; then Van Gogh himself sat up late writing.[18]

In the seminal letter on The "Au Charbonnage" Café, Van Gogh appears to be drawing up a kind of manifesto for himself:

> You surely know that one of the root or fundamental truths, not only of the gospel but of the entire Bible, is "the light that dawns in the darkness." From darkness to Light. Well then, who will most certainly need it, who will have an ear to hear it? Experience has taught us that those who work in darkness, in the heart of the earth like the mine-workers in the black coal-mines, among others, are very moved by the message of the gospel and also believe it.[19]

There is no need to further establish that Van Gogh had been thinking about darkness—about light in the darkness, about darkness turning to light—from very early on. His richly layered thoughts on the subject first take plastic form in a charcoal black-and-white drawing of a night scene that emphatically highlights areas of light and dark. Even before he considered becoming an artist, Van Gogh had formed a fundamental belief system that would continue to orient his life and career until the end.

A few years later, in 1881, by which time Van Gogh had decided that his "real work" was to be an artist, he produced two letter-sketches to Theo that echo some of the same sentiments and questions that were raised in the letter from 1878. Thematically speaking, these letters set the scene for several of the artist's future works representing crepuscular or nocturnal subjects. The two drawings, En Route and Before the Hearth, each depict a worker by night, the first walking in the snow, the second sitting by the fire (ills. 36 and 37).[20] They seem to spring directly from the same line of inspiration that produced the sketch of the charbonnage.

The first letter-sketch in which Van Gogh focuses on a sunset scene appears in 1882, when his career as an artist had barely begun (ill. 38). "Last Saturday evening I tackled something I already dreamed of often," he writes to Theo. "It's a view in the flat green meadows with haystacks. A cinder road with a ditch runs straight through it. And the sun goes down fiery red on the horizon in the middle of the painting."[21]

He then attempts to explain the intense chromatic complications he has had to grapple with in creating his first depiction of a sunset.[22] He describes something akin to a battlefield of vibrant colors.

36
Vincent van Gogh
En Route. 1881
Van Gogh Museum,
Amsterdam

37
Vincent van Gogh
Before the Hearth. 1881
Van Gogh Museum,
Amsterdam

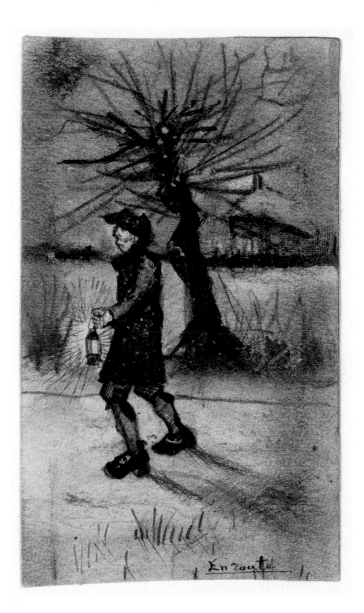

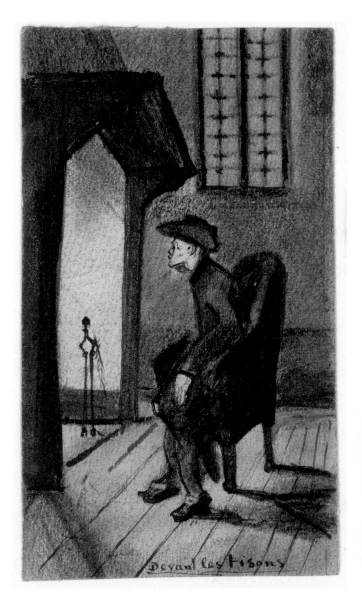

I can't possibly draw the effect quickly here, but this shows the composition. Yet it was all a question of color and tone, the gradations of the range of colors in the sky, first a lilac haze— inside it the red sun, half covered by a dark purple cloud with a delicate edge of gleaming red; beside the sun vermilion reflections, but above a yellow band that turned green and higher up bluish, the so-called Cerulean blue, and here and there lilac and grayish clouds catching reflections from the sun.

The pictorial stage is set for Van Gogh's future sunset paintings. His twilight scenes are often set in wheat fields (occasionally with sowers), with all their connotations of germination, harvest, and the cycle of life. In Van Gogh's first depiction of haystacks, though, what comes across most vividly is the artist's sense of frenzy as he attempts to capture the jumble of colors, poured on top of one another, blending into each other as daylight falls into darkness.

LITERARY REFERENCES AND
VAN GOGH'S POETRY ALBUMS

It should be clear by now that Van Gogh's interest in depicting crepuscular and nocturnal scenes did not stem merely from his exposure to beautiful sunsets or moonlit landscapes in the Netherlands and France. Contrary to an enduring misconception of Van Gogh as a rough and ready chromomaniac driven by his instincts to render what he saw almost as quickly as he saw it,[23] the artist's twilight and night scenes are actually elaborate constructions that also call on his vast literary knowledge. Van Gogh was a voracious reader, reading quickly and consuming books by the dozens. And in thousands of pages of his own letters, he distilled and reflected on his copious readings.[24]

Van Gogh's prodigious literary interest in themes of twilight and night offered a bedrock foundation for his later artistic interest in tackling these themes through paint, charcoal, or pen and ink. Throughout his artistic life, he would absorb and meticulously elaborate on these abundant references in his own representations of late day and night scenes.

Those familiar with Van Gogh's correspondence know that he was in the habit of copying whole poems and inserting them into his letters, often those to Theo. Less commonly known is the fact that the artist assembled a number of poetry albums, in which he compiled pages of poems and prose excerpts by authors he admired. The contents of these albums greatly illuminate Van Gogh's complex practice as an artist. There are three main poetry albums, two dedicated to Theo and one to the Dutch artist Matthijs Maris.[25]

The first album, probably created in the 1870s, is the shortest and contains poetry by three French authors describing evening or night scenes. Among the most telling of these are poems and fragments from Joseph Autran's *La Vie rurale* (1875), including "La Chanson d'Octobre," "Dernières feuilles," and "Les Funérailles de l'année." The second album, completed sometime before March 1875, when the future artist gave it to his brother, is rich with fragments of poetry and other texts by Dutch, English, German, and French authors. Of interest to our topic are the chapter "Les Aspirations de l'Automne," from *L'Amour* (1859), and an excerpt from *La Bible de l'humanité* (1864), both by Jules Michelet, whom Van Gogh greatly admired; various excerpts from Charles Sainte-Beuve's *Causeries du lundi* (1858); Alfred de Musset's "La Nuit de Décembre" (1835), which Van Gogh quoted twice in his correspondence;[26] Emile Souvestre's *Les Derniers Bretons* (1843); Henry Wadsworth Longfellow's "Afternoon in February" (1856), which Van Gogh copied several times; Heinrich Heine's "Der bleiche, herbstliche Halbmond," "Wir sassen im Fischerhause," and "Am fernen Horizonte"; Ludwig Uhland's "Die Orgel"

and "Der Traum";[27] and various excerpts from Johann Wolfgang Goethe's *Der König in Thule* (1842). The album also includes three poems that appear to be copied in Theo's handwriting: Jules Breton's "L'Aube" (The Dawn), from *Les Champs et la mer* (1875); the famous art critic and poet Armand Silvestre's "Une Vaneuse"; and Jan van Beers's "De Bestedeling" (1873). In a Visitor's Book for his friend Annie Slade-Jones, Van Gogh copied poems by Friedrich Rückert, whom he often mentioned in his letters[28] and whose poetry focuses on night with undertones of nostalgia for lost youth, including "Abendfeier," "O wie mild der Abendrauch," "Das Abendlied vom Turme," and "Abendstille."

There is no way we can, in the context of this essay, do justice to the multi-layered literary references from which Van Gogh drew inspiration. But we can examine a few of the artist's most pertinent literary sources, which cast light on his later work. In 1873, when Van Gogh was only twenty, the young man included a copy of "The Evening Hour," a poem by Jan van Beers, in a letter to family friends.[29] He introduced this very long poem in a few lines: "I enclose a copy of a poem by Van Beers, which you may not know. Our Elisabeth copied it out for me on my last evening in Helvoirt, because she knew how much I liked it. It's Brabant to a T

38

Vincent van Gogh

Sketch of *Sunset over a Meadow*

in a letter to Theo van Gogh.

August 14, 1882

Van Gogh Museum,

Amsterdam

I thought you'd enjoy reading it, so I've copied it out for you."[30] Here are a few lines of the poem that resonated so much with the young Vincent:

Slowly the toll of the angelus-bell resounded o'er the fields,

As they blissfully bathed in the gold of the evening sun.

O solemn, moving moment!

It is difficult not to be struck by the following lines by Van Beers, which Van Gogh brewed over and copied:

For the artist, too, on the slope of yon shady hill,

Absorbed in his painting from the earliest morning,

The angelus now gave the sign to retreat. Slowly he wiped

His brush and palette, which he stowed with his canvas in the valise,

Folded his camp-stool and dreamily descended the path

That leads, gently winding, through the flowery dale to the village.

The poem concludes on a note that, in retrospect, is consonant with Van Gogh's later career. Still referring to "the artist," Van Beers goes on:

He found he had sauntered, unnoticing, into the village.

Already the purple and yellow had faded to gray in the west,

And in the east there had risen close by the little church the full

Copper-colored disk of the moon, in mist enshrouded,

When he entered The Swan, the inn where he boarded.

Whether or not one shares Van Gogh's admiration for this poem, it leaves one with the uncanny sense that it encapsulated not only his poetic and existential journey, but also the pictorial journey he would later take—from the wheat fields at sunset to the cafés at night. It is particularly striking when one realizes that he copied this poem long before he ever contemplated becoming an artist.

One can find many similar connections as one goes through the pages of Van Gogh's poetry albums and correspondence. Only a few years later, in 1876, Vincent wrote a long letter to Theo in which he described a walk through meadows and fields as the sun was setting and the houses in town began to be illuminated.[31] It is difficult not to view the juxtaposition of natural and artificial light (sunset, stars, and moon versus gas lamps) through the lens of his later artistic accomplishments, such as *The Starry Night over the Rhône* (ill. 1) or *Terrace of a Café at Night (Place du Forum)* (ill. 39). However, what is most interesting in this letter is that Van Gogh once again refers to literary sources, in this case to support his own phenomenological experience of the contrast between (in Van Goghian terms) light made by God and light made by man. He refers to Emile Souvestre and quotes from his book *Un philosophe sous les toits. Journal d'un homme heureux* (1867).[32] Like Van Gogh, the novel's main character—the philosopher of the title—filters his visual observations through his own philosophical predilections and, even more important, declares that a humble

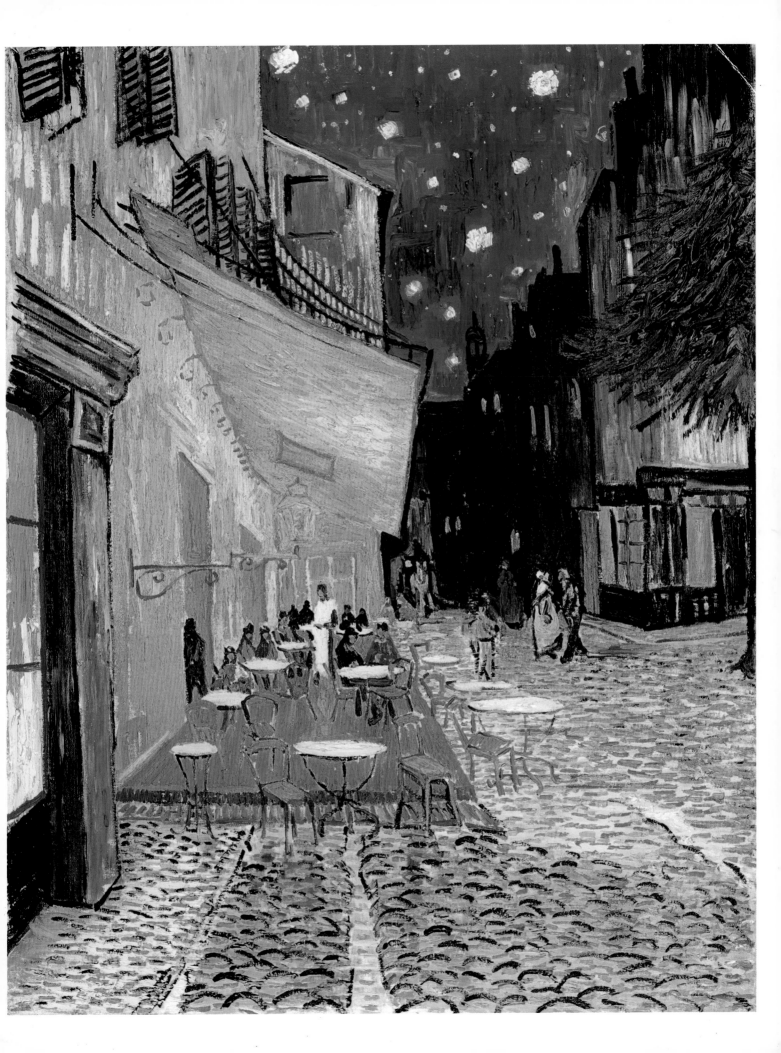

and tormented existence eventually leads to fulsome contentment. Van Gogh chose to quote a passage in which Souvestre described the beauty of Parisian nights.

> 9 May. The beautiful evenings have returned; the trees are beginning to uncurl their buds. Hyacinths, daffodils, violets, and lilacs scent the flower-sellers' stalls; the crowds have begun to stroll along the quays and boulevards again. After supper, I too came down from my garret to breathe the evening air. It is the hour when Paris shows herself in all her beauty. During the day, the plaster of the façades fatigues the eye with its monotonous whiteness, the heavily laden carts make the cobblestones shudder under their huge wheels, the hurrying crowds cross and collide, intent on not missing a moment of business; there is something harsh, anxious, breathless about the city. But everything changes the moment the stars come out; the white houses fade into misty shadow; nothing is to be heard but the wheels of carriages as they bowl along on their way to some party or other; nothing is to be seen but people strolling idly or gaily by; work gives way to leisure.[33]

This letter also functions as a kind of album. The quotation from Souvestre is followed by a long series of verses from Longfellow, a text from the Bible, and, finally, a long excerpt from Hendrik Conscience's *Le Conscrit*.[34] In the latter text, Conscience describes a night scene: he is sitting by a fire and gazing at the stars, which inspires him to reflect on the meaning of life. The "germination" of spiritual and metaphysical thought prompted by an experience of the night is very much in keeping with Van Gogh's personal fascination with nocturnal themes.

Throughout Van Gogh's early years a series of related images recur in his writings and echo his readings. At the same time, these themes appear frequently in Van Gogh's pictorial oeuvre and are a dominant feature in his late paintings. The dark silhouette of a church, lit up with bright windows, stands against the night sky. A peasant's hut—or perhaps a café—appears in the twilight. The moon and stars rise, competing for attention with the disappearing sun. We see this particular moment, the end of day, which carries so much meaning for Van Gogh, depicted again and again in his late work. The points that capture the young man's attention offer a foil for his poetic and spiritual musings and open up a path, whether physical or metaphysical, for the future artist (ill. 40):

> In the evening, when we rode back from Zundert over the heath, Pa and I walked a ways, the sun set red behind the pines and the evening sky was reflected in the marshes, the heath and the yellow and white and gray sand were so resonant with tone and atmosphere. You see, there are moments in life when everything, within us too, is peace and atmosphere, and all of life seems to be like a path across the heath, though it isn't always so.[35]

A path, a road, a map: Van Gogh sees so many metaphors in the starry night, or in a dark horizon with a lit-up dwelling:

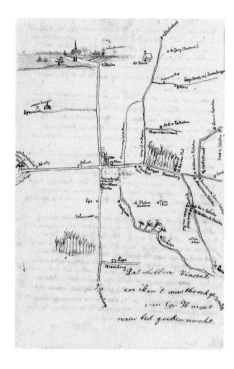

40
Vincent van Gogh
Sketch of a street map of Etten
in a letter to Theo van Gogh.
July 22, 1878
Van Gogh Museum,
Amsterdam

The sight of the stars always makes me dream in as simple a way as the black spots on the map, representing towns and villages, make me dream. Why, I say to myself, should the spots of light in the firmament be less accessible to us than the black spots on the map of France? Just as we take the train to go to Tarascon or Rouen, we take death to go to a star.[36]

If the sight of the stars fed Van Gogh's dreams, his reading of night-related poetry and literature fed his artistic imagination. As he communicated so eloquently in his letters and, later, in his paintings (ill. 41), the twilight and evening hours held an abiding fascination for him. He may not have reached the stars until his death, but during his sadly abbreviated lifetime he traveled a long way toward those spots of light in the firmament, and made their beauty all the more accessible.

41

Vincent van Gogh

Sketch of *Country Road in Provence by Night* (ill. 104) in a letter to Paul Gauguin.

c. June 17, 1890

Van Gogh Museum, Amsterdam

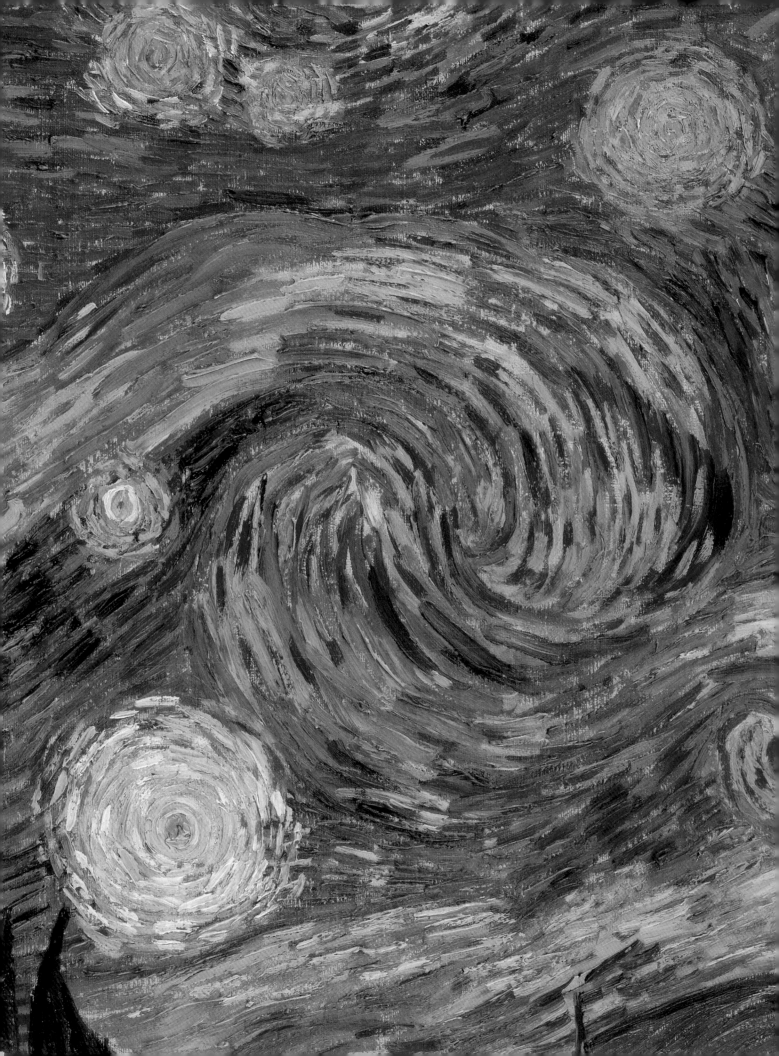

THE COLORS OF THE NIGHT:

TECHNICAL AND STYLISTIC ASPECTS OF

VAN GOGH'S NIGHT SCENES

Sjraar van Heugten

"A starry sky, for example, well—it's a thing that I'd like to try to do."
Vincent van Gogh[1]

For several years now, research into Van Gogh's oeuvre has increasingly focused on his painting and drawing techniques.[2] One important insight to have emerged from this is that Van Gogh worked in a carefully considered and disciplined manner. The artistic development he went through is one of the most remarkable journeys in the history of art. This growth was informed by inventiveness and a capacity for association, while at the same time little was left to chance. From start to finish, often in a long process of trial and error, he sought the right relations between colors, a particular handling of the brush, and a coherent, balanced composition. His extensive knowledge of theory was an important support, but never a straitjacket.

Evening and night scenes are an important element in Van Gogh's work. These canvases illustrate better than any others his desire to find a truly convincing means of expression, and so they are often high points of his artistic and technical achievements. Creating the effect of color in a dark scene imposes constraints on an artist that do not exist when painting a sun-drenched landscape or a colorful still life, and finding the right colors to evoke the feeling of the night is far from easy. In reality the night is not as blue as Van Gogh made it in his two versions of *The Starry Night* (ills. 1 and 54), but he achieved the effect he wanted by using that particular palette. Painting these sorts of light effects demands considerable ingenuity, and the contrasts between light and dark in depicting darkness have to be both convincing in themselves and in balance with the rest of the composition. Technique, style, and content go hand in hand in Van Gogh's evening and night scenes. Color and light effects are carefully measured in order to achieve the poetic effects of darkness. It is only when we study his work closely that it becomes apparent just how effectively he manipulated reality to achieve his goal.

Four paintings provide fertile ground for an examination of Van Gogh's method. These are major works from different periods of his career, representative of his ambitions at each particular time: *The Potato Eaters*, painted in Nuenen in 1885; *The Night Café* and *The Sower*, both painted in Arles in 1888; and *The Starry Night* of 1889, made when he was in Saint-Rémy. These paintings illustrate his extraordinary progress from an old-fashioned painter to one of the great modernists of his age, and yet they reveal striking constants.

THE POTATO EATERS

From December 1883 to November 1885 Van Gogh worked in the Brabant village of Nuenen, where he concentrated on recording rural life. It was there, in the spring of 1885, that he painted *The Potato Eaters* (ill. 49). The previous six months

caption
(pages 60–61)

Detail of ill. 54

Vincent van Gogh

The Starry Night. 1889

The Museum of Modern Art, New York

42

Vincent van Gogh

Woman with a Broom. 1885

Kröller-Müller Museum, Otterlo

TECHNICAL AND STYLISTIC ASPECTS OF VAN GOGH'S NIGHT SCENES | 63

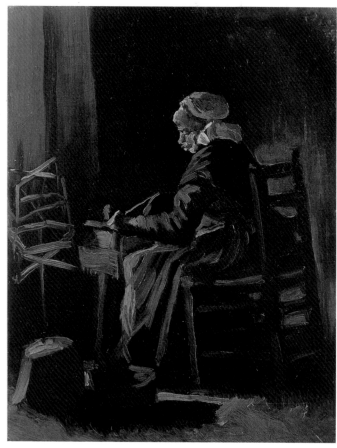

were a period of intense study. He drew and painted peasants' heads and hands, experimented with colors and lighting effects (ill. 43), and studied the possibilities of chiaroscuro in the dark interiors of peasants' cottages (ill. 44). Around March 1, 1885, he wrote Theo: "At present I'm painting not just as long as there's light, but even in the evening by lamplight in the cottages, if I can somehow make things out on my palette, in order to capture if possible something of the singular effects of lighting at night, for instance with a large shadow cast on the wall."[3] *Woman with a Broom* is a result of these efforts (ill. 42).

When Van Gogh decided that the time was ripe for the first real test of his artistic ability in the form of a composite work with figures, he chose a subject—peasant types at their simple meal—that had been very popular among artists for many years. It had been brought into prominence by, among others, Jozef Israëls, a highly respected artist and one of the leading lights of the Hague School. Van Gogh's study of various lighting effects initially left him unsure whether to set the scene during the day or the evening. Eventually he opted for the evening; the result was the two large versions of *The Potato Eaters* (ills. 48 and 49).

43
Vincent van Gogh
Woman Sewing. 1885
Van Gogh Museum,
Amsterdam

44
Vincent van Gogh
Woman Winding Yarn. 1885
Van Gogh Museum,
Amsterdam

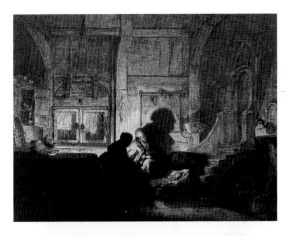

45

After Rembrandt

The Holy Family at Night.

c. 1787

Cabinet des Estampes,
Bibliothèque Nationale, Paris

46

After Rembrandt

The Pilgrims at Emmaus.

In Charles Blanc, *Grammaire
des arts du dessin* (1867), p. 592

Van Gogh's decision to set the scene in the evening was probably influenced in part by his concentrated study of a book on art theory, Charles Blanc's *Grammaire des arts du dessin* (1867), which he had bought in August 1884. It was from this work that Van Gogh derived much of his knowledge about color theory, and it also contained a chapter on chiaroscuro that he found extremely useful.[4] Blanc discussed the different ways in which an artist can use lighting effects, and one particular passage must have been important to Van Gogh:

> But the beauty comes together most clearly in the human head when it is lit from above. The structure of the forehead is defined, the eyes become brighter beneath the dark hollow created by the arch of the brows; the cheekbone is heightened a little, the nose simplified and lengthened, a little brightness highlighting the shadow where the darkness of the nostrils softens and disappears. Finally, if the daylight is not quite perpendicular, the shaft of light brings the lower lip to life, shapes the chin, and leaves the recesses of the neck in shadow, a dark column bearing the light mass of the face.[5]

Van Gogh, admittedly, was not looking for beauty in *The Potato Eaters*, but the expressive power that Blanc attributes here to lighting the face from above must have appealed to him. In any event, this is how he chose to depict his peasants at their meal.

He must also have been struck by Blanc's praise of Rembrandt as a master of chiaroscuro. Van Gogh had great love and admiration for the artist, and *The Holy Family at Night*, at that time attributed to the master, was one of his favorite works (ill. 45). As early as 1875 he had a reproduction of it on the wall in his room in Paris, and he hung it again in his studio in The Hague in 1882. The scene with its powerful lighting effects undoubtedly influenced his own rendition of figures in a dark interior. The figure seen from behind is a striking feature of *The Holy Family*, and an element that Van Gogh borrowed in *The Potato Eaters* in the form of the girl in the foreground. Perhaps, though, another work by Rembrandt, *The Pilgrims at Emmaus*, which Blanc discussed enthusiastically and also illustrated (ill. 46), contributed even more directly to the use of that compositional element.[6] It shows Christ as a powerful source of light that dramatically illuminates one of the two figures in the composition, while the man sitting at the table is a dark silhouette. The child in *The Potato Eaters* who acts as a *repoussoir* and lends depth to the scene has a very respectable pedigree.[7]

47
Vincent van Gogh
Study for *The Potato Eaters*.
1885
Van Gogh Museum,
Amsterdam

Van Gogh drew and painted studies for *The Potato Eaters*. The first small painted study, with four figures, was done in early April 1885 (ill. 47). Later that month he made the first large variation on the subject, now with five figures (ill. 48). It is a sketchily painted canvas with only cursory lighting effects. He very soon made a second version, however, in which he concentrated on the detailing of the composition (ill. 49). When the painting was almost finished he even took it to his friend Anton Kerssemakers for safekeeping because he was afraid he would spoil it in his drive for perfection.

This fear becomes all too understandable when we study the countless devices Van Gogh used to create convincing lighting effects, for it is clear that he could not keep his hands off the canvas.[8] Broadly speaking it was painted from dark to light, but there are later corrections in the highest lights in many places. The highlights in the hands of the man and woman on the right, for instance, were put in with a dirty pink (see left detail, page 69). These should have been the last touches, but Van Gogh added red strokes, and then green touches on top of those, and finally accents here and there in Prussian blue. The need for corrections like these must often have been a consequence of the conditions in which Van Gogh was painting. He was working in a dark cottage, and the canvas was between him and the lamp so that it was backlit. Although he must have used a second lamp to illuminate his work, the lighting was obviously far from ideal. Once he got the painting back to his studio, he must have repeatedly found that the lighting effects were unbalanced. We can see from the changes he made that they were sometimes too strong and he had to tone them down. The spoons in the wooden shoe in the top right corner, for example,

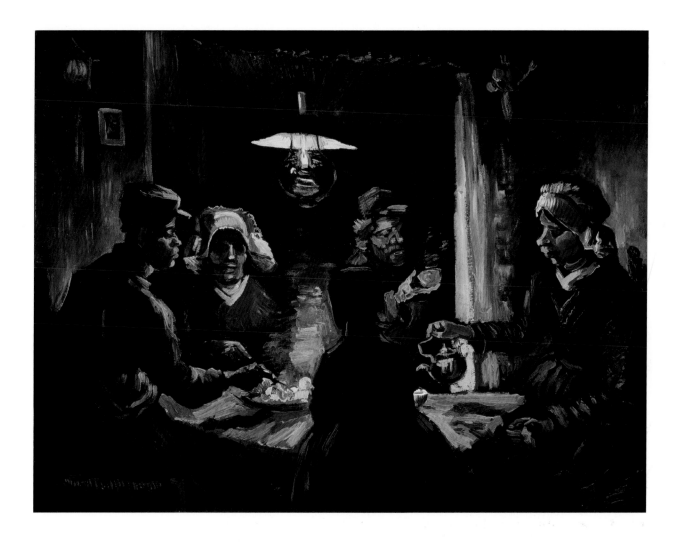

48
Vincent van Gogh
The Potato Eaters. 1885
Kröller-Müller Museum, Otterlo

must originally have stood out too brightly against the dark background. Van Gogh solved that problem, so it would seem, by going over the half-dry paint with a dry, stiff brush, working firmly up and down and rather more gently from side to side. This had the effect of removing paint so that the underlying blue showed through the nuanced beige of the spoons, an effective procedure that looks quite remarkable under the stereomicroscope (see right detail, page 69).

What was of paramount importance, of course, was to do full justice to the figures. Van Gogh did not really achieve this convincingly in the first version. The heads, it is true, stand out fairly well against the dark background, but the bodies are rather lost in the gloom, particularly in the area under the table. In the final work Van Gogh took care that this did not happen. The use of light to model the capped heads and the hands is more subtle and the contrast between the torsos and their background has been more carefully thought through. An ingenious device that he had already tried out in the small study was to use the steam rising from the dish of potatoes and catching the lamplight to give contrast to the figure of the little girl in the foreground. He had also used this in the small version with four

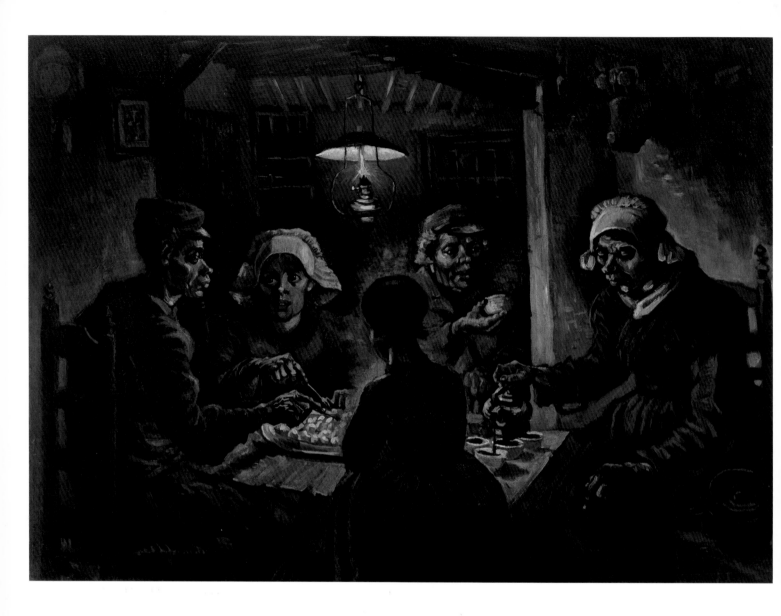

people, but less effectively: there it is just a light patch of steam beside the girl. This time, however, he completely surrounded her head and shoulders with it. He manipulated reality to a degree, since the steam rises from the potatoes only where it suited his purposes. The potatoes near the hands of the man and woman stabbing them with forks are not steaming, because steam was of no use to him in that spot. He made the same decision about the cups of coffee or chicory that the old woman is pouring. While the cup that the old man is raising to his lips is steaming, the four cups on the table are not. Van Gogh left it out so as not to disrupt the clarity of the image.

At the last moment, Van Gogh outlined the man on the left and the old woman on the right with lighter tones against the background, so that it is less dark in these areas than one would expect. He used a very fluid paint in a lightish gray-green for the woman, and worked around the man with drier paint in a bluer shade of green.

49
Vincent van Gogh
The Potato Eaters. 1885
Van Gogh Museum,
Amsterdam

In the final stage of painting he painted outlines in various places in what is probably Prussian blue,[9] and added touches of a pale pink flesh tone to the faces. The hair on the left of the old man's face needed heightening, so Van Gogh gave it a lick of the same pink. The lamp flame was finished with a few streaks of a quite transparent orange, put on over a pink that was already completely dry.[10]

Van Gogh put Eugène Delacroix's color theories into practice in *The Potato Eaters*. He had studied these theories with the aid of books by Jean Gigoux, Charles Blanc, and others.[11] Delacroix worked, so Van Gogh read, exclusively with *ton rompu*, a "broken tone" made by mixing complementary colors (red and green, purple and yellow, blue and orange). These shades extinguish each other, as it were, creating a dirty gray that still, depending on the proportion of the colors in the blend, can retain something of a shade.

It is fascinating to see how he was essentially applying the same color theory in his dark Dutch paintings as he did in his later modern colorful work, but did not yet fully understand it. In 1884–85 he was still working in the tonal painting tradition of the Hague School. The result was a very gray palette that was usually at odds with his search for rich color.[12] In 1885 Van Gogh still fiercely defended his artistic choices, but later he would look back on them with considerably less heat and put them into perspective. When he was in Arles he wrote his friend Emile Bernard about his Nuenen work: "In those days I was enthusiastic about gray, or rather, absence of color. I was always dreaming about Millet, and then I had acquaintances in Holland in the category of painters like Mauve, Israëls."[13] Around the same time he told his sister Wil: "You understand that Israëls and Mauve, who didn't use pure colors, who always worked in gray, do not, with the greatest respect and love, satisfy the present-day longing for color."[14]

Details of ill. 49

Van Gogh attached so much importance to his trial piece that he also recorded his ideas about the frame and the color of the surroundings against which it should be hung: "As regards the potato eaters—it's a painting *that looks well in gold*, I'm sure of that. Still—it would do equally well on a wall hung with a paper that had a deep tone of ripe wheat. It *simply mustn't be seen, though*, without this *enclosure* to it."[15] In Van Gogh's view, certain dark areas looked brighter against a warm gold background.

A NEW HOUSE ON OLD FOUNDATIONS

From 1886 to 1888 Van Gogh lived and worked in Paris. There he became acquainted with the modern art of his time and with colorful Japanese woodcuts. His knowledge of the possibilities of color broadened and deepened significantly during this period, and he developed into a true modern artist. This remarkable artistic about-face did not mean he discarded everything he had previously believed in. He continued to build on the color theories he had absorbed in Nuenen, but he now understood them better and put them into practice with a bright palette. Nor did he abandon the subjects that were close to his heart even though, naturally enough, the motifs he found in Paris were chiefly urban rather than rural. After he settled in Provence in February 1888, however, he again focused on life in the countryside.

By this time Van Gogh had become increasingly gifted as a landscape painter, but his love of figure paintings had never left him. This was the genre he had chosen in Nuenen for his envisaged masterpiece, *The Potato Eaters*, and he turned to it again in Arles for a new plan—to make a notable modern painting specifically through color. Van Gogh believed that the landscape had already taken on its modern form in Monet's work,[16] and he consequently saw a great challenge in making a modern variation of Millet's icon, *The Sower* of 1850 (see ill. 16). He painted an initial version of it in June 1888 (ill. 50).

While he was in Arles Van Gogh was preoccupied with depicting scenes that reflect the seasons, including sowing, which is done in late winter (February) and in fall (November). To him the sower and the wheat sheaf, associated with the never-ending cycle of growth, blossoming, and the end of life (the harvest), were symbols of the eternal.[17] This notion similarly informs his *Sower* of June 1888. It is no coincidence that Van Gogh set the scene against a sunset. The times of the day were also full of significance for him, and his melding here of the glowing end of the day with the beginning of a new life cycle is a sophisticated invention with comforting symbolism.[18]

The process of painting this first version of *The Sower* proved very laborious. Van Gogh was unsure about how to approach it, changed course radically after some

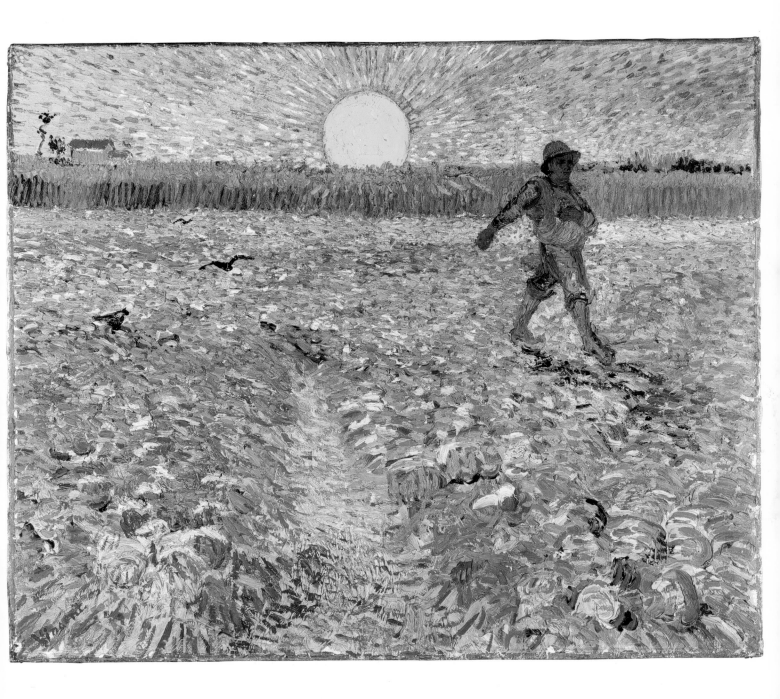

50

Vincent van Gogh

The Sower. 1888

Kröller-Müller Museum, Otterlo

time, and in the end did not achieve a result that satisfied him.[19] It was the power of color that would establish the modernity of the work, and again Delacroix was his guide. The color composition is essentially a complementary contrast between the yellow of the sun, sky, and wheat, and the purplish field. Within these large planes of color, however, Van Gogh worked subtly with other shades, creating a vibrant interplay of simultaneous contrasts. Finally, he outlined the field in yellow and the yellow area at the top in a bluish purple. This concentration on bright, saturated colors produced a distinctive color composition, but had an unintended side effect: although the sun is already starting to sink below the horizon, the scene is so flooded with light that the association with approaching dusk is far from apparent.

Van Gogh made two more variations on the theme. In September 1888 he painted a canvas of modest size and highly experimental coloring; in October he made a large version.[20] The striking color combination in the first work makes it impossible to tell what time of day it is meant to be. The other painting is a daylight scene. The sun is absent from both.

In November 1888, evidently still not satisfied, Van Gogh tackled the subject once more. Again the outcome was two versions of the same composition, one large and one small (ills. 51 and 52). It was sometimes assumed that the small version was a preliminary study for the large one,[21] but it has been established that the large *Sower* was done first.[22] This work shows the signs of a complex creative process—such as *pentimenti*—that is not found in the small version. Close scrutiny has now revealed that the work actually underwent far more changes than had previously been identified.[23] The most remarkable is that the sun has been painted in its entirety over a layer of blue paint. The blue can be seen at the edges of the sun and in tiny gaps within the yellow area. The same blue, sometimes grayer, can also be found elsewhere in the sky, shining through the now yellow, now green shades. Van Gogh had clearly not left a space for the impressive yellow disk in the first instance, and it seems reasonable to conclude that he had originally planned a scene in broad daylight, not at sunset.[24]

The Sower of June 1888 was slightly disappointing in terms of Van Gogh's passionate endeavor to achieve a distinctive coloration, and the effect of dusk is also missing from this painting. The new *Sower*, however, succeeded in every respect. Complementary contrasts (primarily yellow and purple, and red and green) give this work, too, extraordinarily expressive power, but this time Van Gogh elected to work with a more subdued palette and more controlled handling of the brush. The paint was applied to the sky inconspicuously and fairly dry, and impastoed—but always with careful thought—to the field, the tree, and the sower. He devoted a great deal of attention to the effect of sunlight. The sun was painted over the initial

(pages 72–73)
51
Vincent van Gogh
The Sower. 1888
Foundation E. G. Bührle
Collection, Zurich

|

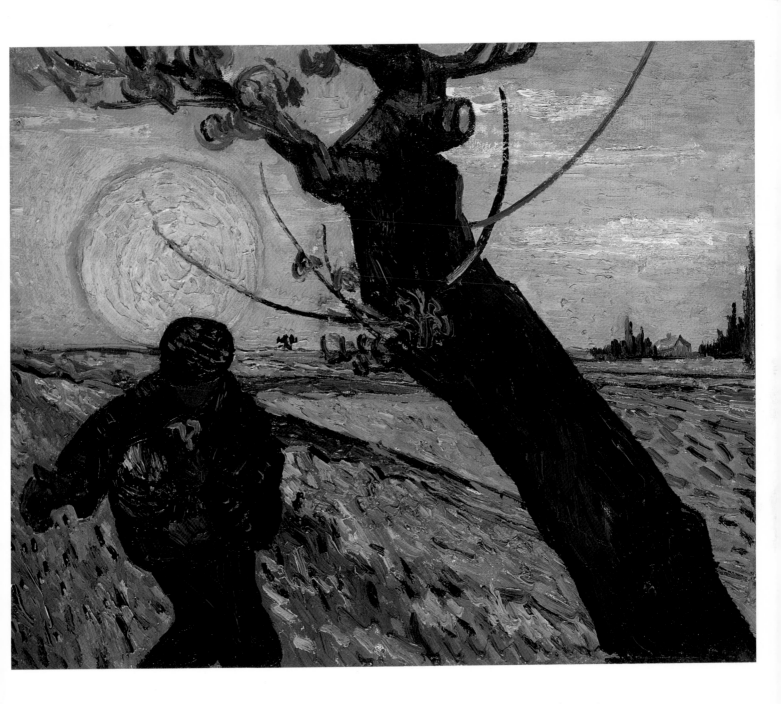

52

Vincent van Gogh

The Sower. 1888

Van Gogh Museum,

Amsterdam

blue and followed by the lime green of the whole sky. Van Gogh then surrounded the sun with a striking halo in yellow ocher and added streaks of the same color in the sky, particularly just above the horizon (see detail, below). Lastly, he gave the sun disk a slightly darker ring in a warmer yellow on top of the lighter yellow. It was a late intervention, for he had previously painted a branch of the tree over the sun and this is interrupted by the broad yellow line. With the various shades of yellow and green placed close together, Van Gogh succeeded in imbuing the sun with a warm glow while at the same time creating the suggestion that the light is already fading from the sky. On top of the lime green of the sky he painted a few white and pink clouds that lend further force to the effect of dusk. Lower in the picture, he put in dark blue streaks at the front of the field. There are no such streaks in the land stretching away to the horizon—another means of creating the impression of approaching twilight. To complete the tree, Van Gogh gave it a dark outline on either side where it stands out against the field, something he did not consider necessary in the part of the trunk higher up against the sky. The sower, finally, was put in on top of the land in heavy yet fluid brushstrokes in several shades of dark blue. By painting the man's head so that it just overlaps the sun, Van Gogh achieved both the effect of a halo and a strong contrast that makes the sun appear lighter and the sower darker. The seeds cast by the peasant were originally a dark color, which

Details of ill. 51

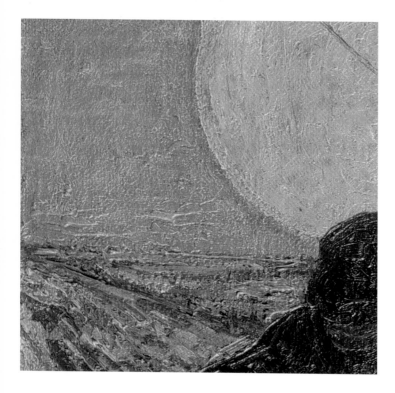

| TECHNICAL AND STYLISTIC ASPECTS OF VAN GOGH'S NIGHT SCENES

meant that they did not stand out sufficiently against the background, so each one was given a tiny touch of warm yellow; this creates a pleasing effect, as if they are catching the last light of the day (see detail, opposite).

The small *Sower* is a response to this second version of the large work. The tree has become so bulky now that there is very little room left in the composition for the peasant, who appears to be in danger of getting crushed. There is no sign here of the search for the right form that is so characteristic of Van Gogh's process of creation.

ARTISTIC COMPETITION: *THE NIGHT CAFÉ*

Van Gogh's attempts to make a modern figure piece were not confined to depicting scenes of rural labor, and he embarked on an interior with figures even before he had found the right form for *The Sower*. Van Gogh had become involved in an artistic competition with two of his most prolific correspondents, Emile Bernard and Paul Gauguin, who were both working in Pont-Aven at the time. Bernard had sent him a series of drawings of brothel scenes, and in September 1888 these gave Van Gogh the idea for a contemporary design in a modern artistic idiom. This was *The Night Café* (ill. 53).

Van Gogh rented a room in this café before he went to live in the Yellow House. A night café was an establishment, typically in the South of France, that stayed open all night. Van Gogh described it to Theo as somewhere people went when they could not afford lodgings, or were so drunk that the lodging-keeper would not let them in. Like *The Potato Eaters*—with which Van Gogh himself compared it[25]—*The Night Café* was a picture of people seeking solace late at night, but in this case it was no warm and comforting refuge. Van Gogh believed that the modern age jeopardized people's peace of mind, and the night café was consequently a place where dark forces lurked and deeply suppressed human passions could suddenly explode. At the same time he wanted to give it a sort of Japanese gaiety and southern amiability.[26] Van Gogh had become familiar with subjects derived from modern night-life while he was in Paris. Impressionists such as Manet, Degas, and Renoir and avant-gardists like Toulouse-Lautrec, Seurat, and Louis Anquetin often used these motifs in their work. Such themes were also prevalent in contemporary literature, in books like Emile Zola's *L'assommoir*.

Van Gogh said that he stayed up for three nights to make the painting, sleeping during the day. The result, he reported to Theo, was a work that was comparable to *The Potato Eaters* in its ugliness, although it was obviously an entirely different work. By "ugliness," Van Gogh must have been referring to the raw expressive power and

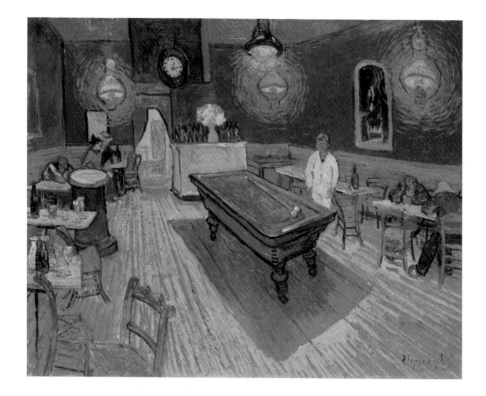

53
Vincent van Gogh
The Night Café. 1888
Yale University Art Gallery,
New Haven

the brutal color scheme that he had endeavored to give both works, one in his old-fashioned artistic idiom, the other in his modern style. In April 1890, toward the end of his stay in the asylum at Saint-Rémy, Van Gogh contemplated making a new version of *The Potato Eaters*. Sadly this came to nothing, for it would certainly have been a fascinating image.

Whereas it is the darkness that indicates the lateness of the hour in his Nuenen figure piece, in *The Night Café* it is the glaring artificial light that tells us night has fallen; the clock confirms that it is almost twelve fifteen. Four visible lamps light the room; there is most likely a fifth on the left just outside the picture. Van Gogh wrote in a letter to Theo that he would paint the scene by gaslight.[27] This probably refers to the lamp that illuminates the billiard table, since the other three look like old-fashioned oil lamps. He used various means to indicate the brightness of the lemon-yellow gaslight. He began with a very thick splotch of lemon and surrounded it with bright yellow rays (see left detail, opposite), but the strength of the light is emphasized above all by a clever device: the dark, almost threatening shadow cast by the billiard table. This gains added prominence because Van Gogh left out all the other shadows—and in these lighting conditions there must have been a great many of them.

He rendered the softer light of the oil lamps, also lemon yellow, by surrounding them with an orange and green glow. In places he toned these brushstrokes down slightly by scraping and scratching (see right detail, opposite). He also gave the middle oil lamp an appreciably greener tinge than the other two; without this, the contrast with the gas lamp would not have been strong enough.

The Night Café is a colorist tour de force. The harsh, saturated red of the walls contrasts with the complementary green above it and the paler shade of the counter with its bottles below—Louis XV green, Van Gogh called it.[28] More subtle greens and reds are at work all over the picture. There is the green of the billiard cloth with the single red ball, a red tabletop in the background, touches of green in the otherwise yellow floor, and the green hair of the white-clad landlord against the red wall behind him. In all this welter of color, the white jacket and trousers are designed to be a resting point for the eye, an idea that Van Gogh borrowed from Blanc.[29] Although Van Gogh declared himself satisfied with *The Night Café*, he was not entirely happy with this figure. A year later, in September 1889, he told Theo of his plan to repeat some of the most successful of his Arles works. He regarded *The Night Café* as one of them, but felt that the color of the white figure in the center would have to be improved.[30]

The style in which *The Night Café* is painted is spontaneous and robust—very much in keeping with the character of this realistic and contemporary scene. Van Gogh consciously sought stylistic means of expression that were of a piece with his subjects, and even reinforced them. A comparison of *The Night Café* and *The Starry Night over the Rhône* (see ill. 1), which Van Gogh painted soon after it, at the end of September 1888, makes this abundantly clear. The reality of modern life dominates

Details of ill. 53

the scene in the café, but the grandeur of nature holds sway in *The Starry Night over the Rhône*. An overwhelming night sky renders the houses of Arles utterly insignificant. The poetic aspects Van Gogh saw in the night are emphasized by the couple strolling in the foreground. The harmonious composition is painted in a correspondingly harmonious style. Here Van Gogh opted for regularity and coherence in his brushwork. The sky is laid down in a horizontal pattern, while the river and the land in the foreground are painted in diagonal strokes. The serene effect achieved through the handling of the paint is entirely in accord with the subject. In both paintings content, style, and technique are inseparable.

ANOTHER STARRY NIGHT

In the famous *Starry Night* that he painted in Saint-Rémy in June 1889, Van Gogh reached unprecedented heights in the depiction of a night sky (ill. 54). Despite the present reputation of this masterpiece, Van Gogh regarded it as just a study—and one he was not even satisfied with, at that. In September 1889 he described it to Theo as a "study of the night" and "Night Effect."[31] Theo shared Van Gogh's dissatisfaction with the painting, for he felt that his brother was seeking a specific style at the expense of "the real sentiment of things."[32] In this period, inspired by the unfettered approach to reality Gauguin and Bernard took in their work, Van Gogh also gave his imagination free rein. Reproducing reality was not what he set out to do.

While his friends were the model for his artistic attitude, Delacroix was yet again his mentor in his use of color. Van Gogh was very interested in Delacroix's color theories, and particularly admired his use of two specific colors: blue and yellow. He wrote from Arles around April 11, 1888:

> So the whole order I made up, in other words the three chromes (the orange, the yellow, the lemon), the Prussian blue, the emerald, the madder lakes, the Veronese green, the orange lead, all of that is hardly found in the Dutch palette, Maris, Mauve, and Israëls. But it's found in that of Delacroix, who had a passion for the two colors most disapproved of, and for the best of reasons, lemon and Prussian blue. All the same I think he did superb things with them, blues and lemon yellows.[33]

In September 1889 he would, as he put it, make "translations in color" of black-and-white prints: Delacroix's *Pietà* and Millet's ten scenes of work on the land.[34] These works are first and foremost experiments in blue and yellow. *The Starry Night*, both the one from Arles and the new version from Saint-Rémy, can be seen as an homage in color to Van Gogh's great exemplar. Other colors feature in the composition, but blue and yellow dominate. This color contrast was a happy notion of Van Gogh's. The night is obviously not as predominantly blue as he depicted it, but if a pigment

with sufficient opacity is used, blue is a color that can be used both light and dark without losing its intensity. Rather than choose a larger number of dark shades, he elected to paint primarily in blue in a range of harmonizing tones. This meant that he was not obliged to maintain the balance in a much more complicated composition in dark colors. This was the problem that had plagued him when he painted *The Potato Eaters*. With his newfound understanding of color theories he now came up with bold solutions that had previously been beyond his grasp.

The composition of *The Starry Night* is complex and daring, but there are no signs of an underdrawing. Admittedly, it is often impossible to find underdrawings in paintings, but because the work was painted quite loosely and the canvas shows through in many places, extensive preparation would certainly have left visible traces.[35] At most, Van Gogh can only have done a very general preliminary sketch.

The cypresses—the darkest tone in the composition—were put in first and were already reasonably dry when the surrounding colors were painted. This is evident because the other colors come up against the green and brown of the trees without disturbing the paint layer.

Van Gogh used a heavily impastoed, rhythmic, and structural brushstroke for his starry sky. This shows up particularly clearly under raking light (see below).

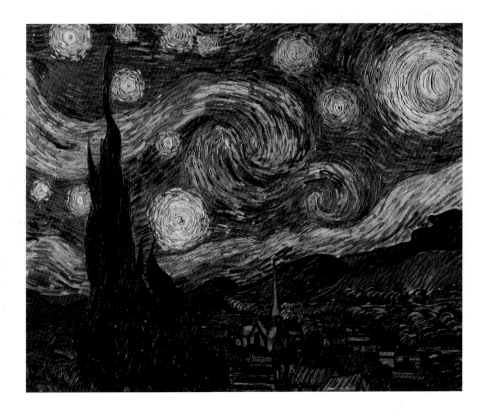

Photograph of ill. 54 in raking light

(pages 82–83)
54
Vincent van Gogh
The Starry Night. 1889
The Museum of Modern Art, New York

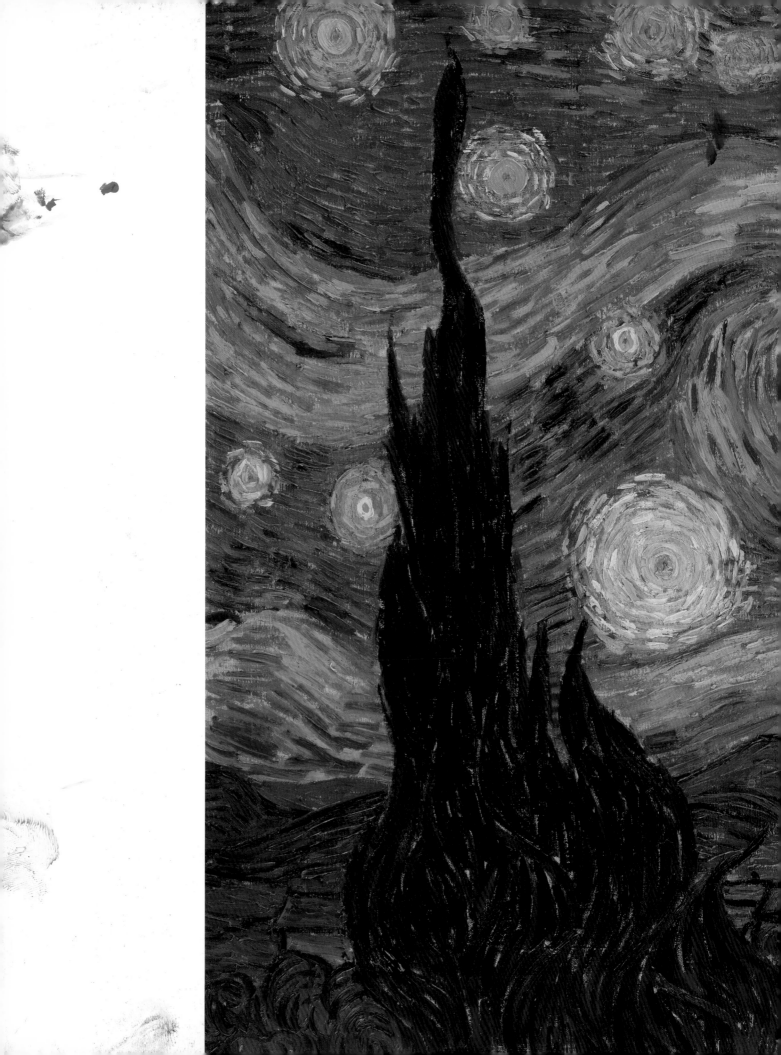

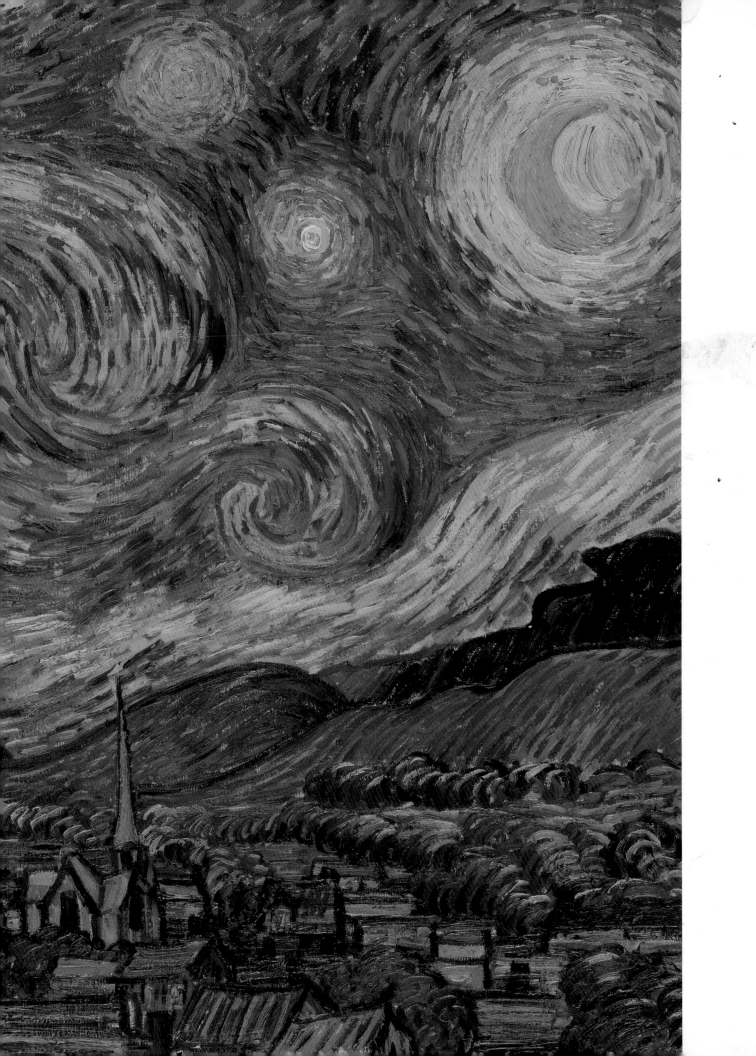

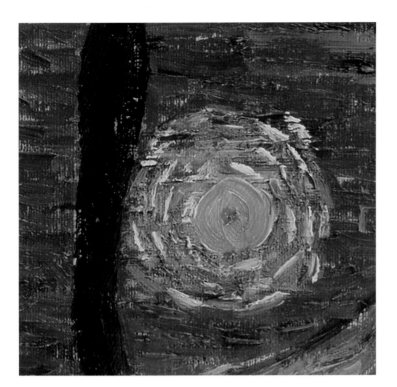

Details of ill. 54

The village and the orchards are also thickly painted, but with a freer touch. These passages are separated from one another by the much more thinly painted and less varied mountains of the Alpilles. Van Gogh used them to create a point of rest in the composition. To keep the picture from becoming too much of a large blue expanse, Van Gogh added a second dividing line between land and sky. Above the Alpilles there is a light strip whose nature is difficult to fathom. It may be the mist above the mountains illuminated by the bright moonlight, but whatever it is, in artistic terms it is a very effective touch.

Van Gogh painted *The Starry Night* according to a grid that he abandoned when his artistic intuition told him to, as we can see from the various stages of composition. He had, for instance, left openings in the blue for the stars, but it turned out that he had not made them large enough: six of the eleven stars were subsequently enlarged over the top of the blue, some just a little, some substantially (see detail, above). The light from the moon was also made larger at a later stage to get the balance between blue and yellow right and intensify the effect of light in the darkness. In the final phase Van Gogh added a deep, dark blue between the two stars to the left of the moon and the lower two on the right of the cypress; this increased the contrast, and hence the atmosphere. The tone of the cypresses was deepened still further with dark blue.

The yellow touches of light in the houses are likewise late additions. This is not to say that Van Gogh did not originally intend to achieve this effect, since he always liked to give houses signs of life.[36]

The remarkable swirl that dominates the sky required considerable thought. Van Gogh wrestled with how much prominence to give it in the composition. Over its full length there are a number of long, pale purple strokes (see detail, opposite). This color did not have the effect that Van Gogh had in mind, and it was eventually muted with short dabs of light blue. It is a minor change whose very subtlety shows us just how far Van Gogh went in balancing every element of his works. Studying effects like these in *The Starry Night* and the other three paintings described here allows us a swift glance over the artist's shoulder and gives us an insight—albeit a limited one—into the intriguing process by which his paintings were created.

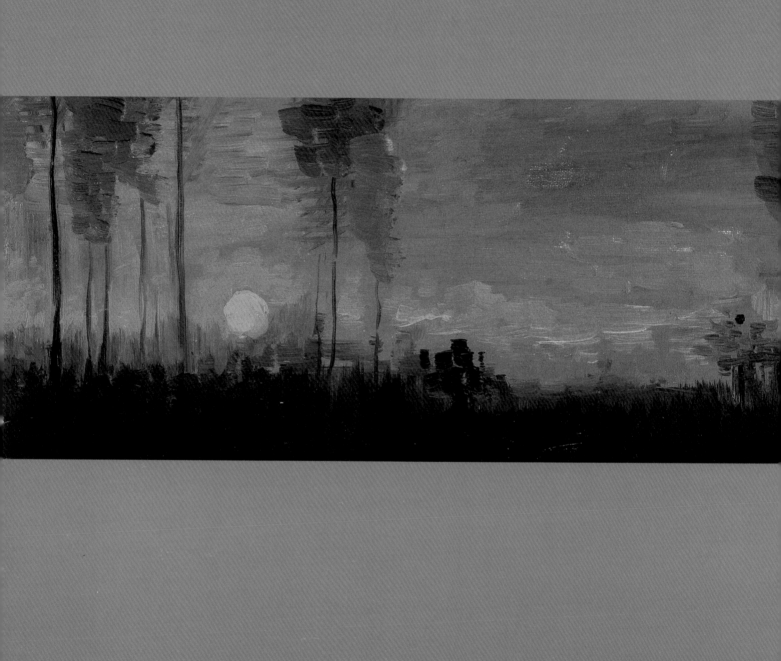

LANDSCAPES AT TWILIGHT

Geeta Bruin

Van Gogh's particular fondness for the half-light began long before he became an artist. In the 1870s he told Theo how the dawn light always captivated him during his early morning walks.[1] At that time the "blessed twilight," as he called it, quoting Charles Dickens, still had a religious significance for him. Referring to passages from the Gospels, he wrote in 1877: "The twilight says such things to those who have ears with which to hear and a heart with which to understand and to have faith in God—blessed twilight."[2]

In 1880, when Van Gogh decided to become an artist, he started out by emulating the artists of the Barbizon School and the Hague School. He had become very familiar with their work when he was employed as an assistant in Goupil & Cie's gallery.[3] Artists like Daubigny, Dupré, and Rousseau were fascinated by the effects of gathering darkness, and their countless *effets de soir* and *effets de nuit* were important examples for Van Gogh. They inspired him to paint atmospheric landscapes with moody chiaroscuro effects.

Van Gogh admired the way the Barbizon painters depicted the wild, uncultivated landscape, and described their decision to concentrate on this as "sublime": "The country shaped them, all they knew was: it's no good in the city, I must go to the

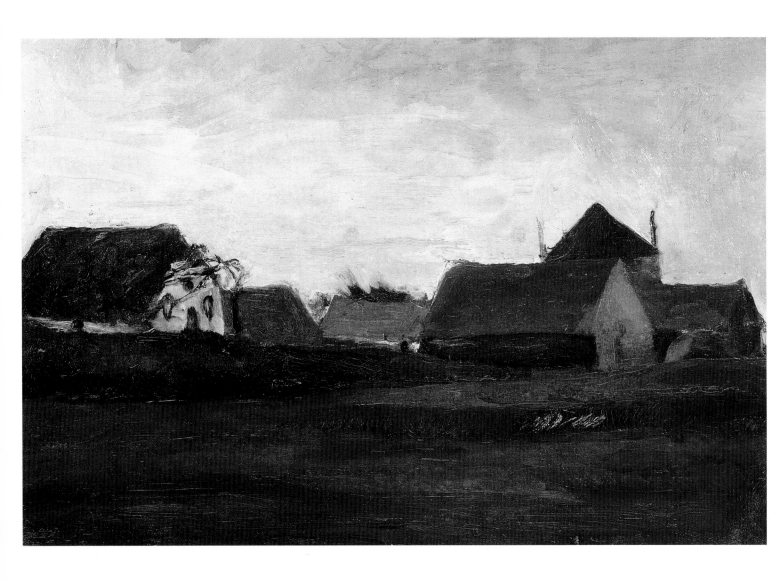

country; I imagine they thought, I must learn to work, become something entirely different, yes, the opposite of what I am now. They said, I'm no good now, I'm going to renew myself in nature."[4] The landscapes by seventeenth-century Dutch masters like Rembrandt and Ruisdael also made an indelible impression on him; he would refer repeatedly to these examples throughout his career.

Van Gogh's special interest in depicting evening and night, his admiration for the landscapes of the Barbizon artists, and his fascination with rural life were reflected in his artistic work early on in his career. In September 1883, for instance, he painted a farmhouse at dusk (ill. 55).[5] Van Gogh had derived the inspiration for this work in the countryside just outside The Hague, where he was living at the time: "I've found splendid things in Loosduinen, old farmhouses, and the effects in the evening are superb there."[6] In his use of color during this period he took his lead from the painters of the Hague School, particularly his teacher Anton Mauve; Van Gogh's work is dominated by the tonal gray colors that Mauve also used so widely.

Not long after he finished this painting, Van Gogh moved to Drenthe, a sparsely populated and largely uncultivated province in the north of the Netherlands. Van Gogh eagerly anticipated working in the unspoiled, rugged countryside he thought he would find there, but the reality of the landscape came as a severe disappointment to him. He thought it was monotonous and told Theo "it's as irritatingly tedious and fatiguing as the desert, just as inhospitable, and as it were hostile." In the same letter, however, he also wrote: "That same irritatingly tedious spot—in the evening as a poor little figure moves through the twilight—when that vast, sun-scorched earth stands out dark against the delicate lilac tints of the evening sky, and the very last fine dark blue line on the horizon separates earth from sky—can be as sublime as in a J. Dupré."[7] He captured these "sublime" twilight effects in the atmospheric drawings *Landscape in Drenthe* (ill. 56) and *Landscape with a Stack of Peat and Farmhouses* (ill. 57).

LIGHT EFFECTS AND COLOR CONTRASTS

At the end of 1883 Van Gogh left Drenthe, where in spite of several euphoric moments he had essentially been desperately lonely, and went to Nuenen in the south of the Netherlands. Here, following his guide Millet, he embarked on a study of traditional peasant life. He concentrated on technical aspects of art like color, tone, and chiaroscuro, consulting books about earlier art, among them Charles Blanc's *Grammaire des arts du dessin* (1867) and *Les artistes de mon temps* (1876). He was particularly gripped by Delacroix's color theories as explained by Blanc, and he put

56
Vincent van Gogh
Landscape in Drenthe. 1883
Van Gogh Museum,
Amsterdam

57
Vincent van Gogh
Landscape with a Stack of Peat and Farmhouses. 1883
Van Gogh Museum,
Amsterdam

them into practice with a heavily impastoed touch and a dark palette. He spoke of
an "*infinite variety* of tones in the *same family*" and of "having a greater love for the
colorist's palette than for nature."[8]

Van Gogh combined his newly acquired insights into the use of color with new,
expressive motifs, and incorporated them in the evening landscape *The Old Tower at
Dusk* of July 1884 (ill. 58). He saw the tower and the adjacent "peasants' graveyard"
as symbols of life and death in the country. He wanted to convey the idea that faith
and the institutions of faith were doomed to perish, but the life of the peasants con-
tinued unchanged and unchanging.[9] *The Old Tower at Dusk* did not go unnoticed: Van
Gogh's former friend and fellow artist Anthon van Rappard referred to it in 1890 in
a letter of condolence to Van Gogh's mother: "And what fine studies he made of the
old tower in the churchyard. I have never forgotten a moonlight view of it, which
struck me so forcibly at the time."[10]

In the fall of 1884 Van Gogh began *Lane of Poplars at Sunset*, which expressed the
melancholy mood that descends with the dusk and reminds man of his mortality
(ill. 59).[11] Van Gogh appears to have incorporated into it the French poet François
Coppée's poem "Tristement," in which just such a mood is evoked by a veiled
woman walking along an avenue in the fall.[12]

The agricultural landscape in Nuenen captivated Van Gogh. At the same time
he gained self-assurance, and his confidence in his painting technique and use
of color and color contrasts grew. He became convinced that a painter should
not slavishly copy reality, but should create from the palette and look for dispa-
rate colors that could ultimately form a single entity: "One begins by fruitlessly

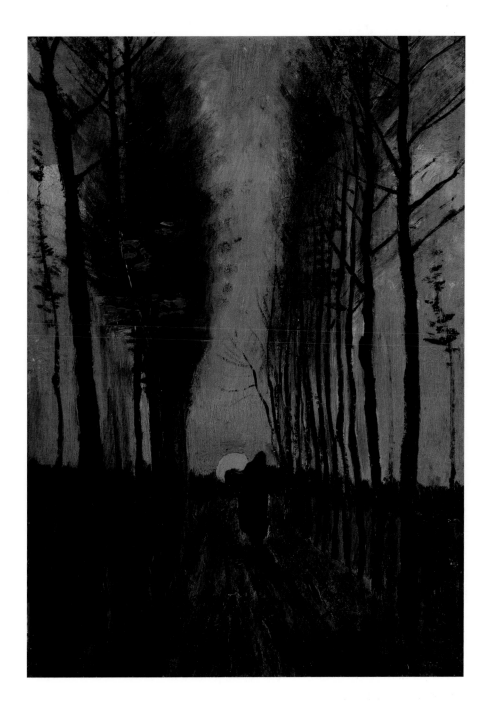

working oneself to death to follow nature, and everything is contrary. One ends by quietly creating from one's palette, and nature is in accord with it, follows from it."[13] This was not to say, though, that he planned to use a light, Impressionist color scheme. "One of the most beautiful things by the painters of this century," he wrote to Theo in April 1885, "has been the painting of DARKNESS that is still COLOR."[14] He applied the principle in *Evening Landscape* (ill. 60) and *Toward Evening* (ill. 61).

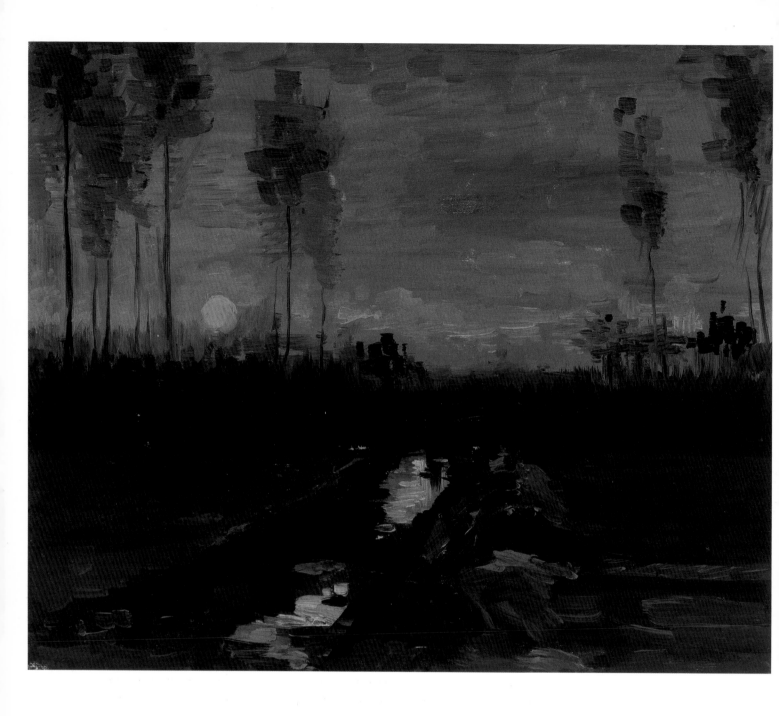

60
Vincent van Gogh
Evening Landscape. 1885
Museo Thyssen-Bornemisza,
Madrid

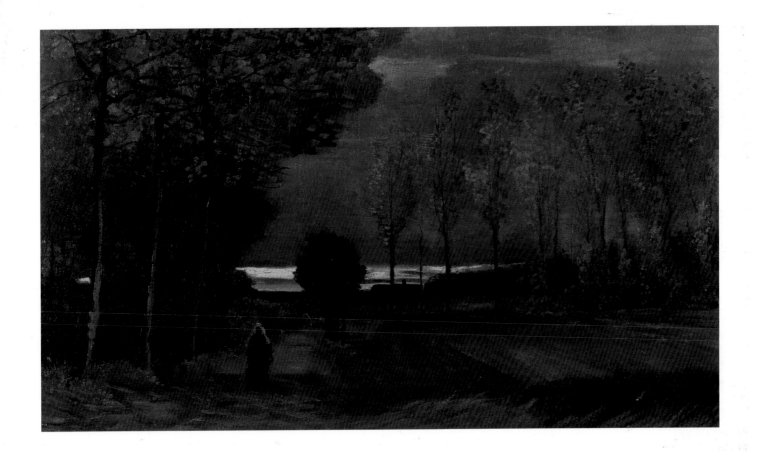

61

Vincent van Gogh

Toward Evening. 1885

Centraal Museum, Utrecht

SEEKING A MODERN PALETTE

In Paris, Van Gogh encountered the Impressionists' modern use of color and light palette. He admired the painters of the Petit Boulevard and their expressive coloring.[15] One of the works Van Gogh painted there was *Sunset at Montmartre*, an atmospheric landscape in a striking, elongated format that shows the setting sun with the factories of Clichy in the background (ill. 62).[16] In *Garden in Montmartre at Sunset* he contrasted the warm, yellow-orange glow of the setting sun with cool blues (ill. 63). Painted in a single session with a rapid touch and broad brushstrokes over a simple underdrawing, it is probably an initial work in a small series that Van Gogh explored further in *Corner in Voyer-d'Argenson Park at Asnières* (ill. 64). Here Van Gogh experimented with the pointillist technique borrowed from Seurat and Signac.

In February 1888 Van Gogh moved to Arles. Here, in the countryside of the South of France, he looked for subjects that he could capture with his new, colorful palette. The area around Arles provided him with ample opportunity. Van Gogh was delighted with "the limpidity of the atmosphere and the gay color effects," which seemed to him to be "as beautiful" as in Japan: "The stretches of water make patches of a beautiful emerald and a rich blue in the landscapes. . . . Pale orange sunsets making the fields look blue—glorious yellow suns."[17] Color became a means of expression in its own right for Van Gogh and the benchmark for his contribution

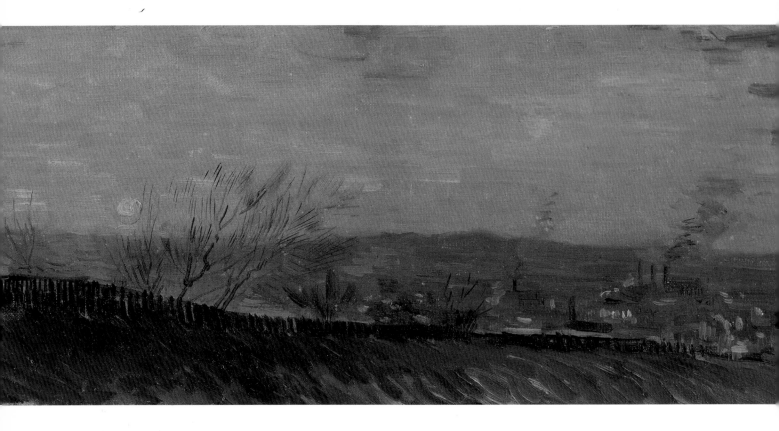

to modern art. In March 1888 he wrote: "You understand that the countryside of
the south cannot exactly be painted with the palette of Mauve, say, who belongs in
the north and is and always will be the master of gray. But today's palette is defi-
nitely colorful—sky blue, pink, orange, vermilion, brilliant yellow, bright green,
bright wine red, violet."[18] Van Gogh used just such a "definitely colorful" palette
in landscapes, and in evening and night scenes like *The Stevedores in Arles*, a work he
painted in August 1888 (ill. 65).

During his stay in the mental hospital in Saint-Rémy Van Gogh continued to
derive inspiration from landscapes in the half-light. On days when he felt well
enough, he went out into the countryside to look for new subjects. He found them
in the cypresses, the wheat fields, and the olive groves that he believed typified the
landscape of Provence. He painted *Olive Grove* in November 1889 in response to a
discussion he had had with Gauguin and Bernard about the depiction of biblical
themes (see ill. 102). By taking the olive grove as his subject he wanted to dem-
onstrate that it was possible to summon the Garden of Gethsemane in a simple,
realistic way.

After Van Gogh moved to Auvers-sur-Oise in May 1890, he resumed his "study
from life of peasants and landscapes."[19] Again he went back to the work of some of

62
Vincent van Gogh
Sunset at Montmartre. 1887
Van Gogh Museum,
Amsterdam

63

Vincent van Gogh

Garden in Montmartre at Sunset.
1887
Van Gogh Museum,
Amsterdam

64

Vincent van Gogh

*Corner in Voyer-d'Argenson
Park at Asnières.* 1887
Yale University Art Gallery,
New Haven

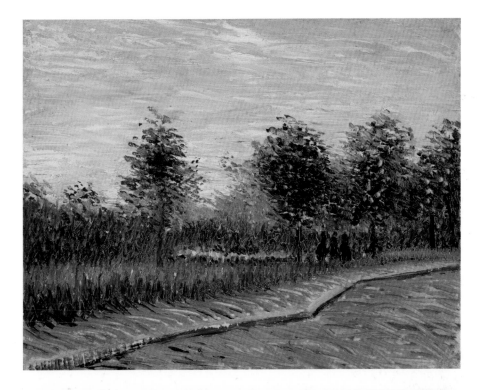

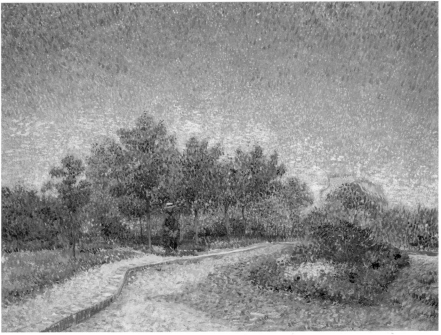

his favorite artists. In June 1889, while he was still in the clinic, he had written that
he "believed more than ever in the eternal youth of the school of Delacroix, Millet,
Rousseau, Dupré, Daubigny, just as much as in the current one."[20] In Auvers the
memory of Daubigny came unbidden to Van Gogh: the Barbizon master had, after
all, lived and worked there, and Van Gogh could almost see his studio from his

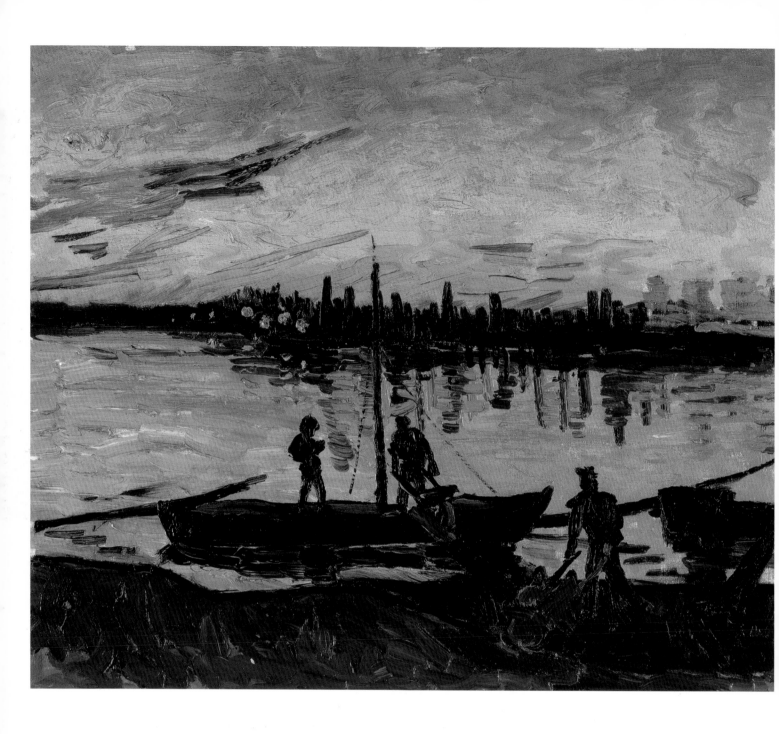

65
Vincent van Gogh
The Stevedores in Arles. 1888
Museo Thyssen-Bornemisza,
Madrid

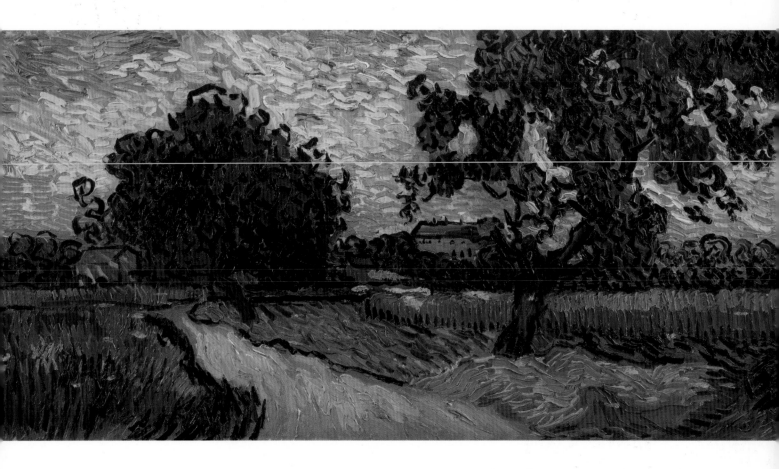

window.[21] In a similar elongated format to one Daubigny often used, he painted several impressive panoramic landscapes in bright colors, among them *Landscape at Twilight* (ill. 66), which he described as "a night effect—two completely dark pear trees against yellowing sky with wheat fields, and in the violet background the castle encased in the dark greenery."[22] Van Gogh was trying here, after the example of the old Barbizon master, to capture the specific mood of the moment.

Van Gogh's enthusiasm for the landscape at twilight makes him part of an old tradition. Evening and night landscapes had been a favored subject for centuries, and were particularly popular with the artists of the Barbizon School whom Van Gogh so admired and had initially followed. After a few years, however, he started to modernize this genre with his striking use of color and rhythmic brushstroke, and Van Gogh proved himself to be a resolute pioneer of modern art.

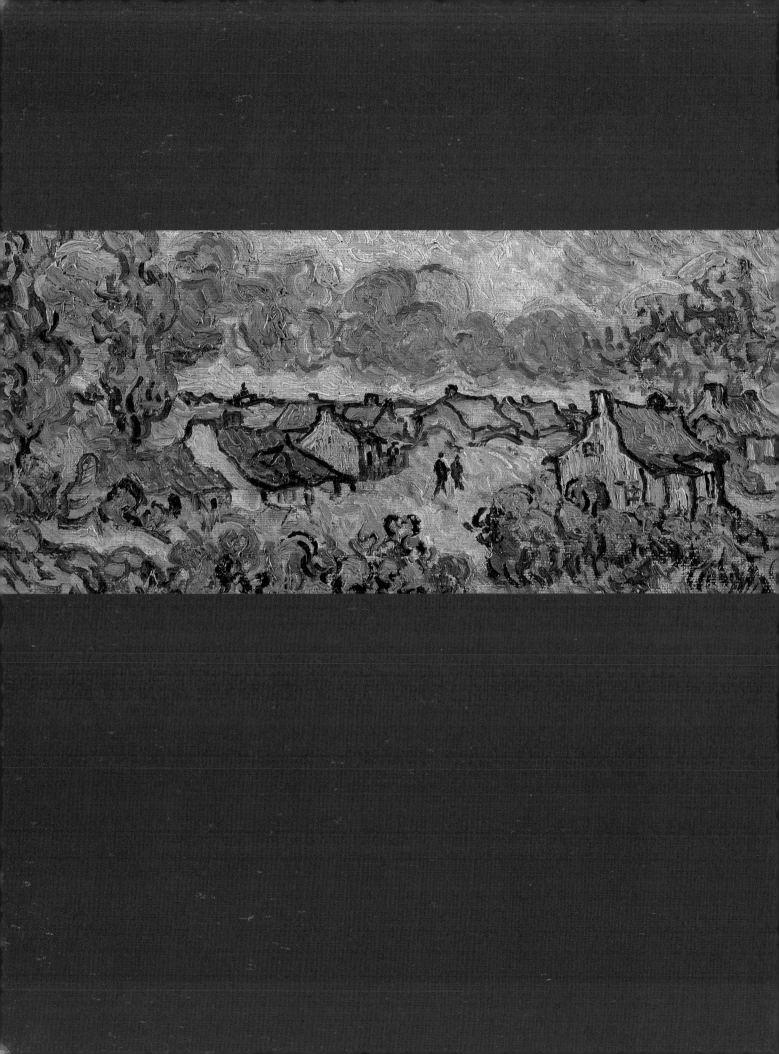

PEASANT LIFE: "LES PAYSANS CHEZ EUX"[1]

Jennifer Field

Van Gogh emulated the artists he admired, making copies after works by Rembrandt, Delacroix, and Millet. In their work, he found examples of night scenes that informed his own compositions. He intended his copies not as literal reproductions but as "translations," explaining, "working either on [Millet's] drawings or the wood engravings, it's not copying pure and simple that one would be doing. It is rather translating into another language, the one of colors, the impressions of chiaroscuro and white and black."[2]

In 1889, while living in Saint-Rémy, Van Gogh copied in paint Millet's series of wood engravings *The Four Hours of the Day* (1860), including *Night (after Millet)*, which he rendered in "a range of violets and soft lilacs, with light from the lamp pale citron, then the orange glow of the fire and the man in red ocher,"[3] and *Evening: The End of the Day (after Millet)* (ills. 67 and 68). According to Griselda Pollock, these works are related to the centuries-old tradition of depicting rural laborers during various seasons of the year, series that are derived in turn from the medieval Books of Hours. Such images upheld the idea of rural labor as "structured by repetition and continuity in rhythms dictated by God and Nature."[4] This theme appealed to Van Gogh, and he explored it in an earlier series of works depicting the landscape

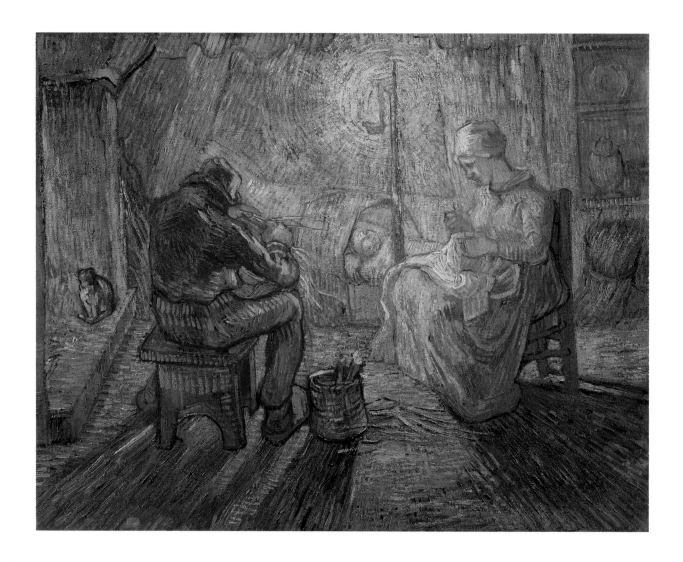

and people of the Brabant region that he made between 1883 and 1885. His admiration for these laborers stemmed from his perception of the humility and simplicity with which they conducted the most fundamental human tasks. In his eyes, they stood closer to nature than educated or more civilized people, and were strongly linked to the cycles of life.

The most famous of the Brabant works, *The Potato Eaters* (ill. 69), was Van Gogh's first major canvas and his first painting of an interior night scene. He painted it in April to May 1885 when he was living with his parents in Nuenen. In a letter from that period, he praised Millet for a *"peasant [that] seems to be painted with the soil he sows!"*[5] Van Gogh sought to similarly convey the daily life of the laborer not only through subject matter, but through an expressive quality manifested through

(pages 100–101)
Detail of ill. 75
Vincent van Gogh
Recollection of Brabant. 1890
Van Gogh Museum,
Amsterdam

67
Vincent van Gogh
Night (after Millet). 1889
Van Gogh Museum,
Amsterdam

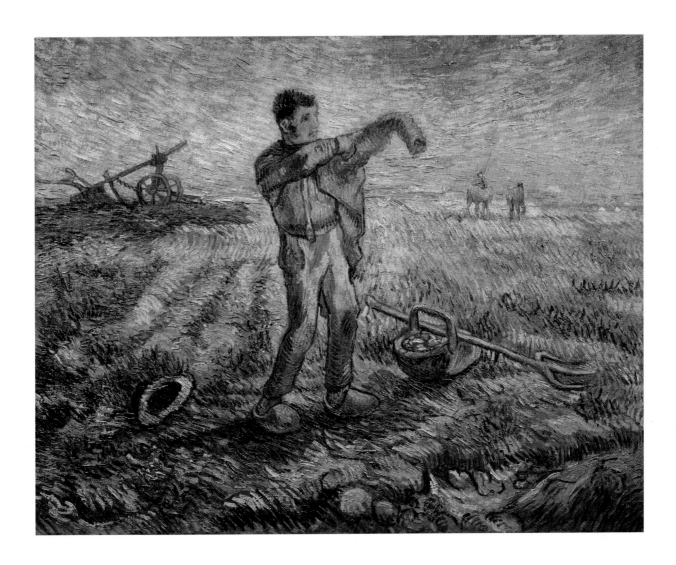

68

Vincent van Gogh

Evening: The End of the Day
(after Millet). 1889

Menard Art Museum, Komaki

(pages 104–5)

69

Vincent van Gogh

The Potato Eaters. 1885

Van Gogh Museum,

Amsterdam

palette and paint handling. As late as October 1887, he wrote to his sister Wil, "What I think about my own work is that the painting of the peasants eating potatoes that I did in Nuenen is after all the best thing I did."[6] In 1890 he even considered remaking it, writing to his brother Theo from the asylum of St.-Paul-de-Mausole in Saint-Rémy, "Please send me what you can find of *figures* among my old drawings, I'm thinking of redoing the painting of the peasants eating supper, lamplight effect. . . . Perhaps I could redo it entirely from memory."[7]

The theme of a family of laborers gathered around their evening meal was a popular subject in Europe at the time, found in paintings such as *Frugal Meal* by Jozef Israëls and *Le Bénédicité* by Charles de Groux (ills. 70 and 71), both of which Van Gogh knew and referred to in his letters.[8] For *The Potato Eaters*, Van Gogh returned

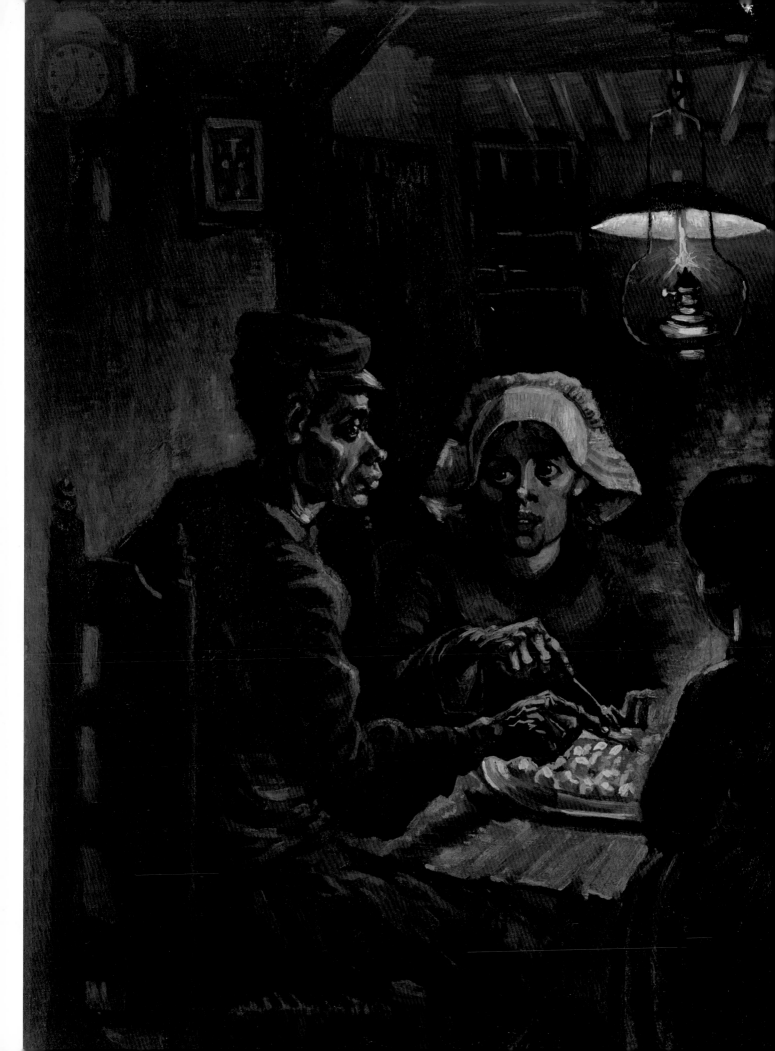

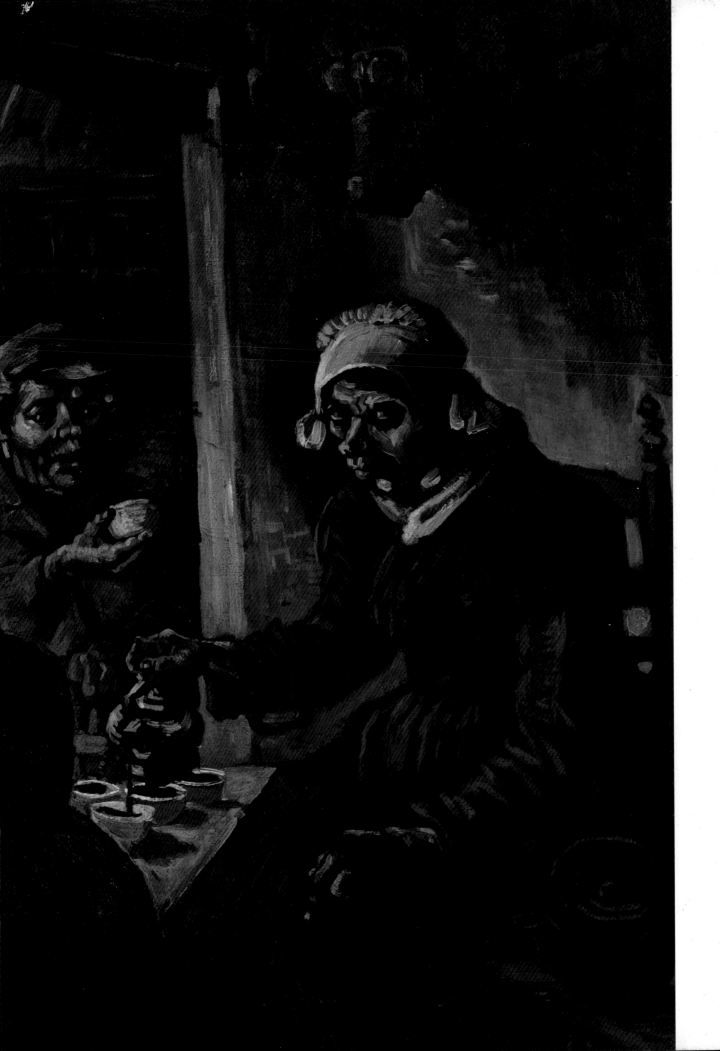

regularly to the home of a peasant family to sketch them at dinner. He made one large study (see ill. 48),[9] now in the Kröller-Müller Museum, Otterlo, and a lithograph before he began the final version, which he completed in his studio, adhering to Delacroix's insistence on working from memory.[10] Following Emile Zola's belief in depicting the essence of a subject rather than a literal, descriptive rendering of it, Van Gogh wrote:

> I really have wanted to make it so that people get the idea that these folk, who are eating their potatoes by the light of their little lamp, have tilled the earth themselves with these hands they are putting in the dish, and so it speaks of 'MANUAL LABOR' and—that they have thus honestly earned their food. I wanted it to give the idea of a wholly different way of life from ours—civilized people. So I certainly don't want everyone just to admire it or approve of it without knowing why.[11]

Indeed, although *The Potato Eaters* is now recognized as a seminal work in Van Gogh's career, it was not much appreciated in his own circle. After receiving the lithograph, the artist Anthon van Rappard, a friend of Van Gogh's, harshly criticized the unnatural poses of the figures; and Theo, the dealer Alphonse Portier, and the artist Charles Serret, who saw the second and final painting, considered it too dark. The dark palette was a result of Van Gogh's various aesthetic concerns. He had briefly considered depicting the scene by daylight, but instead decided on a night scene. The idea of painting this motif first came to him when he visited the cottage one evening and was "carried away by the singular lighting" inside.[12]

Van Gogh employed a range of colors in low tonality to convey the darkened atmosphere in the cottage: "It's in such a low spectrum that the light colors, smeared on white paper, say, would look like ink blots—they appear as lights on the canvas because of the strong forces that are opposed to them, for instance Prussian blue laid on just as it is, without mixing."[13] This quality recalls the chiaroscuro work of Rembrandt, whom Van Gogh greatly admired, and whose *Holy Family at Night* (see

70

Jozef Israëls
Frugal Meal. c. 1861
Glasgow Museums, Culture
and Sport Glasgow

71

Charles de Groux
Le Bénédicité. 1861
Royal Museums of Fine Arts of
Belgium, Brussels

72
Vincent van Gogh
Head of a Woman. 1885
Kröller-Müller Museum, Otterlo

ill. 31; now attributed to the studio of Rembrandt) served as a precedent for Van Gogh's own interior night scene. On April 21, 1885, he wrote to Theo of *The Potato Eaters*, "at the same time, . . . the painting I'm working on is different from lamplights by Dou or Van Schendel—it's perhaps not superfluous to point out how one of the most beautiful things by the painters of this century has been the painting of DARKNESS that is still COLOR."[14]

Having worked out tonal contrasts in previous studies such as *Woman with a Broom* and *Head of a Woman* (ills. 42 and 72), Van Gogh mixed his palette using only the three primary colors, red, yellow, and blue. The shadows in *The Potato Eaters* are deep Prussian blue. For mid-range tones, Van Gogh interwove gray-greens with warmer, dusky reds for highlights and flesh tones, revealing his familiarity with the color theories of Delacroix and Michel Eugène Chevreul, which he learned through Charles Blanc's text *Grammaire des arts du dessin* (1867).[15] Both Delacroix

and Chevreul stressed the use of complementary hues such as green and red for depicting shadow and light, to create a contrasting yet harmonious effect that Van Gogh described as "iridescent."[16]

In *The Potato Eaters*, Van Gogh sensitively captured the effects of the single oil lamp on the faces and hands of the figures and the architecture of the room. The steam rising from the platter of potatoes is highlighted in the downcast light and creates a halo around the dark silhouette of the girl in the foreground.[17] This relationship between dark foreground figure and light background is

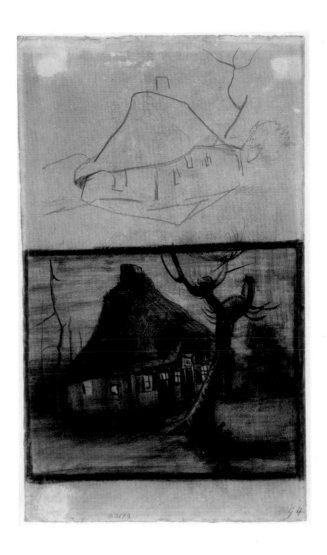

reversed on the left side of the composition, where the pronounced features of the man are brought into focus against the dark rear wall of the cottage, whose windows frame the night sky outside. The light of the lamp anchors the composition in the center of the canvas and unifies the seemingly alienated figures over the private family ritual. Their elliptical arrangement mimics the shape of the lamp's shield overhead.

On May 6, 1885, Van Gogh sent *The Potato Eaters* and ten painted studies to Theo in Paris.[18] By May 22, he was "working on a large study of a cottage in the evening."[19] A second shipment in early June contained two watercolors and thirteen paintings, among them *The Cottage* (ill. 73) and twelve painted studies, including several studies of heads and probably *Head of a Woman*.[20] Along with *The Potato Eaters*, Van Gogh considered *The Cottage* among his first mature works. He applied the same earth tones to both paintings. He most likely began *The Cottage* by laying down the sky in a pigment of gray-green, over which he painted the bright orange streak of a setting sun. In the center of the composition, the flicker of a fire in the hearth of the cottage is visible through an open window.

75

Vincent van Gogh

Recollection of Brabant. 1890

Van Gogh Museum,

Amsterdam

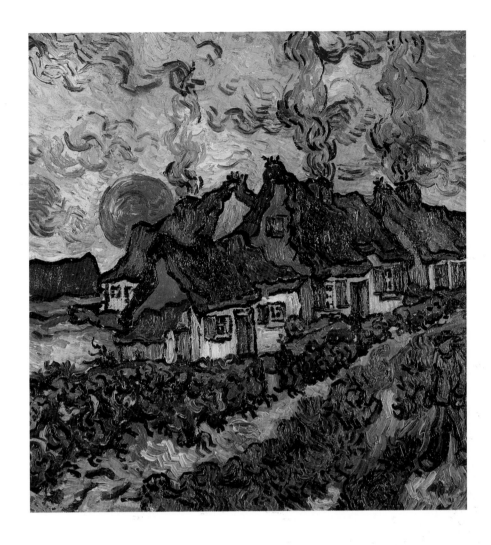

Van Gogh was always in search of unspoiled country life without industrial progress and pollution. Like the painters of the Barbizon School, such as Daubigny, Dupré, and Millet, he had a deep affection for huts and small, picturesque cottages. Two drawn studies of a cottage (ill. 74) reveal Van Gogh's ongoing fascination with this theme, which he returned to throughout his career. In 1890, in Saint-Rémy, during a spell of homesickness for Brabant, he considered another version of *The Cottage*, but it never materialized. Instead, he painted *Recollection of Brabant* and *Cottages and Setting Sun* (ills. 75 and 76). The latter work depicts a row of modest dwellings at dusk similar to the one in his earlier painting but executed in Van Gogh's late style, with a more vibrant palette and expressive brushwork. Arabesque threads of smoke waft into the air as the large red sun hangs heavy over the horizon. The strong upward diagonal of the landscape and row of cottages is offset by the counter-movement of the clouds in the sky. As in many of Van Gogh's night scenes, there are allusions to the cycles of life embodied by work and meager reprieve; one may imagine the man on the right trudging home to a warm hearth after a day of labor.

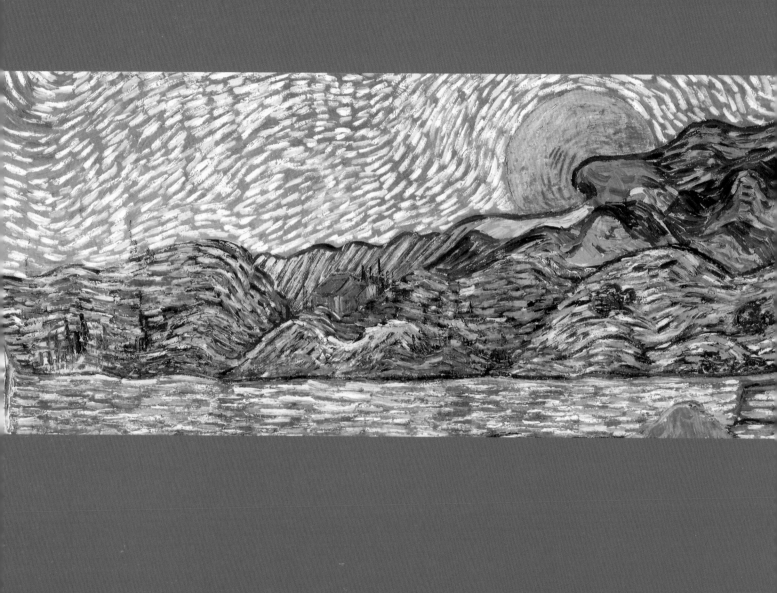

THE VOICE OF THE WHEAT: A NOCTURNE

Maite van Dijk

Evening and night landscapes had become such a popular subject over the course of the nineteenth century that the French critic Paul Desjardins made special mention of them in his review of the 1899 Salon. In "Les Heures, principalement du soir et de la nuit," he wrote that so many of these works had been submitted that it was almost impossible to keep count of them.[1] One of the pioneers of this trend was Millet, who had achieved almost mythical status as a "painter of peasants" following the success of his painting *The Sower* at the Salon of 1850 (see ill. 16). Millet had portrayed his sower as a dark, solitary figure against an atmospheric evening sky. Evening and night were favorite subjects of Millet's, but with *The Sower* in the dusk he introduced something new. Other artists, such as Jules Breton and Léon Lhermitte, followed Millet's example and also painted moody evening skies above fields of wheat and harvest scenes (ills. 77 and 78).

Van Gogh was another of Millet's admirers. In 1875 he attended a sale of almost three hundred paintings, drawings, and pastels by Millet in the Hôtel Drouot in Paris.[2] He described the experience to his brother Theo in these words: "When I entered the room . . . where they were exhibited, I felt something akin to: Put off thy shoes from off thy feet, for the place whereon thou standest is holy ground."[3]

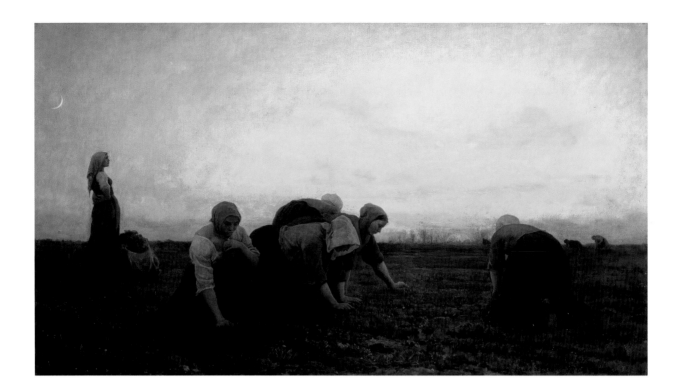

He recognized in Millet's work a deeply religious sense of nature, which Van Gogh described as "something on high."[4] He saw this sentiment expressed in Millet's scenes of rural labor, particularly in his *Sower* of 1850, which he had only seen a pastel of at the sale. Five years later, as an aspiring artist, Van Gogh copied an engraving of *The Sower*, and Millet's masterpiece would continue to "haunt" him for the rest of his life.[5]

The influence of Millet's painting can be seen in Van Gogh's earliest drawings, and he continued to work on the motif of the sower while living in The Hague in 1881–83. It was not until June 1888, however, by which time Van Gogh had moved to Arles in the South of France, that he felt confident enough to undertake a painted study of the subject.

Between June 17 and June 21 Van Gogh wrote Theo and the artists John Russell and Emile Bernard that he had embarked on a study of a sower (ill. 79).[6] It was harvest time and he had gone out into the fields to record the peasants at work. But *The Sower* is only partly taken from life; to some extent Van Gogh had to draw on his imagination since seed was sown only in November and February. Van Gogh regarded "combined" works like this, which he called "tableaux composés," as some of his most important paintings.[7]

It is clear from his letters that Van Gogh was chiefly concerned with the use of color in his *Sower*, and he sent Bernard a sketch with color notes (ill. 80). It was Van Gogh's first attempt to translate Millet's painting in color, and he hoped that this would modernize the subject: "For such a long time it's been my great desire to do a sower, but the desires I've had for a long time aren't always achieved. So I'm almost

(pages 114–15)
Detail of ill. 86
Vincent van Gogh
Landscape with Wheat Sheaves and Rising Moon. 1889
Kröller-Müller Museum, Otterlo

77
Jules Breton
The Weeders. 1868
The Metropolitan Museum of Art, New York

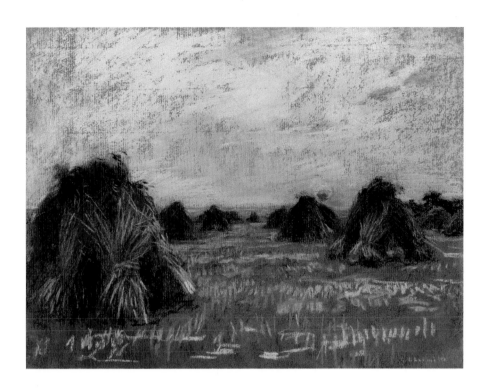

afraid of them. And yet, after Millet and Lhermitte what remains to be done is . . . the sower, with color and in a large format."[8] Van Gogh did indeed paint his sower on a large canvas in bright yellow and purple color contrasts. Emulating Millet, he placed the figure in a wheat field at sunset. With both artists, the association of sowing with the evening derived from their pantheistic view of nature. They saw the cycle of sowing and harvesting as a metaphor for the repetition of days, months, and seasons that reflects eternal life, "that infinite of which the Sower, the sheaf, are the symbols," as Van Gogh expressed it.[9] In *The Sower* Van Gogh used the transition from day to night to symbolize the cycle of existence: as dusk falls the sower sows the seed, so that it can ripen during the night and bring forth new life in the morning.

Van Gogh was not happy with the result, however, and tried to improve the work by painting in an even greater variety of color contrasts, adding a border in complementary colors, and changing the composition. Eventually he decided that his first attempt to paint a monumental sower had failed.[10] The subject continued to absorb him, and in November 1888 he made a second painting of a sower at dusk. This work did satisfy him (ill. 81).[11] Van Gogh had realized that color alone was not enough to modernize Millet's masterpiece. Encouraged by Paul Gauguin, who had been staying with him in Arles since October 1888, he started a bold, abstract version of the sower. As he had done in June, he painted the subject in the complementary colors of yellow and purple, but this time he also experimented with the form. Instead of constructing the scene from two horizontal planes as he had done in his first canvas, he painted a tree in the foreground to add complexity to the composition and make it more dynamic.

It was not only the evening setting but the figure of the sower himself that Van Gogh derived from Millet. The dark form with outstretched hand silhouetted against the dying rays of the sun embodies the words of the French critic Théophile Gautier: "Night is falling, casting a gray veil over the brown earth; the sower strides out with measured tread, tossing seed into the furrow . . . dressed in dark, ragged clothes, a strange sort of cap on his head; he is bony, haggard, and thin beneath this livery of poverty, and yet life is spread by his generous hand and, with a glorious gesture, he who has nothing scatters bread for the future on the land."[12] Van Gogh had read this description of Millet's *Sower* in Alfred Sensier's biography and repeatedly quoted Gautier in his letters.[13] Like Millet, Van Gogh painted the sower's "generous hand" to emphasize the life and the future he is sowing.

The metaphor of sowing is an important theme in the Bible. Van Gogh, the son of a minister, who had once wanted to enter the church himself, frequently referred to biblical texts in his letters, particularly in the years before he became an artist.[14] Nevertheless Van Gogh did not want to paint an explicitly religious work; through the expressive use of color, as in *The Sower* of June, he wanted to create a "symbolic language."[15] This time, Van Gogh was pleased with the result: he signed the canvas and sent it to his brother in Paris in the spring of 1889. He also made a second, smaller version, something he often did with paintings he regarded as successful (ill. 82).[16]

The cycle of sowing, ripening, and harvesting the wheat had a deep symbolic significance for Van Gogh. In a letter to his sister Wil he wrote: "What else can one

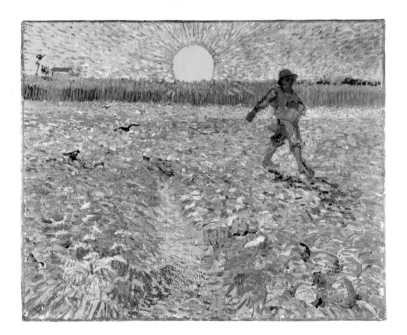

79
Vincent van Gogh
The Sower. 1888
Kröller-Müller Museum, Otterlo

80
Vincent van Gogh
Sketch of *The Sower* in a letter to Emile Bernard. c. June 19, 1888
The Pierpont Morgan Library, New York

mon cher Bernard Pardonne moi si j'écris bien à la hâte je crains
que ma lettre ne sera point lisible mais je veux te répondre tout de suite
Sais tu que nous avons été très bêtes Gauguin toi et moi de ne pas
aller dans un même endroit. Mais lorsque Gauguin est parti moi
j'étais pas encore sûr de pouvoir partir Et lorsque toi tu es parti
il y avait cet affreux argent du voyage et les mauvaises nouvelles
que j'avais a donner des frais ici que l'ont empêché. Si nous étions
parti tous ensemble vers ici cen'aurait pas été si bête car à trois
nous eussions fait le ménage chez nous. Et maintenant que je suis
un peu mieux orienté je commence a entrevoir des avantages ici
Pour moi je me porte mieux ici que dans le nord - je travaille même en
plein midi en plein soleil sans ombre aucune dans les champs de blé et
voilà j'en jouis comme une cigale. Mon dieu si à 25 ans
j'eusse connu ce pays au lieu d'y venir à 35 à cette époque
j'étais enthousiasmé pour le gris ou l'incolore plutôt

je rêvais toujours de millet et puis j'avais des connaissances en hollande
dans la catégorie de peintres mœurs idéels

Voici croquis d'un
Semeur.
Grand terrain de mottes
de terre labourées
franchement violet en
grande partie
Champs de blé mur d'un
ton d'ocre jaune avec un
peu de carmin
Le ciel jaune de chrome
presqu aussi clair que
le soleil lui même qui
est jaune de chrome avec
un peu de blanc tandis que
le reste du ciel est jaune
de chrome 1 et 2 mélangés
très jaune donc
La blouse du semeur est bleu
et son pantalon blanc
toile de 25 carrée

Jaune Jaune.
Jaune rompu vert 1 blanc
Jaune

il y a bien des rappels de jaune dans le terrain
des tons neutres résultantes du mélange du violet avec le jaune mais
je me suis un peu foutu de la vérité de la couleur. Je fais des images naïves
d'almanach plutôt - de vieil almanach de campagne ou la grêle
la neige la pluie le beau temps sont représentés d'une façon tout à fait
primitive. ainsi qu' Anquetin avait si bien trouvé sa moisson
Je ne te cache pas que je ne déteste pas la campagne — y ayant été
élevé des bouffées de souvenirs d'autrefois des aspirations vers cet infini
dont le Semeur la gerbe sont les Symboles m'enchantent encore comme
autrefois

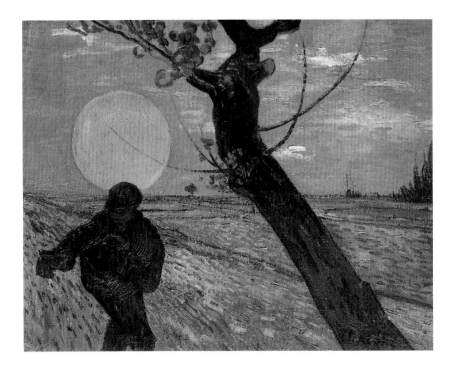

81
Vincent van Gogh
The Sower. 1888
Foundation E. G. Bührle
Collection, Zurich

82
Vincent van Gogh
The Sower. 1888
Van Gogh Museum,
Amsterdam

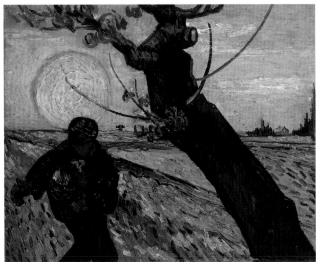

do, thinking of all the things whose reason one doesn't understand, but gaze upon the wheat fields. Their story is ours, for we who live on bread, are we not ourselves wheat to a considerable extent, at least ought we not to submit to growing, powerless to move, like a plant, relative to what our imagination sometimes desires, and to be reaped when we are ripe, as it is?"[17] Van Gogh contrasted the sower who gives life with the reaper who takes it away: "I then saw in this reaper—a vague figure struggling like a devil in the full heat of the day to reach the end of his toil—I then saw the image of death in it, in this sense that humanity would be the wheat being reaped. So if you like it's the opposite of that Sower I tried before."[18] Van Gogh made countless drawings and paintings of wheat fields and harvest themes. One of his earliest works featuring a

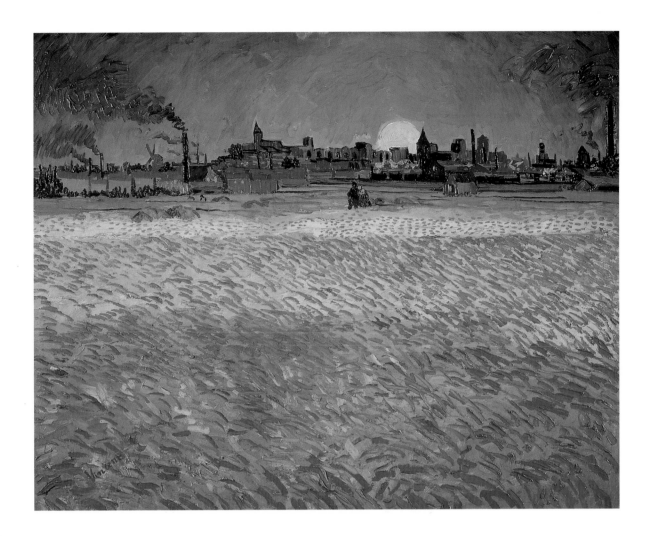

wheat field in the evening dates from July 1884: *The Old Tower at Dusk* is of the church in Nuenen, which Van Gogh depicted many times, with the setting sun (see ill. 58). In the foreground a solitary woman walks toward the church through the tall wheat.[19]

In 1885 Van Gogh left rural Brabant and went to live first in Antwerp and then in Paris. During these years he painted virtually no landscapes. In February 1888 he moved from Paris to Arles in the countryside of southern France, and wheat fields again became an important subject. As soon as the weather permitted, he went out into the fields to paint. In June 1888 Van Gogh worked on a series of fourteen canvases of the harvest and the wheat: "I've had a week of concentrated hard work in the wheat fields right out in the sun, the result was some studies of wheat fields, landscapes, and a sketch of a sower."[20] Van Gogh stressed in his letters that he had painted outdoors in the face of a fierce mistral. He drew a swift sketch in a letter to Emile Bernard to show how he had secured his easel by pegging it to the ground (ill. 84).[21] This was how he had managed to paint *Summer Evening near Arles* (ill. 83): "For example I've painted a no. 30 canvas—the summer evening—at a single sitting. It's not possible to rework it; to destroy it—why, because I deliberately went

mais quand donc ferai je le ciel étoilé ce tableau
qui toujours me préoccupe. — hélas hélas c'est bien
comme dit l'excellent copain Cyprien dans "en ménage" de
JK Huysmans : les plus beaux tableaux sont ceux que l'on rêve
en fumant des pipes dans son lit mais qu'on ne fait pas. S'agit
pourtant de les attaquer quelqu'incompétent qu'on se sente vis a vis
des ineffables perfections de splendeurs glorieuses de la nature.

mais comme je voudrais voir l'étude que tu as fait au bordel
je me fais des reproches à n'en pas finir de ne pas encore avoir fait
de figures ici

Voici encore
un paysage
Soleil couchant?
Lever de lune?
Soir d'été en
tout cas.
Ville violette
astre jaune
ciel bleu vert
les blés ont
tous les tons
Vieil or cuivre
or vert or rouge
or jaune
bronze jaune
vert rouge. toile de 30 carrée

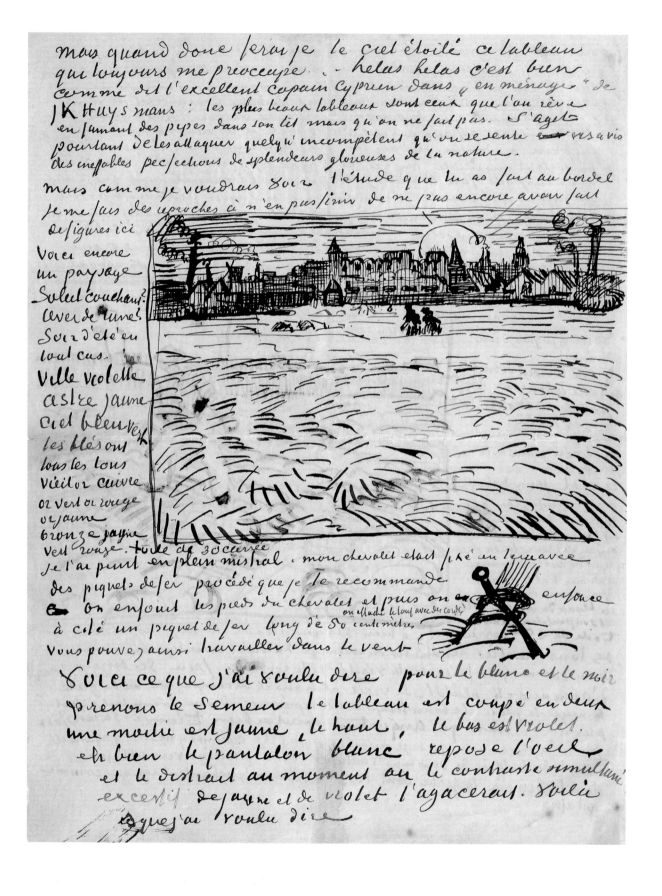

je l'ai peint en plein mistral. mon chevalet était fixé en terre avec
des piquets de fer procédé que je te recommande
on enfouit les pieds du chevalet et puis on enfonce
 on attache le tout avec des cordes
à coté un piquet de fer long de 50 centimètres.
vous pouvez ainsi travailler dans le vent

Voici ce que j'ai voulu dire pour le blanc et le noir
prenons le Semeur le tableau est coupé en deux
une moitié est jaune, le haut, le bas est violet.
eh bien le pantalon blanc repose l'oeil
et le distrait au moment où le contraste simultané
excessif de jaune et de violet l'agacerait. voila
ce que j'ai voulu dire

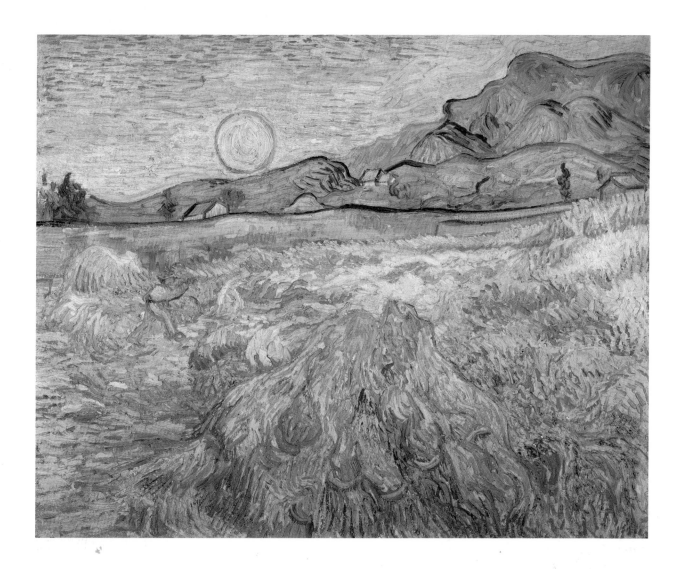

outside to make it, out in the mistral. Isn't it rather intensity of thought than calmness of touch that we're looking for?"[22] Although Van Gogh worked in the open and directly from nature, he did allow himself some artistic license: in the painting the sun sets in the southwest rather than in the west. By having the sun sink behind the Arles skyline, with its last rays lighting up the wheat, Van Gogh achieved an extraordinarily powerful composition. The sunset also adds a romantic cast to the scene as a whole, and this is reinforced by the couple, arm in arm, out for an evening stroll.[23]

Van Gogh regarded *Summer Evening near Arles* as an important painting: he signed the canvas and gave it a title, sent a sketch of it in a letter to Bernard (ill. 84), and made a drawing of the composition. Nevertheless he could not have been entirely satisfied with it since he reworked the canvas in September. Eventually he sent the painting to Bernard in October, in exchange for one of his works.

In the summer of 1889—by this time he had been admitted to the psychiatric hospital in Saint-Rémy—Van Gogh worked on a series of paintings of a walled field

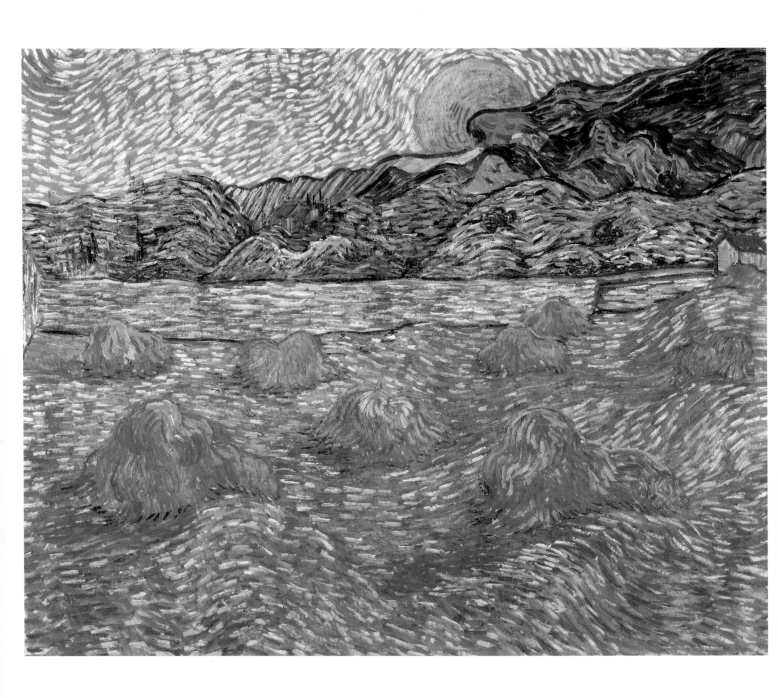

86

Vincent van Gogh

*Landscape with Wheat Sheaves
and Rising Moon.* 1889

Kröller-Müller Museum, Otterlo

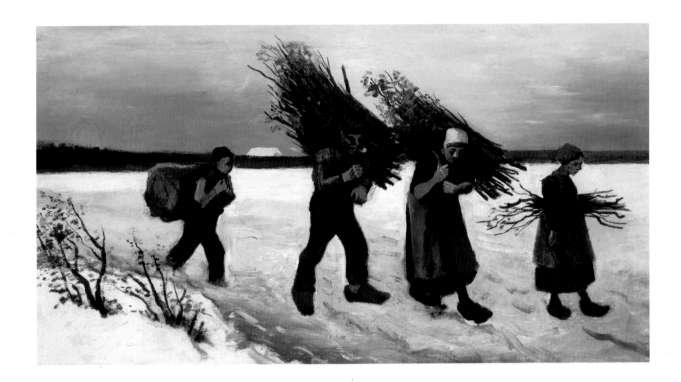

87

Vincent van Gogh

Wood Gatherers in the Snow.

1884

Private collection

that he could see from his room. *Landscape with Wheat Sheaves and Rising Moon* is a view of the wheat field and the foothills of the Alpilles by night (ill. 86). He painted the work in a studio he had set up in the hospital, and probably based the composition on the painting *Wheat Field with Reaper and Sun* (ill. 85). In *Landscape with Wheat Sheaves and Rising Moon* he tried to capture the particular effect of moonlight by adding small touches of pale pink paint all over the canvas. Sadly, these brushstrokes have faded over time to an unconvincing grayish white, so that it is no longer possible to see Van Gogh's intention.[24] A month earlier he had used a similar experimental technique in the painting *The Starry Night* (see ill. 54).[25] Van Gogh painted both works with short, individual strokes, bringing dynamic energy to the night.

Van Gogh painted his last wheat field by evening light, *The Weeders*, in the spring of 1890 (ill. 88). He had previously painted various snow effects, among them a scene with people gathering wood at sunset in 1884 (ill. 87).[26] Van Gogh used the same effect of a setting sun throwing a warm glow over the snow in *The Weeders*, in which he offset the cold tones of the snowy field with the red of the sinking sun in the sky and clouds. Van Gogh borrowed the women, bent double and digging in the frozen, snow-covered ground, from the figures in Millet's famous painting *The Gleaners* (ill. 89).[27]

Unlike other works after Millet that Van Gogh made while he was in Saint-Rémy, such as *The Four Hours of the Day* (see ills. 67 and 68), in this one he did not copy the painting literally. He not only improvised with the color, something he often did, but he also changed the image. He may have been inspired by a snow effect he had seen earlier that year: "Ah, while I was ill, damp, melting snow was falling,

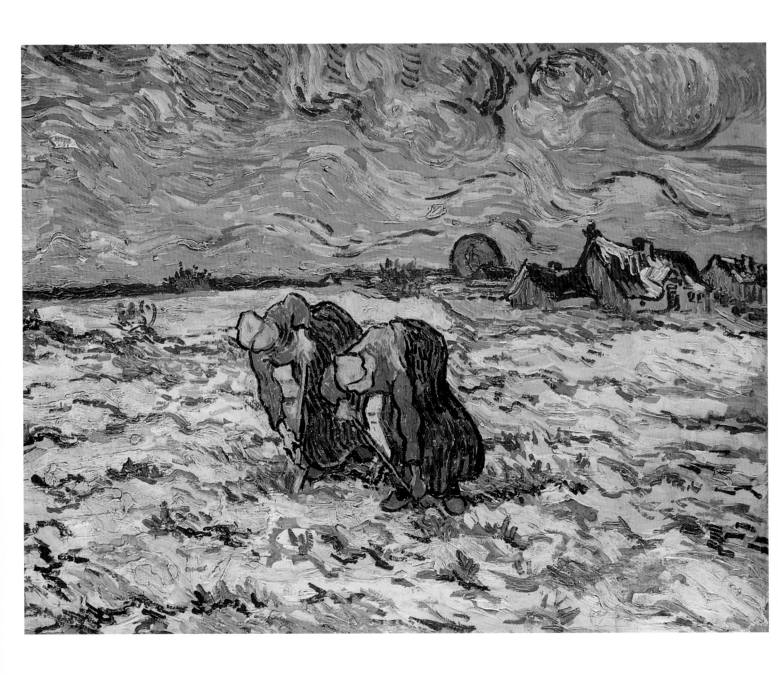

88

Vincent van Gogh

The Weeders. 1890

Foundation E. G. Bührle

Collection, Zurich

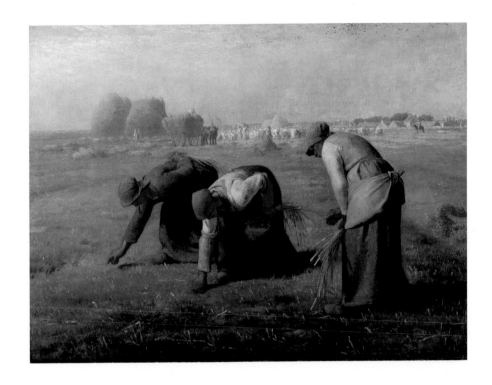

89
Jean-François Millet
The Gleaners. 1875
Musée d'Orsay, Paris

I got up in the night to look at the landscape—never, never has nature appeared so touching and so sensitive to me."[28] For reasons that remain unclear, Van Gogh had already associated *The Gleaners* with snow in 1882.[29] Van Gogh painted his personal interpretation of Millet's masterpiece with the "touching and so sensitive" impression of the setting sun on a snow-covered wheat field. Over a month later Van Gogh wrote Theo that he regarded Millet, along with Breton, as "the voice of the wheat."[30] He could have had no idea that, after his death, he himself would become world famous as the painter of wheat fields.

POETRY OF THE NIGHT

Maite van Dijk and Jennifer Field

In Van Gogh's oeuvre the poetry of the night was a recurrent theme from early on. During his three-month stay in the rural province of Drenthe in 1883, he was especially sensitive to the poetic atmosphere evoked by twilight. In his letters, he devoted many passages to describing these wonderful effects, and he skillfully conveyed them in several drawings (see ills. 56 and 57).[1] His father's parsonage and its garden in Nuenen had an explicitly lyrical meaning for Van Gogh—they set him "so to dreaming."[2] He first depicted them in his oeuvre during the winter of 1883, and in the following two years he explored the subject further in several drawings and paintings. In November 1885, Van Gogh painted his parents' home at dusk (ill. 90); the sun setting behind the parsonage, diffusing its last rays on the path in front of the house, gives the scene a poetic evening mood. Five years later he would depict a house in Auvers-sur-Oise by moonlight, evoking a similarly poetic atmosphere (ill. 91).

The night was a constant source of inspiration for Van Gogh, but in the summer of 1888 it truly became an obsession. In April of that year he had expressed his wish to paint a starry sky in letters to Theo and his friend Emile Bernard, and he reiterated this desire in June: "But when will I do the starry sky, then, that painting

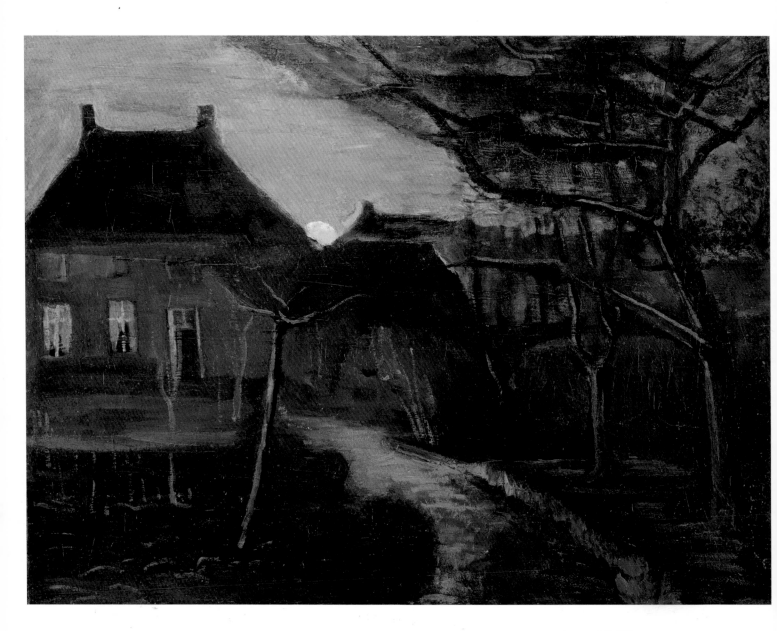

(pages 128–29)
Detail of ill. 100
Vincent van Gogh
The Garden of Saint Paul's Hospital.
1889
Van Gogh Museum, Amsterdam

90
Vincent van Gogh
The Parsonage at Nuenen at Dusk,
Seen from the Back. 1885
Private collection

that's always on my mind?"[3] The night proved to be a catalyst of philosophical, religious, and poetic thoughts for Van Gogh, and in his letters he associated the celestial sky with such qualities as infinity, faith, conviviality, and hope.[4] The subject of the poetry of the night was not unique to him; in countless nineteenth-century poems, books, and tales the night is characterized as a time for contemplation. Van Gogh read avidly and was well aware of this literary tradition. He cited several passages from contemporary writers such as Victor Hugo and the American poet Walt Whitman, in whose texts the night was a central concern. The French writer Alphonse Daudet epitomized the spirit of the night in his short tale *Les Etoiles*, with which Van Gogh was familiar: "If you have ever slept under the stars, you will know that a mysterious world awakens in solitude and silence as we lie sleeping."[5]

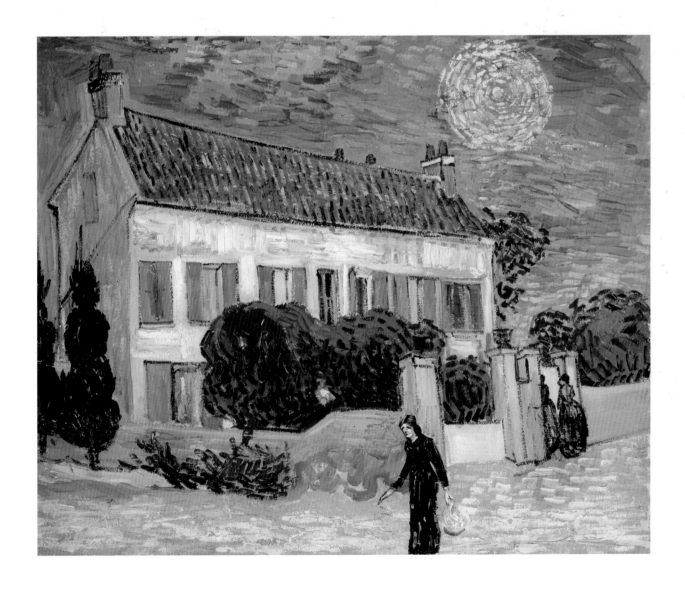

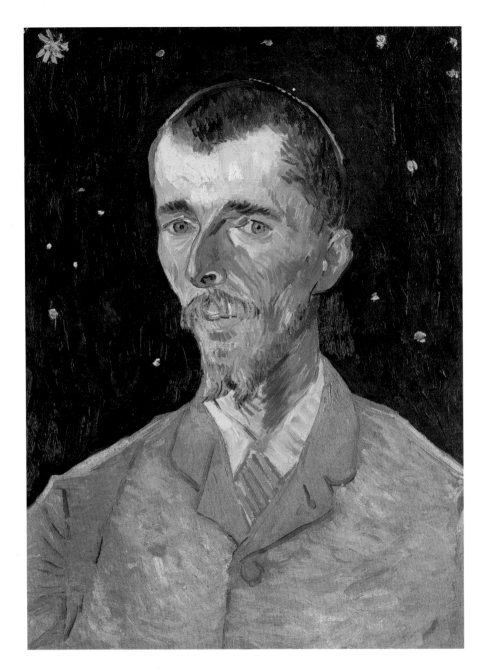

92

Vincent van Gogh

Eugène Boch (The Poet). 1888

Musée d'Orsay, Paris

Van Gogh's poetic associations with the evening and night are nowhere more evident than in his portrait of the Belgian artist Eugène Boch, which he aptly titled *The Poet* (ill. 92). In this painting Van Gogh immortalized his friend and fellow painter, "who dreams great dreams,"[6] against a rich blue background with twinkling stars. With this setting, he sought to evoke his ideal of a universal and eternal bond between all artists, connecting painting with poetry and music: "And in a painting I'd like to say something consoling, like a piece of music. I'd like to paint men or women with that *je ne sais quoi* of the eternal."[7] In *Eugène Boch* Van Gogh expressed his hope of an everlasting life for creativity, uniting all arts and artists, through the infinite stars.

93
Vincent van Gogh
Woman Reading a Novel. 1888
Private collection

(pages 132–33)
94
Vincent van Gogh
Gauguin's Chair. 1888
Van Gogh Museum,
Amsterdam

95
Vincent van Gogh
Van Gogh's Chair. 1888
The National Gallery, London

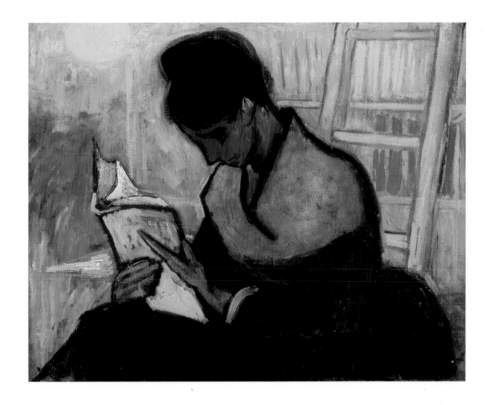

His idea for a brotherhood of artists came closer to realization in October 1888, when he was joined in Arles by Paul Gauguin, whom Van Gogh identified as a poetic painter like Boch. He sought to convey this sentiment in his nocturnal interior painting *Gauguin's Chair* (ill. 94), made in November of that year. The composition features a lit candle as a substitute for Gauguin, its flame echoed in the radiant light cast by the wall sconce in the background. "It is a study of his armchair of dark, red-brown wood," Van Gogh wrote, "the seat of greenish straw, and in the absent person's place a lighted candlestick and some modern novels . . . a memento of him."[8] The painting formed a pair with *Van Gogh's Chair* (ill. 95), a daytime scene in which Van Gogh, in a palette of blue-green and orange, substituted a pipe, tobacco pouch, and handkerchief for his own self. Van Gogh continued his interest in depicting interior night scenes in two other paintings done the same year: *The Dance Hall in Arles* (see ill. 33) and *Woman Reading a Novel* (ill. 93). Their flat planes of color framed in black outlines recall those of Japanese woodblock prints, which he collected and copied in admiration, and the style of *cloisonnisme* established by the Pont-Aven School of painters, including Anquetin, Bernard, and Gauguin.

For Van Gogh, the dark hours not only signified consolation and hope; he also recognized that the poetry of the night had a harsher side, and that during this time people could lose themselves. He expressed this sinister quality only once, in

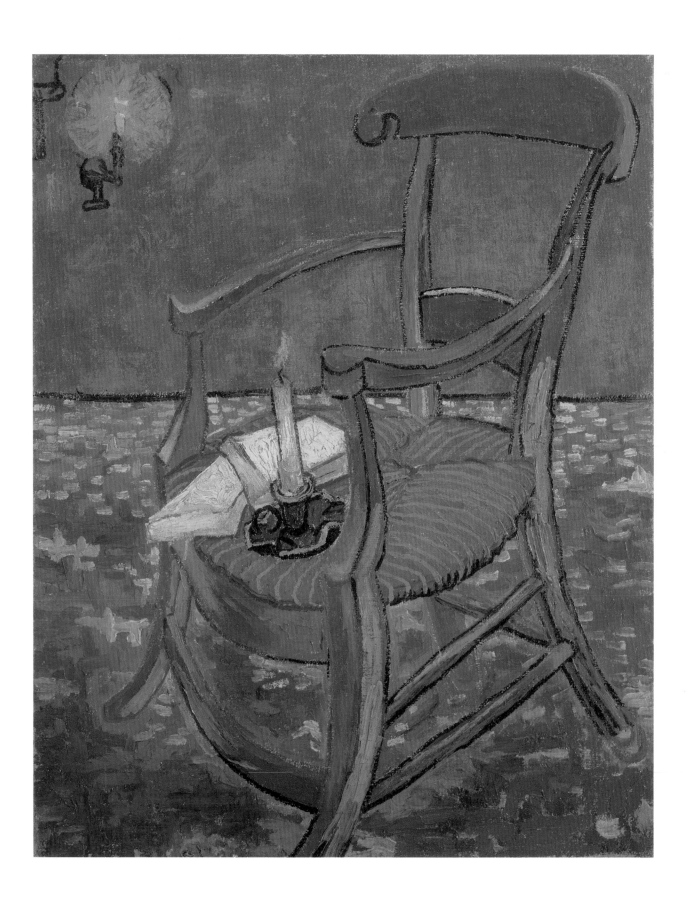

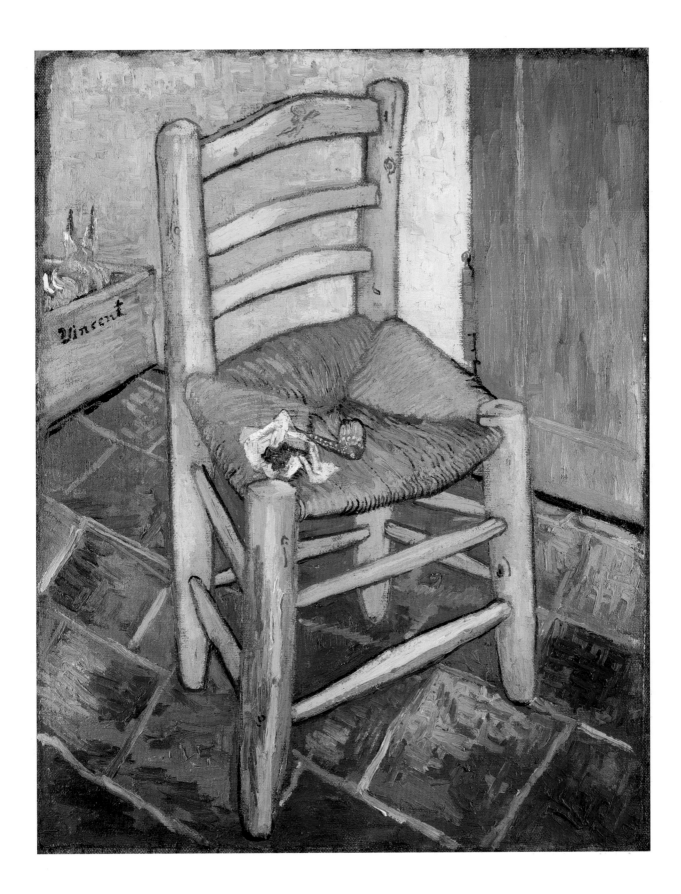

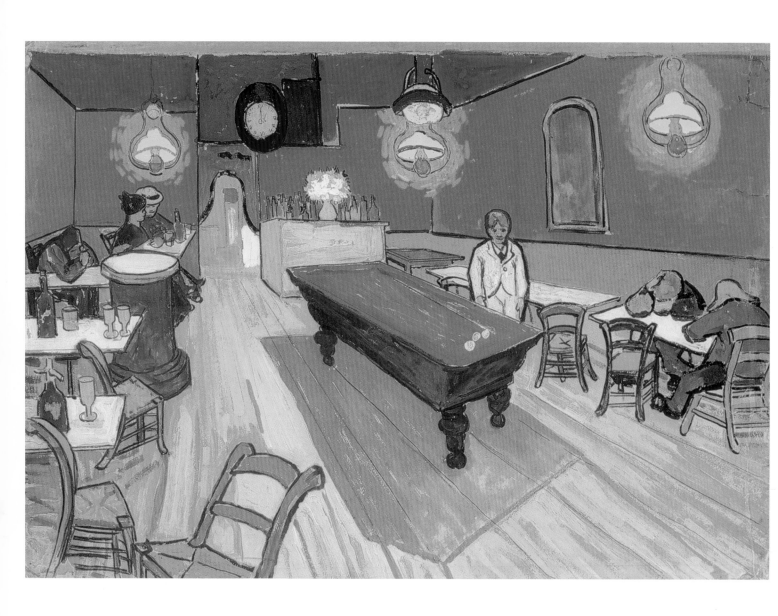

96

Vincent van Gogh

The Night Café. 1888

Private collection

The Night Café (see ill. 27). Only a few days after Van Gogh finished the portrait of Boch, he stayed awake for three consecutive nights, working in the Café de la Gare in Arles. For many years Van Gogh had been preoccupied with painting a nocturnal interior, which he first addressed in *The Potato Eaters* in 1885 (see ill. 69). He considered *The Night Café* a continuation of this earlier painting, since it was an equally ambitious rendering of a complex figure piece set in an interior at night. Both paintings depict a place where its occupants look for some comfort and peace; however, *The Night Café* was also a dangerous place "where you can ruin yourself, go mad, commit crimes."[9] Van Gogh expressed this sentiment through strong red and green complementary colors, offset with a harsh yellow; he sent Theo a gouache after the painting to give him an idea of the tones (ill. 96). The distorted perspective, emphasis on artificial light effects, and overall "ambience of a hellish furnace" were also meant to evoke "terrible human passions."[10]

A revealing letter to his sister Wil from September 1888 clarifies Van Gogh's artistic intentions during that prolific month. In it, he wrote that he had finished *Eugène Boch (The Poet)* and *The Night Café* and said, "I definitely want to paint a starry sky now."[11] He had expressed this desire several times since April of that year but had still not acted on it. Van Gogh felt that he could only paint from nature, and he did not know how he would be able to depict a starry sky unless he worked "at home and from the imagination."[12] But while writing to his sister, he suddenly realized how to achieve his painting of the starry night. He broke off his letter and continued it again after eight days, declaring that he had been interrupted by work on a new painting of a café terrace in the evening (see ill. 39). He confided: "I enormously enjoy painting on the spot at night. In the past they used to draw, and paint the picture from the drawing in the daytime. But I find that it suits me to paint the thing straightaway . . . it's the only way of getting away from the conventional black night."[13] He made a preliminary drawing as a compositional study (ill. 97), and returned to the site to paint the effects of light and color at night.

Van Gogh knew that he had made a revolutionary decision by painting the night directly on the spot, and reported his discovery to Theo that same day.[14] It is not clear what made him grasp the possibility of working *en plein air* at night. The artist only named *Bel Ami*, his favorite book by Guy de Maupassant, which he had reread that summer, as a source of inspiration.[15] It is possible that Van Gogh's recent, successful attempt at a nighttime interior had encouraged him to paint a gas- and starlit exterior scene. Although his original intention to paint a starry sky above cypresses or a ripe wheat field was not feasible, since it would be too dark to work outdoors, he realized that under the gas lamps of the café terrace he would be able to paint at night.[16]

Van Gogh was apparently emboldened by the result of his nocturnal practice, as only twelve nights later he painted *The Starry Night over the Rhône* (see ill. 1). He made a point of emphasizing to Boch that it was painted on location at night, as were *The Night Café* and *Terrace of a Café at Night (Place du Forum).*[17] This time, Van Gogh moved even further outdoors, setting up his easel on the riverbank, where the gaslight of Arles, though distant, still provided sufficient light by which to paint. He combined the complex light effects and reflections of gas- and starlight into a compelling representation of the infinite night sky. He described *The Starry Night over the Rhône* as one of his "poetic subjects,"[18] an impression enhanced by the amorous couple walking in the foreground. Strolling lovers were a recurrent motif in Van Gogh's oeuvre; in four other paintings he depicted couples at night to convey a romantic and evocative mood (ills. 98, 99, 103, and 104).[19]

In May 1889 Van Gogh admitted himself to the asylum of St.-Paul-de-Mausole in Saint-Rémy. He continued to paint the surrounding countryside at various times of day from within these confines, working from views through the window of his room or in the garden of the hospital. He painted two versions of *The Garden of Saint Paul's Hospital* (ills. 100 and 101), in which "The sky is reflected yellow in a puddle after the rain. A ray of sun—the last glimmer—exalts the dark ocher to orange—small dark figures prowl here and there between the trunks."[20]

In early June Van Gogh began to venture out of the hospital and into the surrounding countryside, where he painted *Olive Grove* (ill. 102), which depicts olive trees bathed in the warm glow of the setting sun. This painting reveals Van Gogh's spiritual connection to the earth. As he wrote

100
Vincent van Gogh
The Garden of Saint Paul's Hospital. 1889
Van Gogh Museum,
Amsterdam

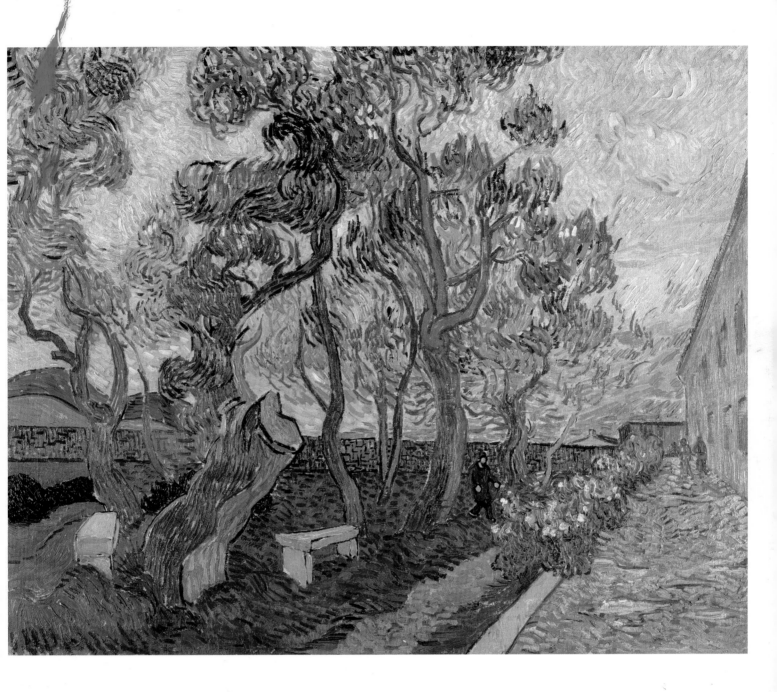

101
Vincent van Gogh
The Garden of Saint Paul's Hospital. 1889
Museum Folkwang, Essen

102

Vincent van Gogh

Olive Grove. 1889

Göteborgs Konstmuseum

to Theo: "the murmur of an olive grove has something very intimate, immensely old about it. It's too beautiful for me to dare paint it or be able to form an idea of it."[21] The subject also has roots in Van Gogh's religious background, as he referred to the biblical story of Christ in the Garden of Olives in three separate letters.[22] In September 1888, he had written to Theo, "For the second time I've scraped off a study of a Christ with the angel in the Garden of Olives. Because here I see real olive trees. But I can't, or rather, I don't wish, to paint it without models. But I have it in my mind with color—the starry night, the figure of Christ blue, the strongest blues, and the angel broken lemon yellow. And all the purples from a blood-red purple to ash in the landscape."[23] This work was never realized, and ultimately Van Gogh abandoned the challenge of painting the figure of Christ from imagination, preferring instead to capture the emotion of the subject through nature.

Van Gogh's interest in working from both nature and his imagination fused in several significant nocturnal compositions from 1889 and 1890, including *The Evening Walk* and *Country Road in Provence by Night* (ills. 103 and 104), which feature familiar motifs such as olive and cypress trees and couples walking arm-in-arm in the moonlight.[24] After leaving Saint-Rémy for Auvers-sur-Oise in June 1890, he wrote to Gauguin about the latter painting:

> I also have a cypress with a star from down there. . . . A last try—a night sky with a moon without brightness, the slender crescent barely emerging from the opaque projected shadow of the earth—a star with exaggerated brightness, if you like, a soft brightness of pink and green in the ultramarine sky where clouds run. Below, a road bordered by tall yellow canes behind which are the blue low Alpilles, an old inn with orange lighted windows, and a very tall cypress, very straight, very dark.[25]

Van Gogh began *The Starry Night* (ill. 105) in mid-June 1889. While he had seized the challenge of painting night scenes out of doors in his previous works *Terrace of a Café at Night (Place du Forum)* and *The Starry Night over the Rhône*, in both these paintings he had relied at least to some extent on artificial light to illuminate his subject and his environment. His focus in *The Starry Night*, however, was an imaginative, awe-inspiring nightscape above a diminutive town, illuminated only by the stars and moon overhead. In a letter to Bernard from April 1888, Van Gogh had declared, "Certainly—imagination is a capacity that must be developed, and only that enables us to create a more exalting and consoling nature than what just a glance at reality (which we perceive changing, passing quickly like lightning) allows us to perceive. A starry sky, for example, well—it's a thing that I'd like to try to do."[26]

By the late nineteenth century, depictions of the night sky had become increasingly popular. Millet, whom Van Gogh so greatly admired, wrote, "If only you knew how beautiful the night is! There are times when I hurry out of doors at nightfall . . . and I always come in overwhelmed. The calm and the grandeur of it

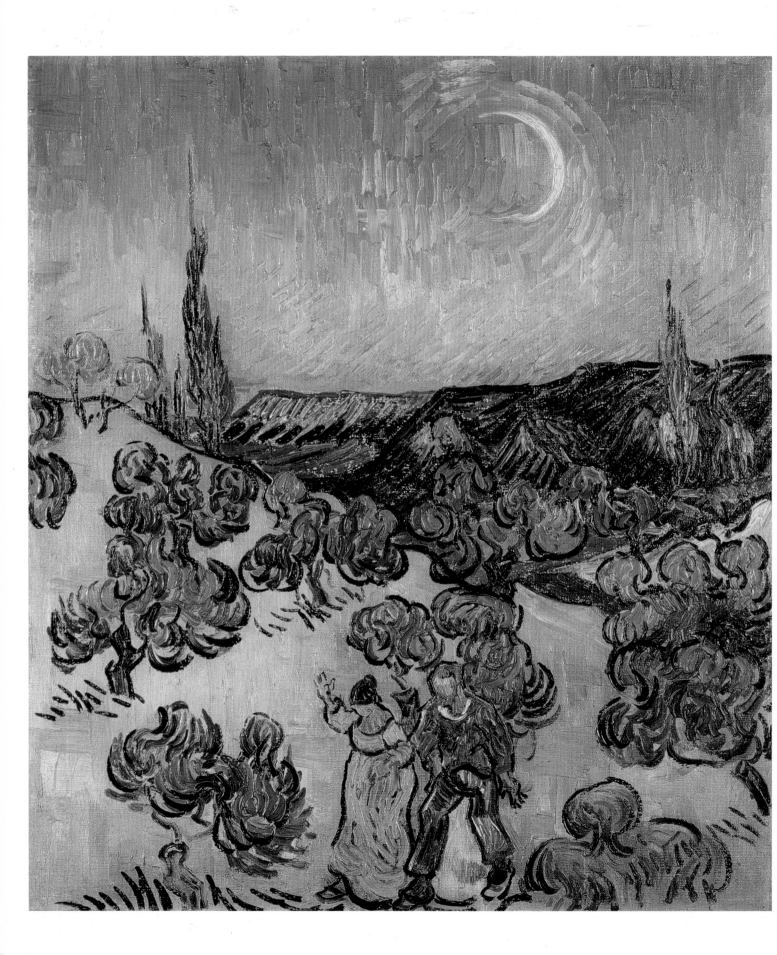

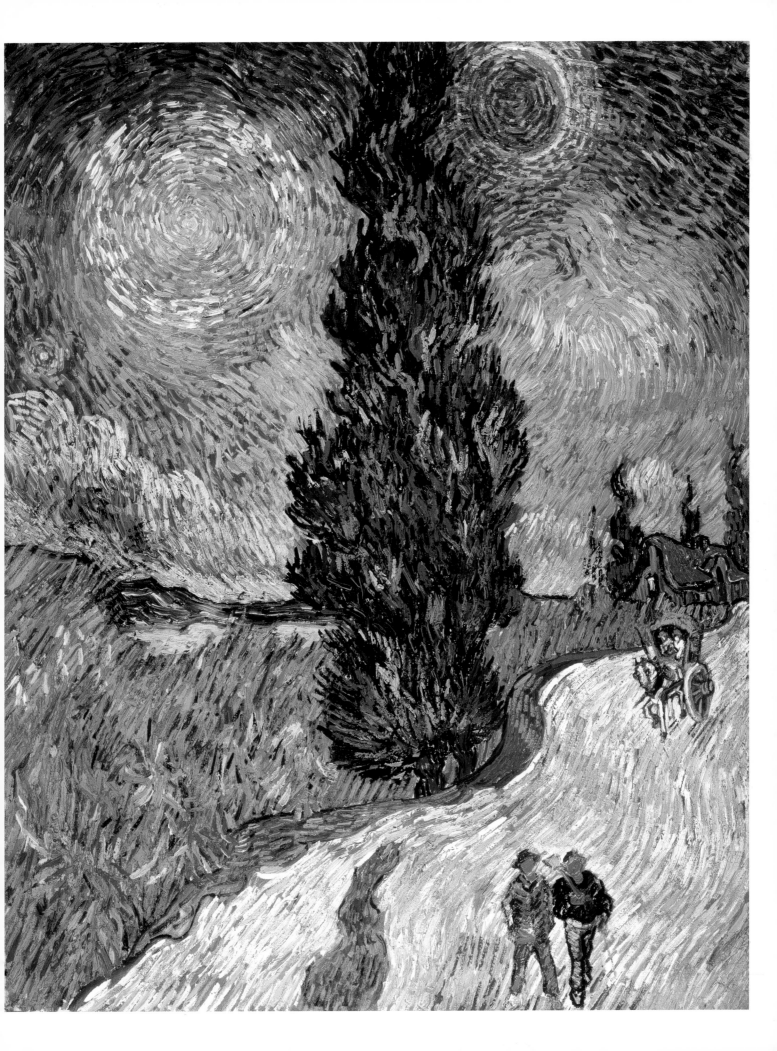

are so awesome that I find I feel actually afraid."[27] Millet had painted a starry night around 1851 (see ill. 32), which Van Gogh may have seen while working at Goupil & Cie between 1873 and 1876. As it did for Millet, the star-filled sky had spiritual significance for Van Gogh. In September 1888 he wrote of "having a tremendous need for, shall I say the word—for religion—so I go outside at night to paint the stars, and I always dream a painting like that."[28] In its composition, *The Starry Night* may be seen as relating to the low horizons typical of Dutch landscape paintings by Baroque artists such as Jacob van Ruisdael, while its meaning carries on the Romantic tradition of the sublime and spiritual in nature. This subject was explored by Whitman, whose "visionary excitement, . . . expansive, bursting energy, and absorption in swift cosmic rhythms" evoke Van Gogh's exterior night scenes, especially *The Starry Night*.[29]

The small village in *The Starry Night*, painted in jewel tones and nestled among the Alpilles, was inspired by the town of Saint-Rémy.[30] The dark cypress trees in the foreground and the swirling astral sky overhead, however, were brought forth from Van Gogh's imagination and his belief in the symbolic properties of color and certain elements of nature; the cypress and the stars, for example, traditionally symbolize eternity. Furthermore, it is known that the moon at the time Van Gogh created *The Starry Night* was a gibbous moon, in the phase between a full moon and a half-moon, and not a crescent as the artist painted it. These flights of imagination reveal the liberties he took with his subject and his obsession with conveying through expressionistic paint handling "nature's rich and magnificent aspects."[31] In his last works Van Gogh had finally found, through the material act of painting, a means of expressing the spiritual qualities of nature.

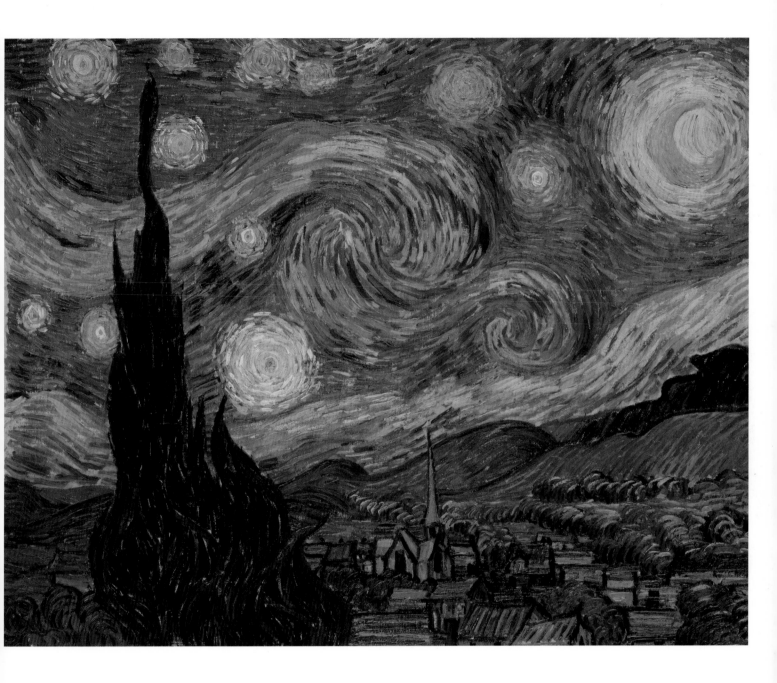

105

Vincent van Gogh

The Starry Night. 1889

The Museum of Modern Art,

New York

NOTES

For the quotations from Van Gogh's letters, the authors have relied on new translations, as yet unpublished, made by the translators for the Van Gogh Letters Project, who have worked from new transcriptions of the Dutch and French letters. The Van Gogh letters have two reference numbers. The first refers to *De Brieven van Vincent van Gogh*, ed. Han van Crimpen and Monique Berends-Albert, 4 vols. (The Hague, 1990); the second refers to *The Complete Letters of Vincent van Gogh*, 3 vols. (Greenwich, Connecticut, 1958).

INTRODUCTION

1 Letter 679/533.
2 This poem is discussed at length on pp. 55–56 in this book.

VAN GOGH AND THE PICTORIAL GENRE OF EVENING AND NIGHT SCENES

I want to thank especially Hans Luijten, Leo Jansen, and Nienke Bakker, editors of the new scholarly edition of Van Gogh's correspondence, scheduled for publication in 2009, for sharing their research results with me. Hans Luijten, Maite van Dijk, Suzanne Bogman, and Aggie Langedijk carefully reviewed the manuscript.

1 Letter 680/534.
2 Ekirch 2005, pp. 11–12.
3 Letter 674/W8. For the literary sources to which Van Gogh refers in regard to evening and night, see the essays by Joachim Pissarro and by Jennifer Field and Maite van Dijk in this book, and Van der Veen 2007, pp. 207–12.
4 Thomson 1994, p. 109.
5 Van Tilborgh and Salé 1998, pp. 114–19.
6 Letter 679/533.
7 For Van Gogh and graphic art see Stolwijk et al. 2003, pp. 99–112.
8 Letter 245/213.
9 Letter 361/R38.
10 Letter 278/R16.
11 See Stolwijk et al. 2003, pp. 123–32.
12 Letter 304/R23.
13 Van Gogh's collection of Japanese woodcuts is described in detail in Van Rappard-Boon et al. 2006, p. 95 (cat. 84) and p. 106 (cat. 107).
14 Letter 656/516.
15 Letter 81/67.
16 Letter 835/620.
17 For Van Gogh's ideas about landscape painting see Stolwijk et al. 2003, pp. 25–36 and 133–34.
18 Examples of this type of composition were much fewer than those of other landscape genres. For this development see Stechow 1966, pp. 171–82, and Waiboer 2005, pp. 9–34.
19 Waiboer 2005, p. 10.
20 Letter 130/110.
21 Letter 824/B21. For the description of this painting in Van Gogh's correspondence see Jansen, Luijten, and Bakker 2007, pp. 352–54, ill. 115.
22 Letter 101/84.
23 For a description of Cuyp's painting see Wheelock 2002, pp. 162–63. Van Gogh refers to the copy in letters 538/427 and 542/431.
24 Letter 372/307.

25 Letter 363/299. The idea is treated in depth in Burmester, Heilmann, and Zimmermann 1999, pp. 18–39.
26 Letter 561/450.
27 Letter 259/226.
28 Letter 363/299.
29 Letters 372/307 and 407/340.
30 Letter 613/489.
31 Letter 801/604.
32 Letter 290/248.
33 Letter 389/324. Van Gogh saw the painting at an exhibition in The Hague in 1882.
34 Letter 540/429. Sjraar van Heugten deals at length with Delacroix's example in his essay in this book.
35 In the last quarter of the nineteenth century Goupil distributed the work of the painters of the Barbizon and Hague Schools on an international scale.
36 The example of the Barbizon School artists and their empathy with and portrayal of the landscape provided a solid foundation for this. For the peasant genre see, e.g., Welker and Stratford 2006, pp. 15–30, and for Van Gogh see Stolwijk et al. 2003, pp. 87–98.
37 Letters 529/R57 and 522/418.
38 Letter 878/614a. For the "voice of the wheat" see the essay by Maite van Dijk in this book.
39 Breton's work is discussed in depth in Bourrut-Lacouture 2002.
40 Letter 34/27.
41 Letter 496/400. For Van Gogh and Millet see especially Van Tilborgh and Salé 1998.
42 Letters 467/378 and 857/W20.
43 A recent publication on this subject is Kosinski 2006, pp. 11–21.
44 Letter 843/W19.
45 See also p. 101 in this book.
46 Letter 157/136.
47 Letter 210/181. For this work see Dekkers 2000, cat. 36, pp. 201–3.
48 Letters 553/442 and 245/213. Van Gogh became acquainted with Rembrandt's work at an early stage and saw and studied it in various collections. He had seen the *Lamentation for Christ* (1650), then attributed to Rembrandt, in the Royal Academy in London; *Supper at Emmaus* (1646) in the Louvre in Paris; and *The Night Watch* (1642), *The Syndics of the Clothmakers' Guild* (1662), and the *Jewish Bride* (c. 1666) in the Trippenhuis in Amsterdam. See also Hecht 2006.
49 Letter 119/100.
50 Letter 132/112.
51 Letter 786/597.
52 Letter 245/213.
53 Gerrit Dou (1613–1675) was a Dutch Baroque artist who studied under Rembrandt. Petrus van Schendel (1806–1870) was born near Breda, and spent many years in Holland before finally settling in Brussels in 1845. He is best known for his night market scenes.
54 Letter 499/402.
55 Letter 635/B8. This is Eugène Delacroix, *Christ Asleep during the Tempest*, c. 1853, The Metropolitan Museum of Art, New York, Bequest of Mrs. H. O. Havemeyer, 1929, The H. O. Havemeyer Collection.
56 Letter 591/471.
57 Letter 572/459a.
58 Letter 617/492.

59 Van Gogh did not see the actual painting, but he knew the work from descriptions by Theo, who organized an exhibition in his gallery at 19, boulevard Montmartre in June–July 1888. Ten paintings by Monet, executed in Antibes that spring, were on exhibit. Theo sold this work to Paul Aubry on June 29, 1888, for 2800 francs.
60 Letter 623/500.
61 See, e.g., Moffett 1986, p. 462, where a review by Alfred Paulet of June 5, 1886, is published.
62 Herbert 1991, pp. 247–48, cat. 166.
63 See especially Cate and Shaw 1996.
64 Letter 699 [553a/544a]. See for *Circus Parade:* Herbert 1991, pp. 305–12, cat. 200.
65 Theo van Gogh bought the sheet for his collection in 1888. He paid 16 francs for it. See Herbert 1991, p. 297, cat. 193, and Stolwijk and Thomson 1999, pp. 178–79.
66 Frèches-Thory, Roquebert, and Thomson 1992, pp. 225–30.
67 Letter 800/T16: "Now I must also tell you that the Independents' exhibition is open and that in it there are your two paintings, The Irises and The Starry Night. . . There are some Lautrecs which look very well, among them a Ball at the Moulin de la Galette which is very good."
68 Letter 702/B19.
69 Letter 721/B19a.
70 Druick and Zegers 2001, p. 190.
71 Letter 722/559.
72 Letter 784/595.
73 See, e.g., letter 784/595: "However, by going the way of Delacroix, more than it seems, by color and a more determined drawing than *trompe l'oeil* precision, one might express a country nature that is purer than the suburbs, the bars of Paris. One might try to paint human beings who are also more serene and purer than Daumier had before him. But of course following Daumier in the drawing of it."
74 Letter 855/626.

THE FORMATION OF CREPUSCULAR AND NOCTURNAL THEMES IN VAN GOGH'S EARLY WRITINGS

My writing on this subject owes a great debt to Maite van Dijk, who has helped in critical ways to unearth seldom-published material and thus measure the depth of Van Gogh's immersion in the literary world. I am indebted to her for her knowledge of Van Gogh and her superb research skills. From the inception of this project to its conclusion, Jennifer Field has, with her characteristic love of perfection, attended to every organizational detail related to this exhibition and its catalogue: I am very thankful for having had the privilege of working with her on this project.

1 I refer to Van Gogh's writings in general, rather than his correspondence specifically, because, as I argue later, he carried on a literary life that went beyond his epistolary efforts. The extent of the artist's passion for, and erudition in, contemporary literature (both fiction and poetry, and in several languages) cannot be overemphasized. Most French (or German) literary critics of the time would have had a hard time comparing Friedrich Rückert's poem "Um Mitternacht" to Alfred de Musset's "Les Nuits," but this type of analysis seemed to come naturally to Van Gogh. His engagement with

literature contributed greatly, in my opinion, to the artist's acute interest in his own writing (and, most likely, his painting as well), whether this consisted of writing letters or copying, and sometimes commenting on, poetry by a wide range of authors. Whether describing his own visual works or the literary works of others, Van Gogh was superbly at ease with the written word. See for Van Gogh and literature: Sund 1992, Jansen 2003, and Van der Veen 2007.
2 Letter 681/W7.
3 Anton Kerssemakers, "Reminiscences of Vincent van Gogh," *De Amsterdammer*, April 14 and 21, 1912. Quoted in Stein 1986, pp. 53–54.
4 Letter 119/100.
5 This is discussed at length in the essay by Chris Stolwijk in this book.
6 Among the paintings by Rembrandt that Van Gogh would have known, the following works represent nocturnal themes: *The Night Watch* (c. 1639–42), *The Holy Family* (1640), *Supper at Emmaus* (1648), and *Evangelist Matthew and the Angel* (1661). During his 1873 and 1877 visits to the Trippenhuis, he saw the important print *The Flight into Egypt* (1651). See also pp. 28–29 in this book. In letter 119/100, Van Gogh directly compares his own experience of twilight with how older masters captured it: "I can't tell you how beautiful it was there in the twilight. Rembrandt, Michel, and others have painted it, the ground dark, the sky still lit by the glow of the sun, already gone down, the row of houses and towers standing out above, the lights in the windows everywhere, everything reflected in the water. And the people and carriages like small black figures everywhere."
7 This was *The Holy Family at Night* (1638–40), then on view at the Rijksmuseum.
8 For a discussion of the wheat fields by night, see the essay by Maite van Dijk in this book.
9 "I enormously enjoy painting on the spot at night" (letter 681/W7).
10 The night paintings of Van Gogh's contemporaries are discussed in the essay by Chris Stolwijk in this book.
11 Letter 147/126 to Theo, dated November 13, 15, or 16, 1878. I am grateful to Maite van Dijk for bringing this letter to my attention.
12 As we will see, Van Gogh had begun to think about nocturnal themes from a literary perspective much earlier, long before he thought about them from a visual perspective.
13 Letter 147/126.
14 The letter opens with this sentence: "On the evening of the day we spent together, which for me passed as if in a twinkling, I want to write to you after all." This offers one of the first clues of the function of the night in Van Gogh's creative system: a time to ponder, to think back on the events of the day.
15 Luke 13:6–9.
16 Only one sermon written by Van Gogh has survived; see letter 95/79, Friday, November 3, 1876. I am grateful to Sjraar van Heugten for this information.
17 I am indebted to Christopher Hudson for sharing his epistemological knowledge of the Gospels.
18 Letter 119/100.
19 I do not believe that one can readily draw a symbolic link between the biblical metaphors Van Gogh is so adept with, and so fond of, and

his own poetic and pictorial imagination. I think the relationship is more like an analogy or an allegory than a symbolic connection.
20 Letter 161/140, January 1881.
21 Letter 258/225.
22 This painting is unknown.
23 The most extreme example of this cliché can be found in Robert Altman's film *Vincent and Theo*, in which Van Gogh is seen gorging on whole tubes of paint.
24 The Van Gogh Museum has undertaken the colossal task of producing a complete, multilingual version of the artist's letters, annotated by Leo Jansen, Hans Luijten, and Nienke Bakker. This enormous project is scheduled to be published in autumn 2009.
25 Two of these albums are in the collection of the Van Gogh Museum: Poetry Album I for Theo van Gogh (inventory number b1472V/1962), and Poetry Album II for Theo van Gogh (inventory number b3049V/1984). The third, Poetry Album I for Matthijs Maris, is in the collection of the Teylers Museum in Haarlem. Fieke Pabst published and described these albums for the first time in 1988: Pabst 1988.
26 Letters 39/32 and 730/564.
27 Van Gogh was particularly keen on Heine's and Uhland's poetry, although he concluded his assessment of their work in one letter on a definitely negative note as he wrote that it is "rather dangerous stuff—[it creates] an illusion that does not last long" (letter 61/49).
28 Letters 38/31, 39/32, 41/34, 46/37, and 130/110. Van Gogh compares Rückert to Musset in letter 39/32.
29 My profound thanks to Maite van Dijk for her essential contribution on this topic. Van Beers (1821–1888) was a Belgian poet, popular in the Netherlands for his romantic/realist vein of poetry. He is sometimes compared to Longfellow, although, to my knowledge, there is presently no translation of his work available in English. Van Gogh refers to "The Evening Hour" several times in his correspondence (letters 10/9a, 11/10, and 71/57), and was evidently quite moved by the language the poet used to evoke the spiritual mood that surrounds the sunset.
30 Letter 10/9a. The following excerpts from Van Beers's poem are quoted from this letter.
31 "The clouds stayed red long after the sun had set and the dusk had settled over the fields; and in the distance we saw the lamps lit in the village" (letter 92/76).
32 Souvestre 1867. The book is divided into twelve chapters, each dedicated to a particular day within the given month.
33 Letter 92/76.
34 Conscience 1864.
35 Letter 144/123. Ill. 40 is a sketch from this letter.
36 Letter 642/506.

THE COLORS OF THE NIGHT

1 Letter 597/B3.
2 Research of this kind is a major part of the work of the Van Gogh Museum. Last year saw the publication of the fourth and last volume of the catalogue of Van Gogh's drawings, which focused on the technical aspects of his draftsmanship. The second volume of the three-volume catalogue of Van Gogh's

paintings in the Van Gogh Museum will appear in 2009, and will contain in-depth technical analyses of his Paris paintings. At the same time there is a major ongoing project in the Van Gogh Museum devoted to Van Gogh's studio practices, seen against the backdrop of those of his contemporaries. This will culminate in a publication and exhibition in 2011.
3 Letter 488/395.
4 Blanc 1867, chapter 12, pp. 582–94, of the "Peinture" section is devoted to chiaroscuro. Blanc was director of fine arts in France in 1848 and again in 1872–73. He was also the founder of the *Gazette des beaux-arts*.
5 Blanc 1867, pp. 587–88.
6 Blanc 1867, pp. 591–93; the illustration on p. 592.
7 A *repoussoir* is an element of the composition placed in the foreground that lends depth to the rest of the picture by seeming to push backward.
8 The painting was examined in the conservation studio at the Van Gogh Museum. My thanks to Devi Ormond, who helped me to better understand the technical aspects and took the detailed photographs.
9 The pigment was not chemically analyzed, but under ultraviolet light it revealed the dark shade that indicates Prussian blue underneath.
10 See also p. 109 in this book.
11 Blanc 1867, pp. 594–610; Blanc 1876, pp. 25–88; Gigoux 1885, pp. 64–83. Van Gogh read more about Delacroix in Silvestre 1864.
12 For the development of Van Gogh's colorist insights see my essay in Stolwijk et al. 2003, pp. 123–32.
13 Letter 630/B7.
14 Letter 633/W4.
15 Letter 501/404.
16 Letters 606/482, 667/525, and 771/59.
17 Letter 630/B7.
18 See also the essay by Maite van Dijk in this book.
19 See Ten Berge, Van Kooten, and Rijnders 2003, p. 234, for the complex structure of the paint skin.
20 F573a / JH1596 and F494 / JH1617 respectively.
21 Pickvance 1984, cat. nos. 128, 129. I took that view in Conisbee, Van Heugten, and Van Tilborgh 1988, cat. nos. 75, 76.
22 Druick and Zegers 2001, p. 217. See also Gloor et al. 2004, pp. 52–54.
23 My thanks to Lukas Gloor, who alllowed me to study the painting in the gallery, and to my colleague Frans Stive, who was extremely helpful during this process.
24 The possibility that the image was painted over an earlier picture cannot be entirely ruled out, but Van Gogh did this so rarely in the work he completed in the South of France that it does not seem likely. There is no X-ray of the work. When the exhibition closes, the painting will undergo further technical examination in the Van Gogh Museum; it is to be hoped that a definite judgment can then be made.
25 Letter 679/533.
26 Letter 680/534.
27 Letter 660/518.
28 Letter 697/533.
29 Blanc 1867, pp. 602–3.
30 Letter 802/605.
31 Letter 806/607.

32 Letter 815/T19.
33 Letter 598/476.
34 Letter 806/607.
35 The painting underwent close examination in the restoration workshop at The Museum of Modern Art. No underdrawing showed up under infrared reflectography. It is possible that Van Gogh made an underdrawing in diluted oil paint or another medium that is not revealed by this method. The canvas was also examined with ultraviolet light and with raking light. My thanks to Chief Conservator Jim Coddington, who generously gave of his time and shared his knowledge to assist me in my study of *The Starry Night*. Thanks, too, to his colleagues Corey d'Augustine and Chris McGlinchey.
36 The absence of color in the drawing that he made after the painting a little while later, F1540 / JH1732 (Museum of Architecture, Moscow), made it more difficult to create this suggestion. Van Gogh consequently chose to show smoke rising from some of the chimneys, signs of life that are not found in the painting.

LANDSCAPES AT TWILIGHT

1 Letters 56/44, 82/69, and 119/100, among others.
2 Letter 130/110.
3 Van Gogh worked for Goupil & Cie from 1869 to 1876.
4 Letter 404/339.
5 It is believed that this was Dirk van Rijn's farm on Leyweg in Loosduinen.
6 Letter 386/321.
7 Letter 390/325.
8 Letter 540/429.
9 Van Tilborgh and Vellekoop 1999, p. 157.
10 Quoted in De Brouwer 2000, p. 55.
11 See Ten Berge, Van Kooten, and Rijnders 2003, pp. 72–74.
12 Van Tilborgh and Vellekoop 1999, p. 68.
13 Letter 540/429.
14 Letter 499/402.
15 Letter 572/459a.
16 With thanks to Louis van Tilborgh and Ella Hendriks.
17 Letter 590/B2.
18 Letter 593/W3.
19 Letter 867/632.
20 Letter 780/593.
21 Daubigny spent his final years, until his death in 1878, in Auvers-sur-Oise.
22 Letter 896/644.

PEASANT LIFE

1 The title of this essay is taken from a letter from Vincent to Theo from Nuenen in early 1885: "I intend to make a series of scenes from rural life, in short—les paysans chez eux" (letter 496/400).
2 Letter 841/623.
3 Letter 818/613.
4 Pollock 1988, p. 413.
5 Letter 499/402.
6 Letter 576/W1.
7 Letter 864/629.
8 Van Gogh mentions the painting by Israëls in letters 210/181 and 258/225. He mentions the painting by Groux in letters 142/121, 278/R16, 478/390, 606/482, and 677/531.

9 See also p. 66 in this book.
10 Letters 500/403 and 533/R58.
11 Letter 501/404.
12 Letter 529/R57.
13 Letter 529/R57.
14 Letter 499/402.
15 While Blanc does not cite Chevreul specifically, the color theories he outlines in *Grammaire des arts du dessin* are those of Chevreul.
16 Letter 501/404. See Wright 2001.
17 See also pp. 67–68 in this book.
18 Letter 503/406.
19 Letter 505/408.
20 Letter 509/410.

THE VOICE OF THE WHEAT

1 Thomson 1994, p. 109.
2 Van Tilborgh and Salé 1998, p. 34.
3 Letter 36/29.
4 Letter 290/248.
5 Letter 684/535.
6 Letters 631/501, 630/B7, and 629/501a.
7 Letter 680/534. For a discussion of this group of paintings see Van Uitert 1981–82, pp. 223–45.
8 Letter 631/501.
9 Letter 630/B7. It is striking that Van Gogh continued his letter by expressing the wish to paint a starry sky above a wheat field.
10 Letter 668/523.
11 "From time to time a canvas that makes a painting, such as that sower, which I too think is better than the first one" (letter 728/560).
12 Sensier 1881, p. 127.
13 Letters 499/402, 502/405, 503/406, 506/409, and 509/410.
14 Particularly the Gospels of St. Matthew and St. Mark.
15 Letter 637/503. For Van Gogh's use of color see p. 74 in this book.
16 For an in-depth discussion of the two paintings see pp. 74–77 in this book.
17 Letter 788/W13.
18 Letter 801/604.
19 For a discussion of this painting see p. 92 in this book.
20 Letter 631/501.
21 Letter 630/B7.
22 Letter 636/B9.
23 Van Gogh often painted courting couples to lend a poetic or romantic significance to the work. See p. 137 in this book.
24 Ten Berge, Van Kooten, and Rijnders 2003, p. 308.
25 For discussions of this painting see pp. 80–85 and 141–44 in this book.
26 Van Gogh made this painting in 1884 as a study for a commission by the goldsmith and amateur artist Antoon Hermans to decorate his dining room. Van Gogh designed a series of six paintings of work on the land at different times of the year. Van Gogh's decorations disappeared from Hermans's house after his death; the paintings are known from sketches and studies. See Van Tilborgh and Salé 1998, pp. 68–80.
27 Van Gogh had already drawn stooping women like these when he was still in the Netherlands; he mentioned Millet's painting for the first time in a letter of 1882, saying that he knew it from reproductions and had read about it in Sensier's biography. See letter 281/241 and Sensier 1881, pp. 178–81.

28 Letter 835/620.
29 Letter 281/241.
30 Letter 878/614a.

POETRY OF THE NIGHT

1 For a discussion of Van Gogh's early landscape painting by night see the essay by Geeta Bruin in this book.
2 Letter 438/R44.
3 See for the April letters to Theo and Bernard: 598/476 and 597/B3; for the June letter, 630/B7.
4 Letters 635/B8, 642/506, 647/B11, and 695/543.
5 Daudet n.d., p. 46. We are indebted to Wouter van der Veen for all his advice and suggestions regarding Van Gogh's literary influences. His groundbreaking dissertation on this topic, entitled *Van Gogh: A Literary Mind,* will be published in fall 2008.
6 Letter 663/520.
7 Letter 677/531.
8 Letter 854/626a.
9 Letter 680/534.
10 Letters 680/534 and 679/533.
11 Letter 681/W7.
12 Letter 597/B3.
13 Letter 681/W7.
14 Letter 685/537.
15 The book's opening scene is set on the nocturnal Parisian boulevards with their bustling terraces.
16 Letter 596/474. Van Gogh's paintings of wheat fields by evening and night are discussed in the essay by Maite van Dijk in this book.
17 Letter 696/553b.
18 Letter 701/545.
19 *Two Lovers* (ill. 98) is the remaining fragment of a larger painting, which is known through a letter-sketch Van Gogh sent to Bernard on March 18, 1888. *The Lovers: The Poet's Garden IV* was confiscated by the Nazis in 1937 and has since been lost. Van Gogh made a letter-sketch of the painting (ill. 99).
20 Letter 824/B21.
21 Letter 766/587.
22 Also known as Christ in the Garden of Gethsemane, this theme is referred to in letters 641/505, 689/540, and 824/B21.
23 Letter 689/540.
24 Analyses of astronomical data have provided clues on the extent to which Van Gogh navigated between reality and imagination in depicting his starry skies. Around the same time he executed *Country Road in Provence by Night* (ill. 104), for example, it was announced in a French astronomic journal that April 20, 1890, would be an especially favorable night to observe a crescent moon flanked by Venus and Mercury. See Sinnott 1988.
25 Letter 893/643.
26 Letter 597/B3.
27 Quoted in Olson 1985, p. 89.
28 Letter 695/543.
29 Werness 1985, p. 39. For more comparisons between Whitman and Van Gogh, see Layman 1984.
30 For more on Van Gogh's actual sources for *The Starry Night*, see Soth 1986.
31 Letter 681/W7.

148 | NOTES

BIBLIOGRAPHY

Amigorena, Angelier, and Jacques-Lefèvre 1995
Amigorena, Horatio, François Angelier, and Nicole Jacques-Lefèvre. *La Nuit*. Grenoble: J. Millon, 1995.

Banu 2005
Banu, Georges. *Nocturnes: peindre la nuit, jouer dans le noir*. Paris: Biro, 2005.

Ten Berge, Van Kooten, and Rijnders 2003
Ten Berge, Jos, Toos van Kooten, and Mieke Rijnders. *The Paintings of Vincent van Gogh in the Collection of the Kröller-Müller Museum*. Otterlo: Kröller-Müller Museum, 2003.

Bieri and Minder 1998
Bieri, Helen, and Nicole Minder. *Effets de nuit*, exh. cat. Vevey: Cabinet cantonal des estampes; Gingins: Fondation Neumann; Geneva: Editions du Tricorne, 1998.

Blanc 1867
Blanc, Charles. *Grammaire des arts du dessin. Architecture, sculpture, peinture*. Paris: J. Renouard, 1867.

Blanc 1876
Blanc, Charles. *Les artistes de mon temps*. Paris: Firmin-Didot, 1876.

Blühm and Lippincott 2000
Blühm, Andreas, and Louise Lippincott. *Light! The Industrial Age 1750–1900: Art & Science, Technology & Society*, exh. cat. (Van Gogh Museum, Amsterdam; Carnegie Museum of Art, Pittsburgh). New York: Thames & Hudson, 2000.

Boime 1984
Boime, Albert. "Van Gogh's Starry Night: A History of Matter and a Matter of History." *Arts Magazine* 59, no. 4 (December 1984): 86–103.

Bourrut-Lacouture 2002
Bourrut-Lacouture, Annette. *Jules Breton: Painter of Peasant Life*, exh. cat. (Musée des Beaux-Arts, Arras; Musée des Beaux-Arts, Quimper; National Gallery of Ireland, Dublin). New Haven: Yale University Press, 2002.

De Brouwer 2000
De Brouwer, Ton. *De oude toren en Van Gogh in Nuenen*. Venlo: Van Spijk, 2000.

Burmester, Heilmann, and Zimmermann 1999
Burmester, Andreas, Christoph Heilmann, and Michael F. Zimmermann. *Barbizon: Malerei der Natur—Natur der Malerei*. Munich: Klinkhardt & Biermann, 1999.

Cate and Shaw 1996
Cate, Philip Dennis, and Mary Lewis Shaw, eds. *The Spirit of Montmartre: Cabarets, Humor, and the Avant-Garde, 1875–1905*, exh. cat. (Jane Voorhees Zimmerli Art Museum, New Brunswick; The Society of the Four Arts, Palm Beach; The Samuel P. Harn Museum of Art, University of Florida, Gainesville). New Brunswick, N.J.: Rutgers University Press, 1996.

Choné 1992
Choné, Paulette. *L'Atelier des nuits: histoire et signification du nocturne dans l'art d'Occident*. Nancy: Presses Universitaires de Nancy, 1992.

Conisbee, Van Heugten, and Van Tilborgh 1988
Conisbee, Philip, Sjraar van Heugten, and Louis van Tilborgh. *Van Gogh & Millet*, exh. cat. Amsterdam: Van Gogh Museum, 1988.

Conscience 1864
Conscience, Hendrik. *Scènes de la vie flamande*, trans. Léon Wocquier. Paris: Michel Lévy, 1864.

Cooper and Donaldson-Evans 1992
Cooper, Barbara T., and Mary Donaldson-Evans, *Modernity in Late Nineteenth-Century France*. Newark: University of Delaware Press, 1992.

Daudet n.d.
Daudet, Alphonse. *Lettres de mon Moulin*. Paris, n.d.

Dekkers 2000
Dekkers, Dieuwertje, ed. *Jozef Israëls 1824–1911*, exh. cat. (Groninger Museum, Groningen; Jewish Historical Museum, Amsterdam). Zwolle: Waanders, 2000.

Druick and Zegers 2001
Druick, Douglas, and Peter Zegers. *Van Gogh and Gauguin: The Studio of the South*, exh. cat. Chicago: The Art Institute of Chicago; Amsterdam: Van Gogh Museum, 2001.

Ekirch 2005
Ekirch, A. Roger. *At Day's Close: Night in Times Past*. New York: W. W. Norton, 2005.

Frèches-Thory, Roquebert, and Thomson 1992
Frèches-Thory, Claire, Anne Roquebert, and Richard Thomson. *Toulouse-Lautrec*, exh. cat. (Hayward Gallery, London; Galeries nationales du Grand Palais, Paris). London: South Bank Centre, 1992.

Gigoux 1885
Gigoux, Jean. *Causeries sur les artistes de mon temps*. Paris: Callman-Lévy, 1885.

Gloor et al. 2004
Gloor, Lukas, et al. *Foundation E. G. Bührle Collection Zürich*, vol. 3. Treviso: Linea d'Ombra, 2004.

Hecht 2006
Hecht, Peter. *Van Gogh and Rembrandt*. Amsterdam: Van Gogh Museum, 2006.

Hendriks and Van Tilborgh 2006
Hendriks, Ella, and Louis van Tilborgh. *New Views on Van Gogh's Development in Antwerp and Paris: An Integrated Art Historical and Technical Study of His Paintings in the Van Gogh Museum*. Ph.D. dissertation, University of Amsterdam, 2006, vol. 2.

Herbert 1991
Herbert, Robert L., ed. *Georges Seurat 1859–1891*, exh. cat. Paris: Galleries nationales du Grand Palais; New York: The Metropolitan Museum of Art, 1991.

Van Heugten, Van Tilborgh, and Van Uitert 1990
Van Heugten, Sjraar, Louis van Tilborgh, and Evert van Uitert. *Vincent van Gogh: Paintings*, exh. cat. Amsterdam: Van Gogh Museum, 1990.

Jansen 2003
Jansen, Leo. "Literatuur als leidraad: Vincent van Gogh als lezer." *Literatuur: magazine over Nederlandse letterkunde* 20 (February 2003): 20–26.

Jansen, Luijten, and Bakker 2007
Jansen, Leo, Hans Luijten, and Nienke Bakker. *Vincent van Gogh, Painted with Words: The Letters to Emile Bernard*. New York: Rizzoli, 2007.

Kosinski 2006
Kosinski, Dorothy, ed. *Van Gogh's Sheaves of Wheat*, exh. cat. Dallas: Dallas Museum of Art, 2006.

Layman 1984
Layman, Lewis M. "Echoes of Walt Whitman's 'Bare-Bosom'd Night' in Vincent van Gogh's 'Starry Night'." *American Notes and Queries* 12, no. 22 (1984): 105–9.

Moffett 1986
Moffett, Charles S., ed. *The New Painting: Impressionism 1874–1886*. Geneva: R. Burton, 1986.

Olson 1985
Olson, Roberta. *Fire and Ice: A History of Comets in Art*. New York: Published for the National Air and Space Museum, Smithsonian Institution, by Walker and Co., 1985.

Pabst 1988
Pabst, Fieke. *Vincent van Gogh's Poetry Albums*. Zwolle: Waanders, 1988.

Pickvance 1984
Pickvance, Ronald. *Van Gogh in Arles*, exh. cat. New York: The Metropolitan Museum of Art, 1984.

Pickvance 1986
Pickvance, Ronald. *Van Gogh in Saint-Rémy and Auvers*, exh. cat. New York: The Metropolitan Museum of Art, 1986.

Pickvance 1988
Pickvance, Ronald. "Van Gogh's Night Café: Synthesis at Work." In *Vincent van Gogh: International Symposium*. Tokyo: Tokyo Shinbun, 1988.

Pollock 1988
Pollock, Griselda. "Van Gogh and the Poor Slaves: Images of Rural Labour as Modern Art." *Art History* 11, no. 3 (September 1988): 408–32.

Van Rappard-Boon et al. 2006
Van Rappard-Boon, Charlotte, et al. *Japanese Prints: Catalogue of the Van Gogh Museum's Collection*. Amsterdam: Van Gogh Museum; Zwolle: Waanders, 2006.

Saint-Girons 2006
Saint-Girons, Baldine. *Les marges de la nuit: pour une autre histoire de la peinture*. Paris: Amateur, 2006.

Sensier 1881
Sensier, Alfred. *La vie et l'oeuvre de Jean-François Millet*. Paris: A. Quantin, 1881.

Silvestre 1864
Silvestre, Théophile. *Eugène Delacroix: documents nouveaux*. Paris: M. Lévy, 1864.

Sinnott 1988
Sinnott, Roger W. "Astronomical Computing: Van Gogh, Two Planets, and the Moon." *Sky & Telescope* (October 1988): 406–8.

Soth 1986
Soth, Lauren. "Van Gogh's Agony." *The Art Bulletin* 68, no. 2 (June 1986): 301–13.

Souvestre 1867
Souvestre, Emile. *Un philosophe sous les toits. Journal d'un homme heureux*. Paris: M. Lévy, 1867.

Stechow 1966
Stechow, Wolfgang. *Dutch Landscape Painting of the Seventeenth Century*. London: Phaidon, 1966.

Stein 1986
Stein, Susan Alyson. *Van Gogh: A Retrospective*. New York: H. L. Levin Associates, 1986.

Stolwijk and Thomson 1999
Stolwijk, Chris, and Richard Thomson. *Theo van Gogh 1857–1891: Art Dealer, Collector and Brother of Vincent*, exh. cat. Amsterdam: Van Gogh Museum, 1999.

Stolwijk et al. 2003
Stolwijk, Chris, et al. *Vincent's Choice: Van Gogh's Musée Imaginaire*, exh. cat. (Van Gogh Museum, Amsterdam). London: Thames & Hudson, 2003.

Sund 1988
Sund, Judy. "The Sower and the Sheaf: Biblical Metaphor in the Art of Vincent van Gogh." *The Art Bulletin* 70, no. 4 (December 1988): 660–76.

Sund 1992
Sund, Judy. *True to Temperament: Van Gogh and French Naturalist Literature*. Cambridge: Cambridge University Press, 1992.

Thomson 1994
Thomson, Richard. *Monet to Matisse. Landscape Painting in France 1874–1914*, exh. cat. Edinburgh: National Gallery of Scotland, 1994.

Van Tilborgh 1993
Van Tilborgh, Louis. *The Potato Eaters by Vincent van Gogh*. Zwolle: Waanders, 1993.

Van Tilborgh 1994
Van Tilborgh, Louis. "Starry, Starry Night: Van Gogh's Sterrennacht." *Kunstschrift* 38, no. 6 (November–December 1994): 36–39.

Van Tilborgh and Salé 1998
Van Tilborgh, Louis, and Marie-Pierre Salé. *Millet—Van Gogh*, exh. cat. (Musée d'Orsay, Paris). Paris: Réunion des Musées Nationaux, 1998.

Van Tilborgh and Vellekoop 1999
Van Tilborgh, Louis, and Marije Vellekoop. *Vincent van Gogh Paintings: Dutch Period 1881–1885, Van Gogh Museum*. Amsterdam: Van Gogh Museum, 1999.

Van Uitert 1981–82
Van Uitert, Evert. "Van Gogh's Concept of His Oeuvre." *Simiolus* 4 (1981–82): 223–45.

Van der Veen 2007
Van der Veen, Wouter. *Van Gogh, homme de lettres. Littérature dans la correspondance de Vincent van Gogh*. Ph.D. dissertation, University of Utrecht, 2007.

Vitali 1998
Vitali, Christoph, ed. *Die Nacht*, exh. cat. Munich: Haus der Kunst, 1998.

Waiboer 2005
Waiboer, Adriaan. *Northern Nocturnes: Nightscapes in the Age of Rembrandt*, exh. cat. Dublin: National Gallery of Ireland, 2005.

Welker and Stratford 2006
Welker, Janie M., and Linda Stratford, eds. *A Romance with the Landscape: Realism to Impressionism*, exh. cat. Lexington: University of Kentucky Art Museum, 2006.

Welsh-Ovcharov 1981
Welsh-Ovcharov, Bogomila. *Vincent van Gogh and the Birth of Cloisonism*, exh. cat. Amsterdam: Van Gogh Museum; Toronto: Art Gallery of Ontario, 1981.

Werness 1985
Werness, Hope B. "Whitman and Van Gogh: Starry Nights and Other Similarities." *Walt Whitman Quarterly Review* 2, no. 4 (Spring 1985): 35–41.

Wheelock 2002
Wheelock, Arthur K., ed. *Aelbert Cuyp*, exh. cat. (National Gallery of Art, Washington; National Gallery, London; Rijksmuseum, Amsterdam). London: Thames & Hudson, 2002.

Wright 2001
Wright, Beth S., ed. *The Cambridge Companion to Delacroix*. Cambridge: Cambridge University Press, 2001.

LIST OF ILLUSTRATIONS

All works in the collection of the Van Gogh Museum are the property of the Vincent van Gogh Foundation, with the exception of the works numbered 56, 57, 62.

References to Van Gogh's works appear with two reference numbers. The first (F) refers to J.-B. de la Faille, *The Works of Vincent van Gogh: His Paintings and Drawings* (Amsterdam, 1970); the second (JH) refers to Jan Hulsker, *The New Complete Van Gogh: Paintings, Drawings, Sketches* (Amsterdam and Philadelphia, 1996).

Works marked with an asterisk are included in the exhibition.

*27
Vincent van Gogh
The Night Café. 1888
Oil on canvas, 28 ½ x 36 ¼" (72.4 x 92.1 cm)
Yale University Art Gallery, New Haven
Bequest of Stephen Carlton Clark, B.A. 1903
F463 / JH1575
New York only

28
Vincent van Gogh
The Brothel. 1888
Oil on canvas, 13 x 16 ⅛" (33 x 41 cm)
The Barnes Foundation, Merion, Pennsylvania
F478 / JH1599

29
Paul Gauguin
Night Café. 1888
Oil on burlap, 28 ⅜ x 36 ¼" (72 x 92.1 cm)
The Pushkin State Museum of Fine Arts, Moscow

30
Paul Gauguin
Human Miseries (Grape Harvest in Arles). 1888
Oil on burlap, 28 ¾ x 36 ⅝" (73 x 93 cm)
Ordrupgaard, Copenhagen

*31
Studio of Rembrandt van Rijn
The Holy Family at Night. 1638–40
Oil on panel, 26 ³⁄₁₆ x 30 ¹¹⁄₁₆" (66.5 x 78 cm)
Rijksmuseum, Amsterdam
Amsterdam only

*32
Jean-François Millet
Starry Night. c. 1851
Oil on canvas, 25 ¾ x 32" (65.4 x 81.3 cm)
Yale University Art Gallery, New Haven
Leonard C. Hanna, Jr. B.A. 1913, Fund
Amsterdam only

*33
Vincent van Gogh
The Dance Hall in Arles. 1888
Oil on canvas, 25 ⁹⁄₁₆ x 31 ⅞" (65 x 81 cm)
Musée d'Orsay, Paris
Life-interest gift of M. and Mme André Meyer, 1950
F547 / JH1652

34
Edgar Degas
Women on a Café Terrace, Evening. 1877
Pastel on paper, 21 ⁷⁄₁₆ x 28 ⅛" (54.5 x 71.5 cm)
Musée d'Orsay, Paris
Bequest of Gustave Caillebotte, 1896

*35
Vincent van Gogh
The "Au Charbonnage" Café. 1878
Pencil and brown ink on laid paper,
5 ½ x 5 ⁹⁄₁₆" (14 x 14.2 cm)
Van Gogh Museum, Amsterdam
FXXXI / JH –

*36
Vincent van Gogh
En Route. 1881
Pencil and brown and black ink on wove paper,
3 ⅞ x 2 ⁵⁄₁₆" (9.8 x 5.8 cm)
Van Gogh Museum, Amsterdam
F– / JH Juv.15

*37
Vincent van Gogh
Before the Hearth. 1881
Pencil and brown and black ink on wove paper,
3 ⅞ x 2 ⁵⁄₁₆" (9.8 x 5.8 cm)
Van Gogh Museum, Amsterdam
F– / JH Juv.16

*38
Vincent van Gogh
Sketch of *Sunset over a Meadow* in a letter to Theo
van Gogh. August 14, 1882 [258/225]
Black ink and gray pencil on laid paper,
10 ⁷⁄₁₆ x 8 ¼" (26.5 x 20.9 cm)
Van Gogh Museum, Amsterdam

39
Vincent van Gogh
Terrace of a Café at Night (Place du Forum). 1888
Oil on canvas, 31 ¾ x 25 ¹¹⁄₁₆" (80.7 x 65.3 cm)
Kröller-Müller Museum, Otterlo
F467 / JH1580

40
Vincent van Gogh
Sketch of a street map of Etten in a letter to Theo
van Gogh. July 22, 1878 [144/123]
Pencil and black ink on wove paper, 7 ¼ x 5 ⅜"
(18.4 x 13.6 cm)
Van Gogh Museum, Amsterdam

*41
Vincent van Gogh
Sketch of *Country Road in Provence by Night* in a
letter to Paul Gauguin. c. June 17, 1890 [896/643]
Pen and ink (discolored to brown) on wove paper,
13 ⅜ x 8 ⁹⁄₁₆" (34 x 21.8 cm)
Van Gogh Museum, Amsterdam

*42
Vincent van Gogh
Woman with a Broom. 1885
Oil on canvas mounted on panel, 16 ⁹⁄₁₆ x 10 ¹¹⁄₁₆"
(42 x 27.2 cm)
Kröller-Müller Museum, Otterlo
F152 / JH656

43
Vincent van Gogh
Woman Sewing. 1885
Oil on canvas, 17 x 13 ⁷⁄₁₆" (43.2 x 34.2 cm)
Van Gogh Museum, Amsterdam
F71 / JH719

44
Vincent van Gogh
Woman Winding Yarn. 1885
Oil on canvas, 15 ¾ x 12 ⅝" (40 x 32 cm)
Van Gogh Museum, Amsterdam
F36 / JH698

45
After Rembrandt
The Holy Family at Night. c. 1787
Etching
Cabinet des Estampes, Bibliothèque Nationale,
Paris

46
After Rembrandt
The Pilgrims at Emmaus
Etching, reproduced in Charles Blanc, *Grammaire
des arts du dessin* (1867), p. 592
Library Van Gogh Museum, Amsterdam

47
Vincent van Gogh
Study for *The Potato Eaters.* 1885
Oil on canvas, 15 ¾ x 20 ⅛" (40 x 51.1 cm)
Van Gogh Museum, Amsterdam
F77r / JH686

48
Vincent van Gogh
The Potato Eaters. 1885
Oil on canvas mounted on panel, 12 ⅜ x 16 ¾"
(31.5 x 42.5 cm)
Kröller-Müller Museum, Otterlo
F78 / JH734

*49
Vincent van Gogh
The Potato Eaters. 1885
Oil on canvas, 32 ⁵⁄₁₆ x 44 ⅞" (82 x 114 cm)
Van Gogh Museum, Amsterdam
F82 / JH764

*50
Vincent van Gogh
The Sower. 1888
Oil on canvas, 25 ¼ x 31 ⅝" (64.2 x 80.3 cm)
Kröller-Müller Museum, Otterlo
F422 / JH1470

*51
Vincent van Gogh
The Sower. 1888
Oil on burlap mounted on canvas, 28 ¹⁵⁄₁₆ x 36 ⅝"
(73.5 x 93 cm)
Foundation E. G. Bührle Collection, Zurich
F450 / JH1627
Amsterdam only

*52
Vincent van Gogh
The Sower. 1888
Oil on canvas, 12 ⅝ x 15 ¾" (32 x 40 cm)
Van Gogh Museum, Amsterdam
F451 / JH1629

53
See ill. 27

*54
Vincent van Gogh
The Starry Night. 1889
Oil on canvas, 29 x 36 ¼" (73.7 x 92.1 cm)
The Museum of Modern Art, New York
Acquired through the Lillie P. Bliss Bequest
F612 / JH1731

*84
Vincent van Gogh
Sketch of *Summer Evening near Arles* in a letter to
Emile Bernard. c. June 19, 1888 [630/B7]
Black ink on laid paper, 10 9/16 x 8 1/8"
(26.8 x 20.6 cm)
The Pierpont Morgan Library, New York
Gift of Eugene V. Thaw in honor of Charles E.
Pierce, Jr., 2007
New York only

85
Vincent van Gogh
Wheat Field with Reaper and Sun. 1889
Oil on canvas, 28 3/8 x 36 1/4" (72 x 92 cm)
Kröller-Müller Museum, Otterlo
F617 / JH1753

*86
Vincent van Gogh
Landscape with Wheat Sheaves and Rising Moon.
1889
Oil on canvas, 28 3/8 x 35 15/16" (72 x 91.3 cm)
Kröller-Müller Museum, Otterlo
F735 / JH1761

87
Vincent van Gogh
Wood Gatherers in the Snow. 1884
Oil on canvas mounted on panel, 26 3/8 x 49 5/8"
(67 x 126 cm)
Private collection
F43 / JH516

88
Vincent van Gogh
The Weeders. 1890
Oil on canvas, 19 11/16 x 25 3/16" (50 x 64 cm)
Foundation E. G. Bührle Collection, Zurich
F695 / JH1923

89
Jean-François Millet
The Gleaners. 1875
Oil on canvas, 32 15/16 x 43 11/16" (83.6 x 111 cm)
Musée d'Orsay, Paris
Gift of Mrs. Pommery, 1890

*90
Vincent van Gogh
*The Parsonage at Nuenen at Dusk, Seen from the
Back.* 1885
Oil on canvas, 16 1/8 x 21 7/16" (41 x 54.5 cm)
Private collection, on loan to the Noordbrabants
Museum, 's-Hertogenbosch
F183 / JH952

91
Vincent van Gogh
White House at Night. 1890
Oil on canvas, 23 7/16 x 28 3/4" (59.5 x 73 cm)
State Hermitage Museum, St. Petersburg
F766 / JH2031

92
See ill. 2

93
Vincent van Gogh
Woman Reading a Novel. 1888
Oil on canvas, 28 3/4 x 36 1/4" (73 x 92 cm)
Private collection
F497 / JH1632

*94
Vincent van Gogh
Gauguin's Chair. 1888
Oil on canvas, 35 5/8 x 28 9/16" (90.5 x 72.5 cm)
Van Gogh Museum, Amsterdam
F499 / JH1636

95
Vincent van Gogh
Van Gogh's Chair. 1888
Oil on canvas, 36 1/8 x 28 3/4" (91.8 x 73 cm)
The National Gallery, London
F498 / JH1635

96
Vincent van Gogh
The Night Café. 1888
Pencil, watercolor, and gouache on paper,
17 5/16 x 24 7/8" (44 x 63.2 cm)
Private collection
F1463 / JH1576

*97
Vincent van Gogh
Café Terrace at Night. 1888
Black ink and pencil on laid paper,
25 3/4 x 18 9/16" (65.4 x 47.1 cm)
Dallas Museum of Art
The Wendy and Emery Reves Collection
F1519 / JH1579
New York only

98
Vincent van Gogh
Two Lovers. 1888
Oil on canvas, 12 13/16 x 9 1/16" (32.5 x 23 cm)
Private collection
F544 / JH1369

99
Vincent van Gogh
Sketch after a painting (now lost) in a letter to
Theo van Gogh. c. October 21, 1888 [714/556]
Black ink (discolored to brown) on paper, 3 9/16 x 5 1/4"
(9 x 13.4 cm)
Van Gogh Museum, Amsterdam

*100
Vincent van Gogh
The Garden of Saint Paul's Hospital. 1889
Oil on canvas, 28 1/8 x 35 5/8" (71.5 x 90.5 cm)
Van Gogh Museum, Amsterdam
F659 / JH1850
Amsterdam only

101
Vincent van Gogh
The Garden of Saint Paul's Hospital. 1889
Oil on canvas, 28 15/16 x 36 1/4" (73.5 x 92 cm)
Museum Folkwang, Essen
F660 / JH1849

102
Vincent van Gogh
Olive Grove. 1889
Oil on canvas, 29 1/8 x 36 5/8" (74 x 93 cm)
Göteborgs Konstmuseum
F586 / JH1854

103
Vincent van Gogh
The Evening Walk. 1890
Oil on canvas, 19 1/2 x 17 15/16" (49.5 x 45.5 cm)
Museu de Arte de São Paulo
F704 / JH1981

*104
Vincent van Gogh
Country Road in Provence by Night. 1890
Oil on canvas, 35 11/16 x 28 3/8" (90.6 x 72 cm)
Kröller-Müller Museum, Otterlo
F683 / JH1982
Amsterdam only

105
See ill. 54

The following works were included in the
exhibition but are not illustrated here:

Louis Anquetin
Night Sail. 1887
Pastel on paper, 19 ½ x 25 ⅜" (49.5 x 64.5 cm)
Van Gogh Museum, Amsterdam
Amsterdam only

Gustave Doré
A Night Shelter in London. Date unknown
Wood engraving, 8 ¹⁄₁₆ x 9 ⁷⁄₁₆" (20.5 x 24 cm)
Van Gogh Museum, Amsterdam
Amsterdam only

Vincent van Gogh
Letter to Theo van Gogh. November 2, 1883 [407/340]
Black ink (discolored to brown) on wove paper,
8 ¼ x 10 ½" (21 x 26.7 cm)
Van Gogh Museum, Amsterdam
New York only

Vincent van Gogh
Sketch of *The Potato Eaters* in a letter to Theo van
Gogh. April 9, 1885 [495/399]
Black ink on wove paper, 10 ⅜ x 8 ⅛" (26.4 x 20.7 cm)
Van Gogh Museum, Amsterdam

Vincent van Gogh
The Potato Eaters. 1885
Lithograph, 8 ⁷⁄₁₆ x 12 ⅜" (21.5 x 31.4 cm)
The Museum of Modern Art, New York
Gift of Mr. and Mrs. A. A. Rosen
F1661 / JH737
New York only

Vincent van Gogh
The Potato Eaters. 1885
Lithograph, 10 ⁷⁄₁₆ x 12 ⅝" (26.5 x 32 cm)
Van Gogh Museum, Amsterdam
F1661 / JH737
Amsterdam only

Vincent van Gogh
Couple Dancing. 1885
Black, red, and blue chalk on wove paper,
3 ⅝ x 6 ⁷⁄₁₆" (9.2 x 16.3 cm)
Van Gogh Museum, Amsterdam
F1350b / JH969

Vincent van Gogh
Dance Hall. 1885
Black, red, and blue chalk and black ink
on wove paper, 3 ⅝ x 6 ⁷⁄₁₆" (9.2 x 16.3 cm)
Van Gogh Museum, Amsterdam
F1350a / JH968

Vincent van Gogh
Two Women in a Balcony Box. 1885
Black, red, and blue chalk on wove paper,
3 ⅝ x 6 ⁹⁄₁₆" (9.2 x 16.6 cm)
Van Gogh Museum, Amsterdam
F1350v / JH967

Vincent van Gogh
Letter to Wil van Gogh. c. September 14, 1888
[681/W7]
Black ink on wove paper, sheet one: 8 ¼ x 10 ½"
(20.9 x 26.7 cm); sheet two: 8 ¼ x 5 ¼" (21 x 13.3 cm)
Van Gogh Museum, Amsterdam
New York only

Vincent van Gogh
Letter to Theo van Gogh. September 16, 1888
[685/537]
Black ink on wove paper, 8 ¼ x 10 ½" (21 x 26.7 cm)
Van Gogh Museum, Amsterdam
New York only

Vincent van Gogh
Sketch of *The Sower* in a letter to Theo van Gogh.
c. November 21, 1888 [727/558a]
Black ink (discolored to brown) on wove paper,
10 ⅝ x 8 ¼" (27 x 21 cm)
Van Gogh Museum, Amsterdam

Utagawa Hiroshige
View of the Saruwakacho Theater Street. 1856
Color woodcut, 13 ⅜ x 8 ¹¹⁄₁₆" (34 x 22 cm)
Van Gogh Museum, Amsterdam
Amsterdam only

Utagawa Hiroshige
Enjoying the Cool of the Evening in Shijo, Kyoto. 1859
Color woodcut, 13 x 8 ¹¹⁄₁₆" (33 x 22 cm)
Van Gogh Museum, Amsterdam
Amsterdam only

Jean-François Millet
Peasant and Donkey Returning Homewards at Dusk.
1866
Pastel and black chalk on wove paper, 16 ⅛ x 19 ¹¹⁄₁₆"
(41 x 50 cm)
Museum Mesdag, The Hague
Amsterdam only

Mathew White Ridley
Pits and Pitmen—The Night Shift. 1871
Wood engraving, 8 ¾ x 11 ¾" (22.3 x 29.8 cm)
Van Gogh Museum, Amsterdam
Amsterdam only

Artist unknown
The Old Night Cabman. Date unknown
Wood engraving, 8 ¼ x 6 ¾" (20.9 x 17.1 cm)
Van Gogh Museum, Amsterdam
Amsterdam only

ACKNOWLEDGMENTS

This project could not have been realized without the generous cooperation of the lending museums and private collectors. We would like to express our unending gratitude to the following: Centraal Museum, Utrecht (Pauline Terreehorst and Len van den Berg); Dallas Museum of Art (John R. Lane, Bonnie Pitman, and Dorothy Kosinski); Foundation E. G. Bührle, Zurich (Hortense Anda-Bührle and Lukas Gloor); Kröller-Müller Museum, Otterlo (Evert J. van Straaten and Liz Kreijn); Menard Museum, Komaki (Norimichi Aiba); The Morgan Museum and Library, New York (William M. Griswold and Declan Kiely); Musée d'Orsay, Paris (Guy Cogeval, Serge Lemoine, and Sylvie Patry); Museo Thyssen-Bornemisza, Madrid (Carlos Fernández de Henestrosa y Argüelles and Guillermo Solana); Museum Mesdag, The Hague (Maartje de Haan); The New York Public Library (Paul LeClerc and Denise A. Hibay); Noordbrabants Museum, 's Hertogenbosch (Charles de Mooij and Ingrid Sonderen); Rijksmuseum, Amsterdam (Wim Pijbes and Ronald de Leeuw); Yale University Art Gallery, New Haven (Jock Reynolds, Jennifer Gross, and Lawrence Kanter); and all private lenders who wish to remain anonymous.

We have received crucial support and assistance from our colleagues at The Museum of Modern Art and the Van Gogh Museum. We are greatly indebted to the continuous encouragement and advice of our directors, Glenn D. Lowry and Axel Rüger. The involvement of Jennifer Russell (Senior Deputy Director for Exhibitions, Collections and Programs) and John Elderfield (now Chief Curator Emeritus of Painting and Sculpture, The Museum of Modern Art) was also essential to the realization of this project. Jay Levenson (Director, International Program) and Luis Pérez-Oramas (The Estrellita Brodsky Curator of Latin American Art) at The Museum of Modern Art kindly assisted in delicate loan negotiations. We have been extremely fortunate to collaborate with Chris Stolwijk (Head of Research, Van Gogh Museum), Geeta Bruin (Assistant Exhibitions Curator, Van Gogh Museum), Jennifer Field (Curatorial Assistant, Department of Painting and Sculpture, The Museum of Modern Art), and Maite van Dijk (Research Assistant, Department of Painting and Sculpture, The Museum of Modern Art). Their thoughtful and detailed attention has been invaluable to this exhibition, and they made important, substantial contributions to the catalogue.

They join us in thanking the following people for their critical contributions to the organization of the exhibition. At The Museum of Modern Art: Ramona Bronkar Bannayan (Director of Collection Management and Exhibition Registration), Maria DeMarco Beardsley (Coordinator of Exhibitions), Sacha Eaton (Assistant Registrar, Exhibitions), Susanna Ivy (Senior CEMS Coordinator), Jerry Neuner (Director of Exhibition Design and Production), Pete Omlor (Manager, Art Handling and Preparation), Susan Palamara (Registrar, Exhibitions), Peter Perez (Framing Conservator), and Eliza Sparacino (Manager, Collections and Exhibitions Technologies). At the Van Gogh Museum: Edwin Becker (Head of Exhibitions), Fouad Kanaan (Head Registrar), Adrie Kok (Registrar), and the many preparators and technicians who made possible the installation of the exhibition in both New York and Amsterdam. We are

also grateful to Deborah Wye (The Abby Aldrich Rockefeller Chief Curator) and Emily Talbot (Curatorial Assistant) at The Museum of Modern Art for generously lending a lithograph from the Department of Prints and Illustrated Books and contributing to the research for this exhibition.

Suzanne Bogman (Head of Publications, Van Gogh Museum) and Geri Klazema (Editorial Assistant, Van Gogh Museum) dedicated themselves to the publication of this book, in close cooperation with David Frankel (Managing Editor), Christopher Hudson (Publisher), and Kara Kirk (Associate Publisher) at The Museum of Modern Art. This catalogue, designed by Caroline Van Poucke, was made possible by the sensitive and intelligent editorial work of Aggie Langedijk and Kate Norment. We would also like to thank Lynne Richards and Irene Smets for their translations. This book could not have been produced without the enthusiastic support of the publishers Jan Martens and Ronny Gobyn, and their staff members, Ann Mestdag and Hans Cottyn.

The vast amount of research conducted in preparing this book and the exhibition would not have been possible without the incredible assistance of Fieke Pabst, Patricia Schuil, and Anita Vriend in the Department of Research and Documentation at the Van Gogh Museum; and Sheelagh Bevan (Assistant Librarian), Milan Hughston (Chief of Library and Museum Archives), Kevin Madill (Assistant Librarian, Research), and Jennifer Tobias (Librarian) at The Museum of Modern Art. Our special gratitude goes out to Monique Hageman at the Van Gogh Museum, whose assistance, together with the astounding support and research of the independent scholar Stefan Koldehoff, helped us with every aspect of the provenance research. We are also indebted to the immense and indispensable knowledge of Leo Jansen (Curator of Paintings), Hans Luijten (Curator of Research), and Marije Vellekoop (Curator of Prints and Drawings) at the Van Gogh Museum. The scholarship of Nienke Bakker (Researcher, Van Gogh Museum) was especially valuable in researching Van Gogh's letters, and her comments and advice are reflected in every part of this book. The expertise of the museums' conservators was paramount for a better understanding of Van Gogh's artistic practice; we would like to express our deepest thanks to Jim Coddington (Agnes Gund Chief Conservator), Michael Duffy (Conservator), and Chris McGlinchey (Conservation Scientist) at The Museum of Modern Art; and Ella Hendriks (Head of Conservation), Esther Hoofwijk (Depot Manager/Conservation Technician), Devi Ormond (Conservator), and Frans Stive (Technical Documentalist) at the Van Gogh Museum.

We also received much assistance from outside the museum. So many people helped in some way on the project that it is impossible to name them all. However, we do want to mention Guy Bennett, Nanne Dekking, Issei Fujiwara, Julio Landmann, Marsha Malinowski, C.C. Marsh, Koji Miura, Charles S. Moffett, Beatriz Pimenta Camargo, Susan Alyson Stein, Jennifer Tonkovich, Wouter van der Veen, and Ully Wille.

Sjraar van Heugten and Joachim Pissarro

INDEX

Page numbers in *italics* refer to illustrations.

Index of Works